Giotto: The Arena Chapel Frescoes

Illustrations · *Introductory Essay* ·
Backgrounds and Sources · *Criticism*

NORTON CRITICAL STUDIES IN ART HISTORY

Giotto:
The Arena Chapel Frescoes

*Illustrations · Introductory Essay ·
Backgrounds and Sources · Criticism ·*

EDITED BY

JAMES H. STUBBLEBINE

RUTGERS UNIVERSITY

W · W · NORTON & COMPANY

New York · London

W. W. Norton & Company, Inc., 500 Fifth Avenue, New York, N.Y. 10110
W. W. Norton & Company Ltd., 37 Great Russell Street, London WC1B 3NU

Copyright © 1969 by W. W. Norton & Company, Inc.
ISBN 0-393-09858-3
Library of Congress Catalog Card No. 67-17689

PRINTED IN THE UNITED STATES OF AMERICA
0

CONTENTS

LIST OF ILLUSTRATIONS

TEXT ILLUSTRATIONS

PREFACE

Although the frescoes by Giotto in the Arena Chapel in Padua are among the most celebrated works in the history of art, they are often difficult for the beginning student to appreciate visually and intellectually. This book is intended to serve two main functions. On the one hand, it is a general introduction to the subject, particularly through the essay by the editor. On the other, it is intended to provide the materials for a study in depth through the presentation of the early documents pertaining to the Arena Chapel and through the critical essays, which explore the frescoes from various stylistic and iconographic points of view.

The translation here of the Italian and Latin documents offers the student a body of what has been relatively inaccessible information. Documents on the Arena Chapel are few in number and refer only obliquely to the decoration of the interior. If by some chance there had been preserved a dated contract between Giotto and his patron, Enrico Scrovegni, setting forth the terms of the project, we might pay less attention to those other documents and early sources that have been handed down. As it is, we must carefully examine what little evidence there is in order to judge when and under what circumstances Giotto painted his frescoes. Scant as the material is, it helps to fill out a picture of what happened so long ago in Padua. We can read of the purchase of the land of the Paduan Arena in 1300 by Enrico Scrovegni, the Bishop's permission to build the Chapel in 1302, the dedication of the Chapel in 1303 as reported in the inscription (now lost) on Enrico's tomb, the papal bull of 1304 granting indulgences to visitors to the Chapel, the complaint in 1305 by the neighboring monks regarding the excessive luxuriousness of the new Chapel, and the decision of the Venetian High Council in March 1305 to lend wall hangings for the consecration of the Arena Chapel.

Within a very few years we hear of the completed frescoes. Be-

tween 1308 and 1312 Francesco da Barberino mentions the figure of Envy which Giotto had painted in the Arena Chapel, and between 1312 and 1318 Riccobaldo Ferrarese includes the Arena Chapel in a brief list of places where Giotto had painted. We include the references made to the frescoes by Ghiberti and Vasari not because they add anything to our knowledge, but because, curiously, these famous artist-writers, who otherwise acknowledged the greatness of Giotto, both pass over the Paduan frescoes in very few words, leaving us with the impression that they had never seen them with their own eyes.

A consideration of Giotto's frescoes involves us in such a related matter as the history of the religious customs associated with the Paduan Arena. The article by Zanocco included here contains revealing documentary evidence on the celebration in the Arena of the Feast of the Annunciation, a theme of particular importance in Giotto's fresco program. Only a superficial examination of Giotto's frescoes would ignore the role of the Scrovegni family, because the history of the patron, Enrico, and his father, Reginaldo, is inextricably bound up with the creation and decoration of the Chapel. The passage from Dante in which the poet characterizes the usurious Reginaldo in such dread phrases provides the background against which we must read the illuminating article by Ursula Schlegel on the motivation for the building of the Chapel and on how this motivation is repeatedly manifested in Giotto's frescoes.

The Golden Legend by Voragine, which provided artists with a treasure of scenarios from the moment it came into circulation, may well have given Giotto ideas for a number of his scenes. The universal appeal of the *Legend* lay in the way the author restated in the simplest language and most vivid narrative style the old apocryphal legends, at the same time giving an aura of unimpeachable erudition. We have not excised the tales of adventure and misadventure with which Voragine embellishes his stories of the saints, for these amusing vignettes are a vital part of Voragine's book and must have excited the boundless admiration of his contemporaries.

The critical essays brought together here do not make a comprehensive collection, nor could this be hoped within the limits of this book, given the vastness of the literature on Giotto. Nevertheless, they have been selected to give a variety of viewpoints and approaches. The article by Richard Offner is famous chiefly for its vehement demonstration of why Giotto could not have painted the frescoes of the life of St. Francis in the upper church at Assisi. It is included here because it contains one of the keenest analyses of Giotto's style ever written and because the Paduan frescoes are discussed in some detail and with great insight. A common theme in studies of the Arena

Chapel is the meaningful juxtaposition of various scenes; one such study, that of Professor Alpatoff, is included here. As is often the case, the examination of one factor in a program of frescoes augments our understanding of the whole; such is Dorothy Shorr's study of the iconography of the Virgin Mary in *The Last Judgment* on the west wall of the Arena Chapel. The reader should be stimulated, not discountenanced, by the differences of interpretation that crop up between critics, such as the conflicting identifications by Shorr and Schlegel of the figures standing behind the model of the Chapel in *The Last Judgment.* The kind of scientific approach that Millard Meiss and the conservationist Leonetto Tintori employed in their study of the working procedures in the frescoes of the life of St. Francis in Assisi was also used in their short study of Giotto's frescoes in Padua. And here, in this close examination of the painted surface itself and of the artist's mode of work, the genius of Giotto—proclaimed time and again since his name was first uttered by appreciative writers—is revealed in still another dimension.

Many have helped usher this book into being. Chief among these is Professor Josef Thanner of Rutgers University, who translated the article by Ursula Schlegel. For additional translations I am much obliged to Mr. Robert Bongiorno and Miss Adelheid Juks. My thanks go to Professor Alpatoff of Moscow University, to Mrs. Shorr of the Institute of Fine Arts of New York University, to Dr. Schlegel of the Staatliche Museen, Berlin-Dahlem, and to Professor Meiss of the Institute for Advanced Study, Princeton, not only for their permission to republish their articles, but for the pleasant and helpful conversations and correspondence attendant upon the arrangements. For innumerable favors, patient help, and encouragement I owe debts of gratitude to Professors Joseph Chierici, Martin Eidelberg, Remigio Pane, and Johannes Nabholz, all of Rutgers University, and to Dr. Alessandro Prosdocimo of the Museo Civico of Padua and Dr. Terisio Pignatti of the Civici Musei Veneziani.

JAMES H. STUBBLEBINE

THE ILLUSTRATIONS

PHOTO CREDITS

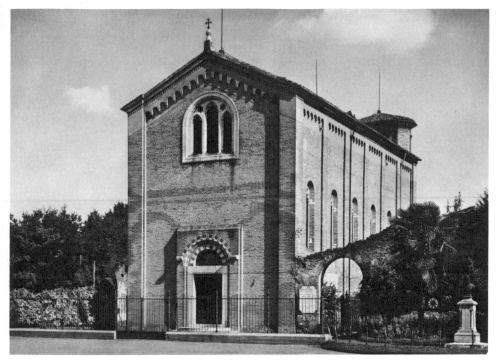

1. Exterior View of the Arena Chapel

2. Nineteenth-Century Engraving of the Scrovegni Palace and the Arena Chapel

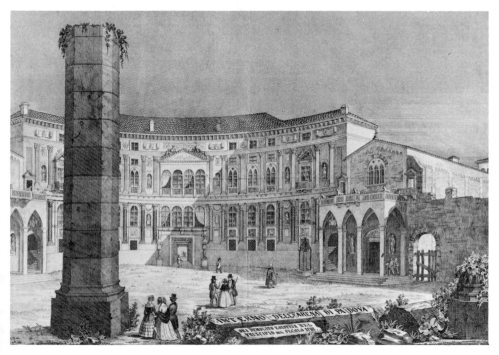

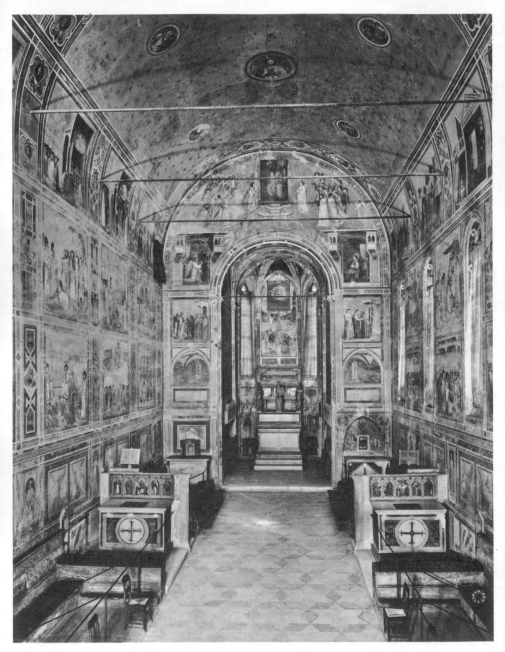

3. View Toward the Altar in the Arena Chapel

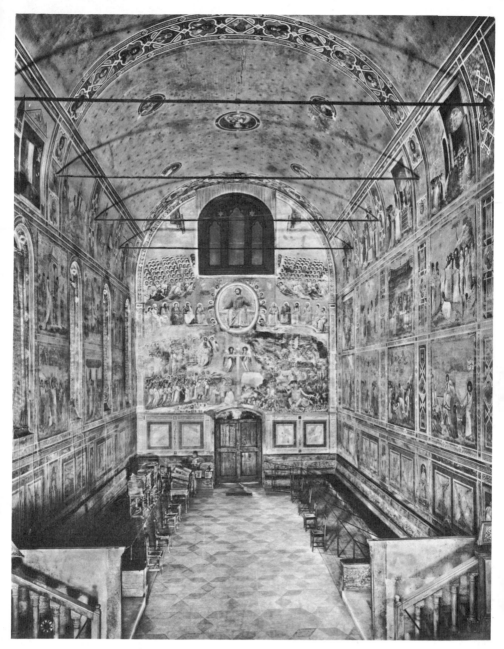

4. View Toward the Entrance in the Arena Chapel

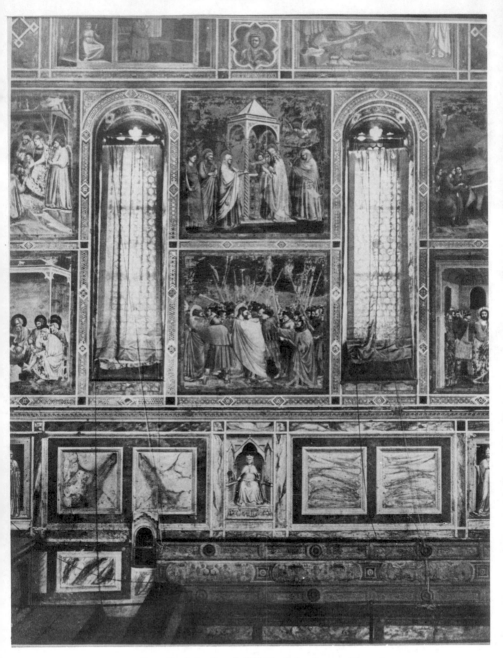

5. Detail of the South Wall of the Arena Chapel

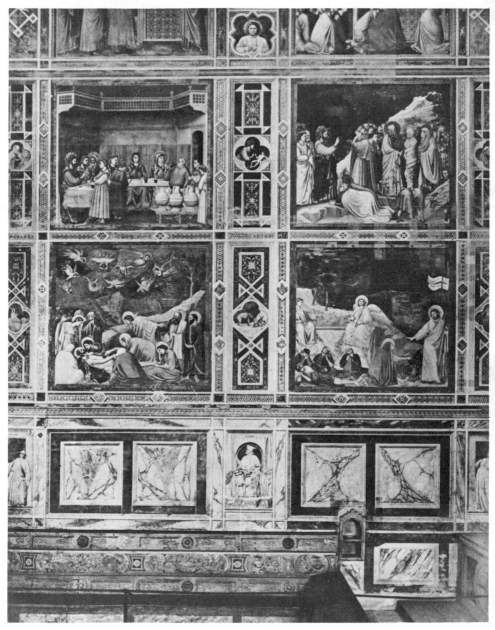

6. Detail of the North Wall of the Arena Chapel

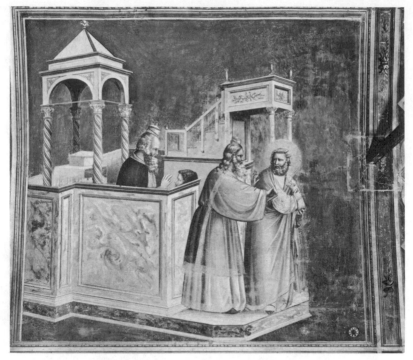

7. *The Expulsion of Joachim from the Temple*

8. *Joachim Retires to the Sheepfold*

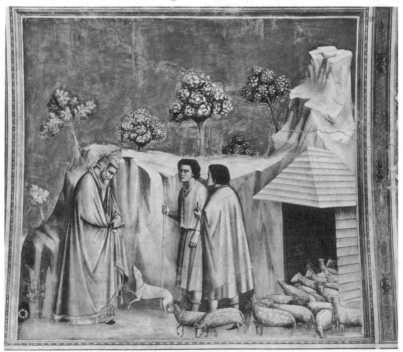

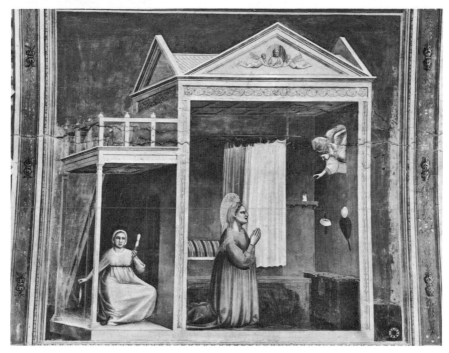

9. *The Annunciation to Anna*

10. *The Sacrifice of Joachim*

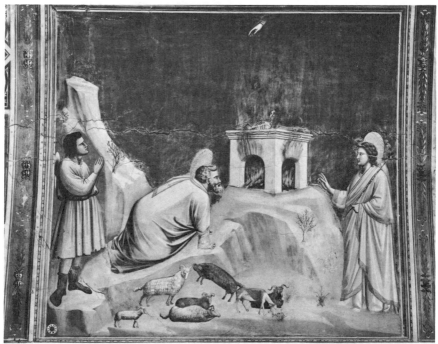

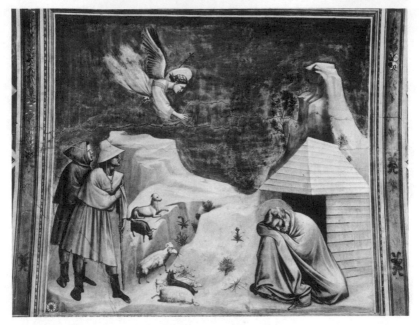

11. *The Vision of Joachim*

12. *The Meeting at the Golden Gate*

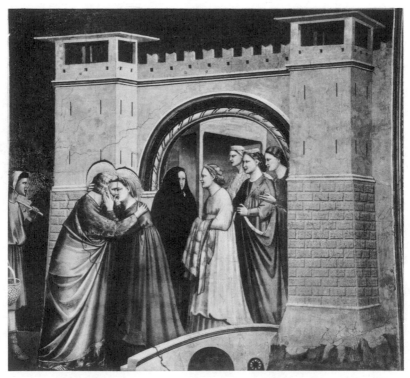

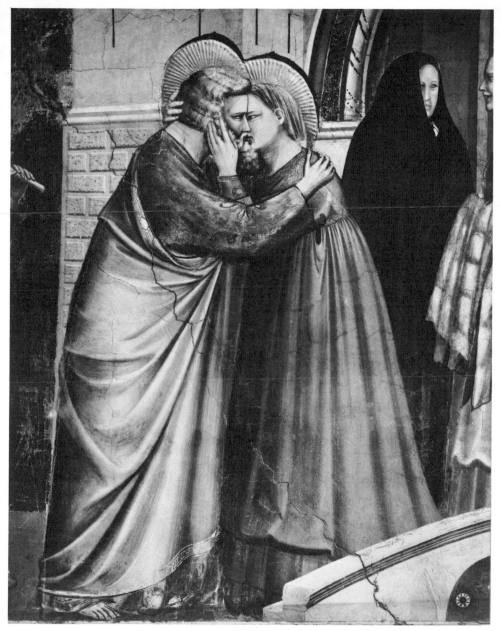

13. Detail of Joachim and Anna from fig. 12

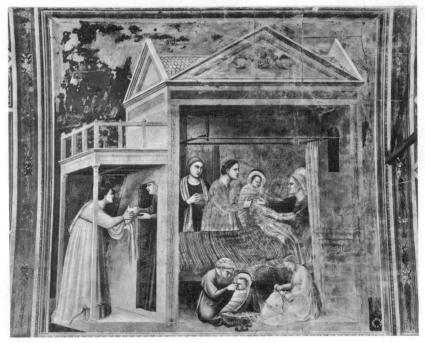

14. *The Birth of the Virgin*

15. *The Presentation of the Virgin in the Temple*

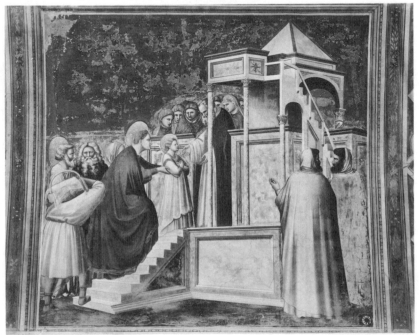

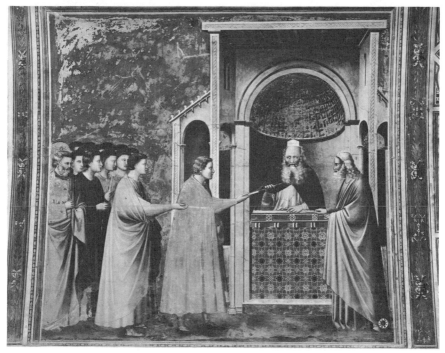

16. *The Presentation of the Rods*

17. *The Watching of the Rods*

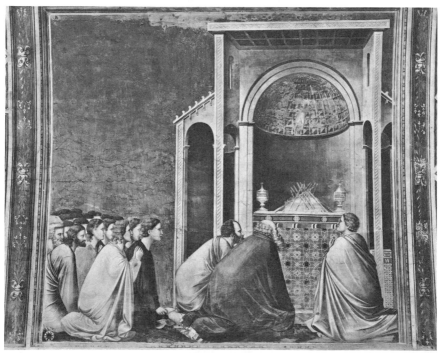

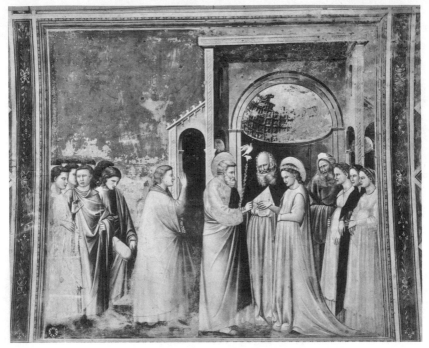

18. *The Betrothal of the Virgin*

19. *The Virgin's Return Home*

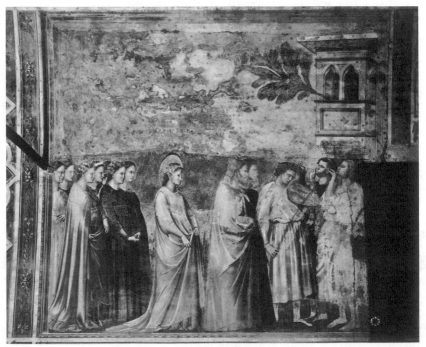

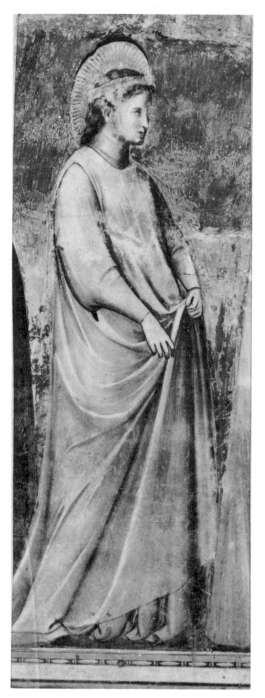

20. Detail of the Virgin from fig. 19

21. *God the Father Dispatching Gabriel*

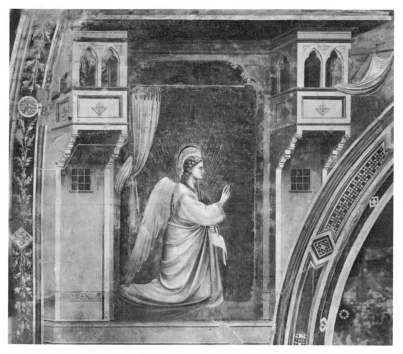

22. The Archangel Gabriel

23. The Annunciate Virgin

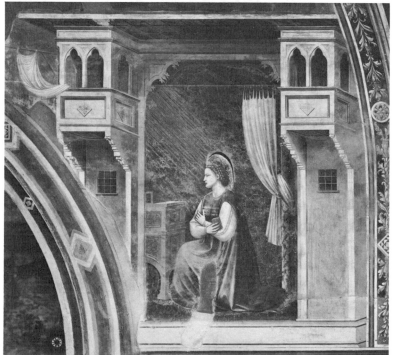

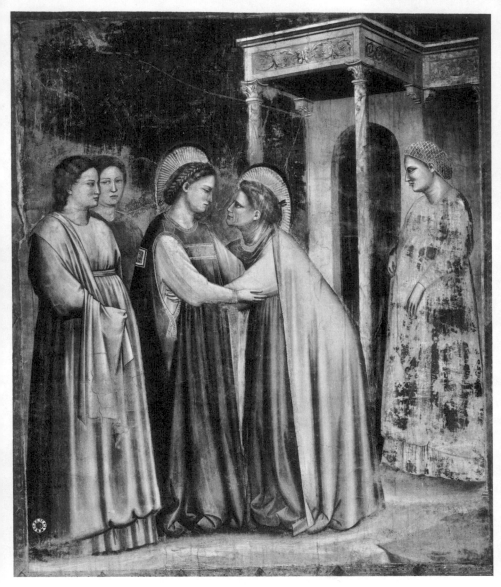

24. The Visitation

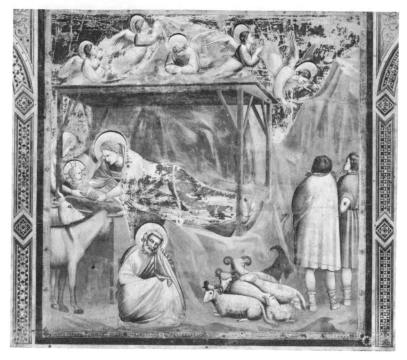

25. *The Nativity*

26. The Virgin and Child from fig. 25

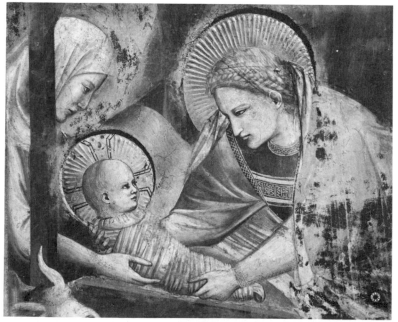

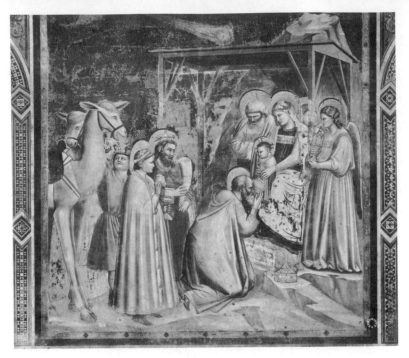

27. *The Adoration of the Magi*

28. *The Presentation of Christ in the Temple*

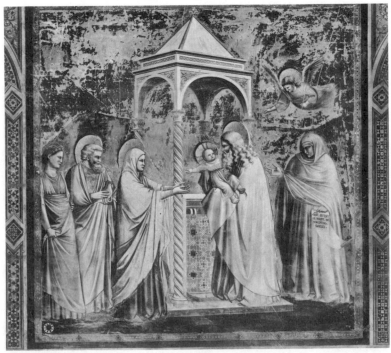

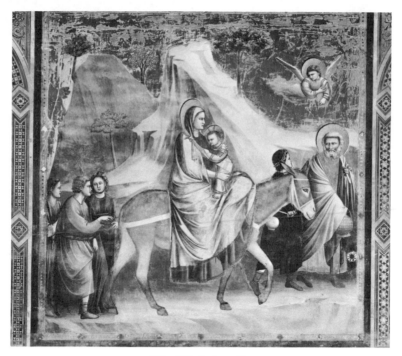

29. *The Flight into Egypt*

30. *The Massacre of the Innocents*

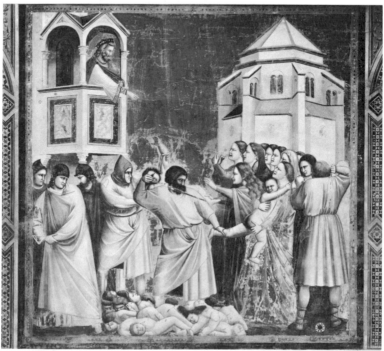

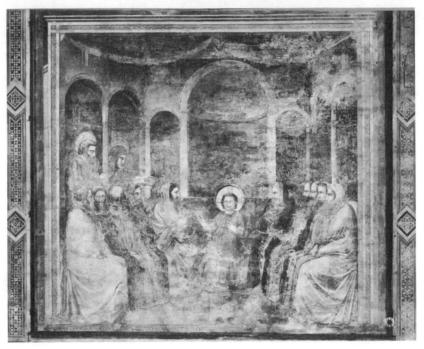

31. *Christ Disputing with the Elders*

32. *The Baptism of Christ*

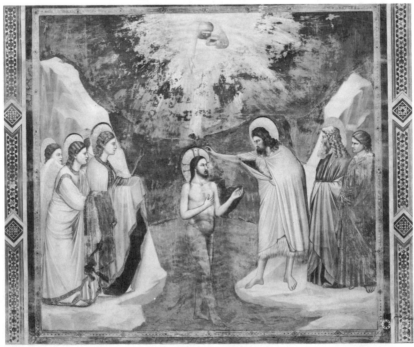

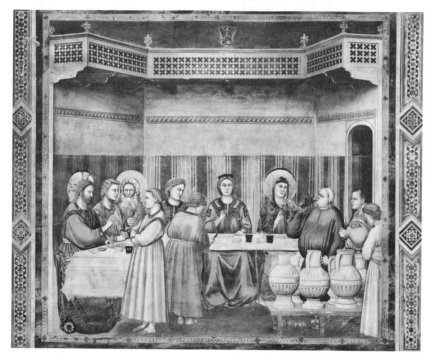

33. *The Marriage at Cana*

34. *The Raising of Lazarus*

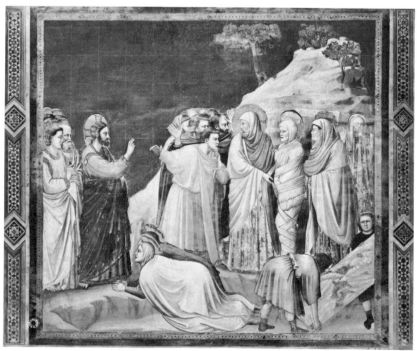

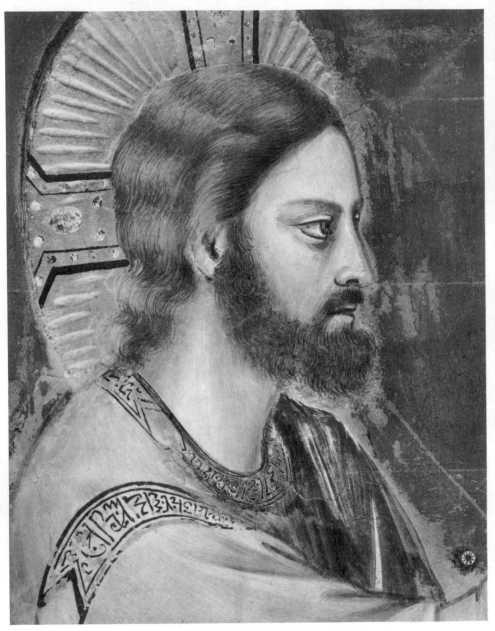

35. Detail of Christ from fig. 34

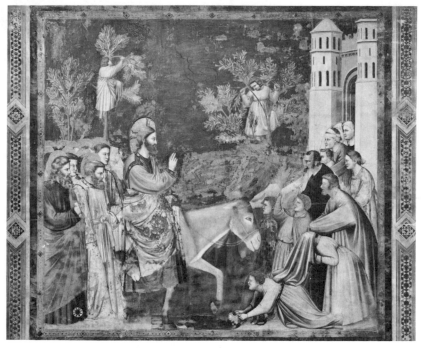

36. *The Entry into Jerusalem*

37. *The Expulsion of the Merchants from the Temple*

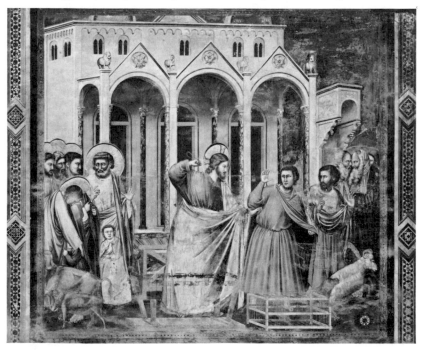

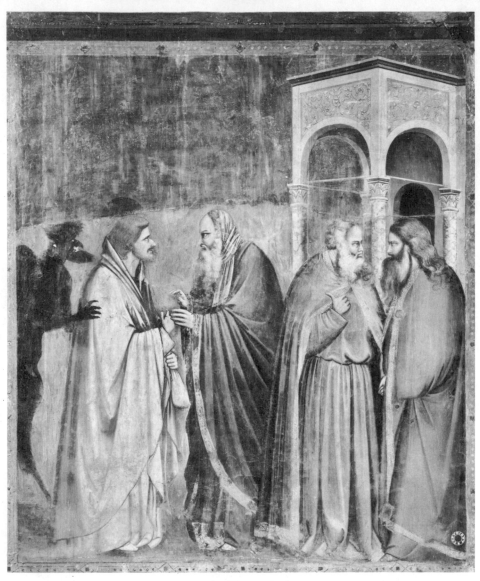

38. *The Pact of Judas*

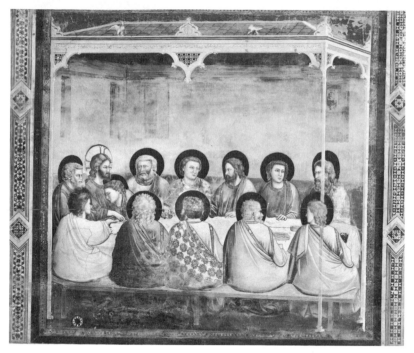

39. *The Last Supper*

40. *The Washing of the Feet*

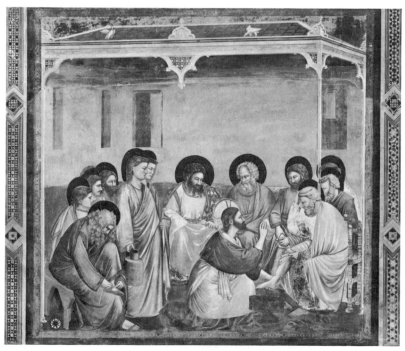

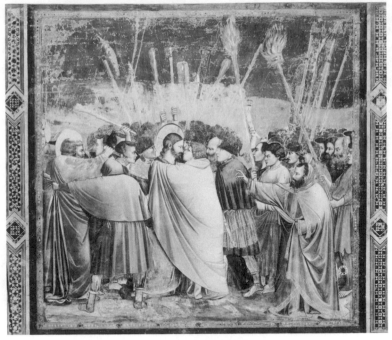

41. *The Betrayal of Christ*

42. Detail of Christ and Judas from fig. 41

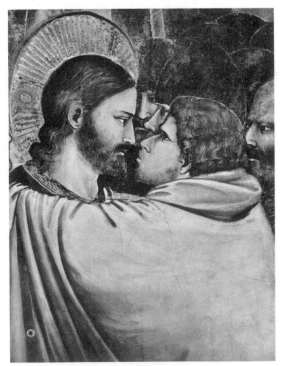

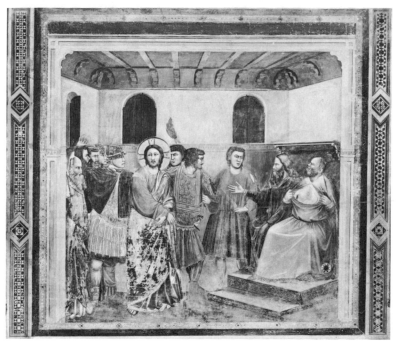

43. *Christ Before Caiaphas*

44. *The Mocking of Christ*

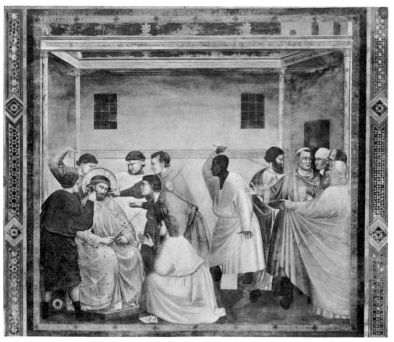

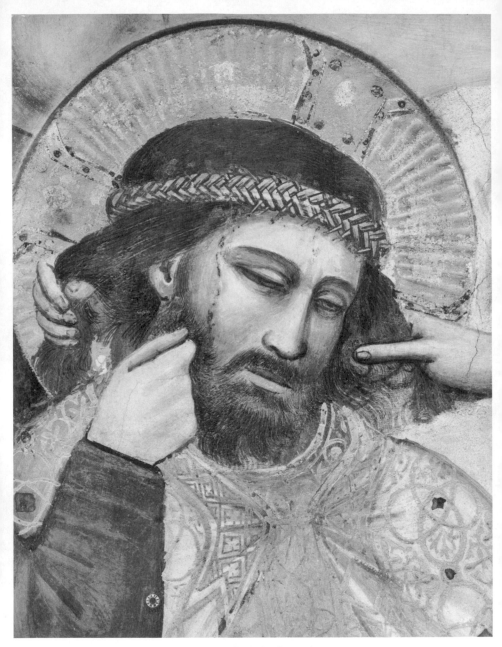

45. Detail of Christ from fig. 44

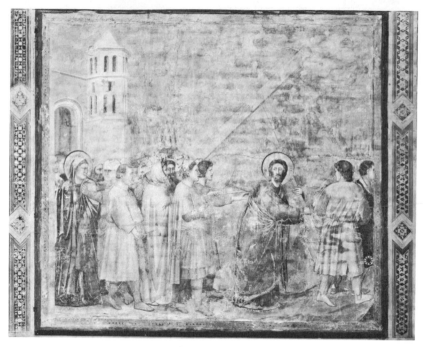

46. *The Road to Calvary*

47. *The Crucifixion*

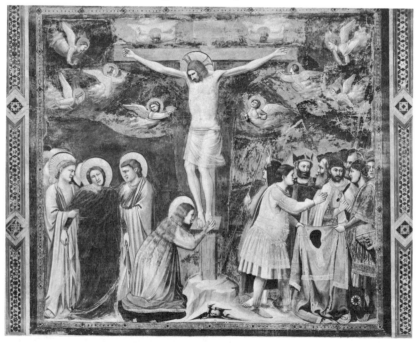

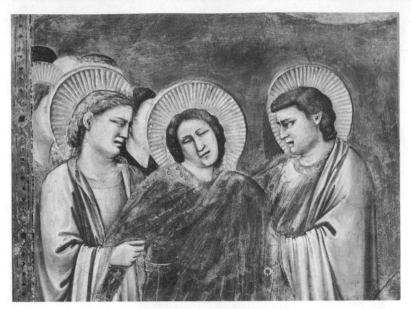

48. Detail of the Virgin from fig. 47

49. Detail of Christ from fig. 47

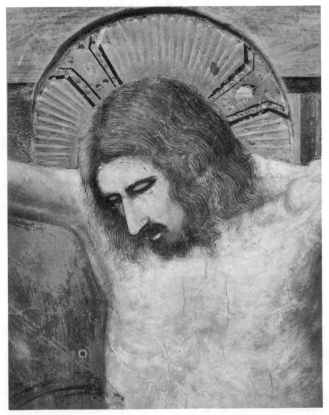

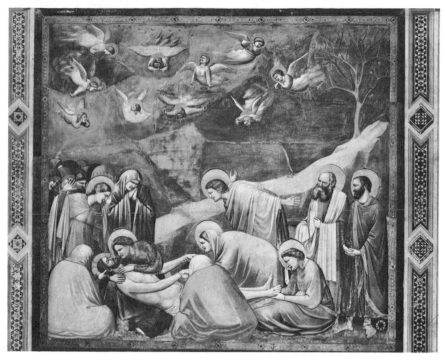

50. *The Pietà*

51. Detail of Christ and the Virgin from fig. 50

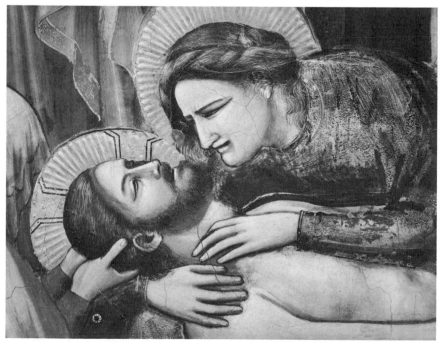

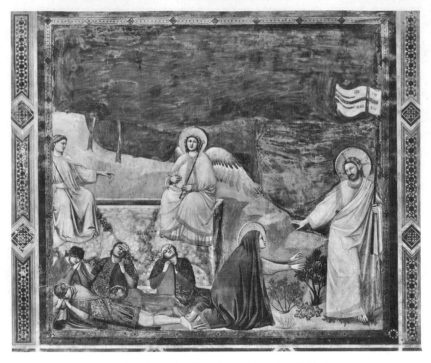

52. *The Angel at the Tomb* and the *Noli Me Tangere*

53. Detail of the Magdalen from fig. 52

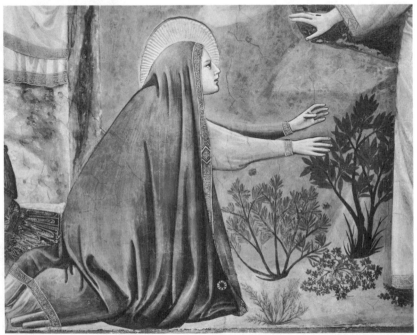

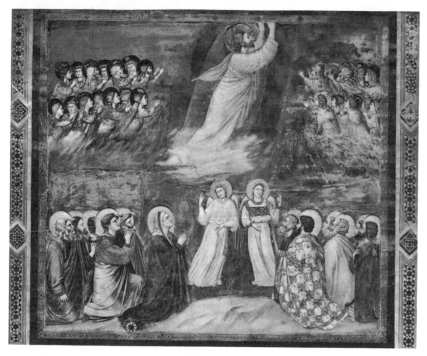

54. *The Ascension*

55. *The Pentecost*

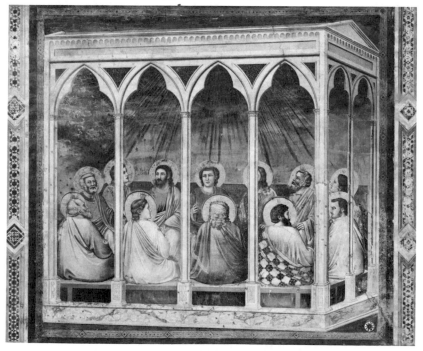

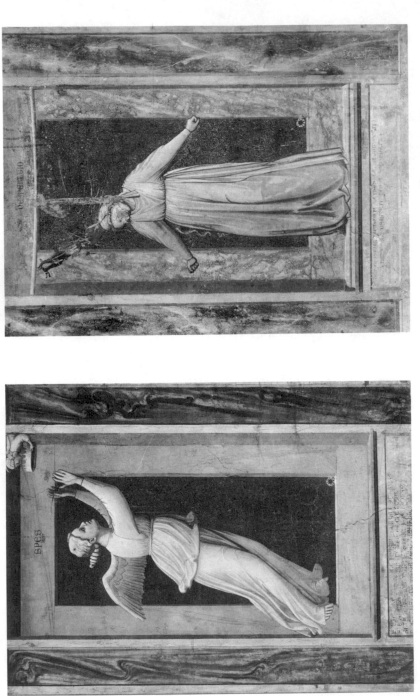

56. *Hope*

57. *Despair*

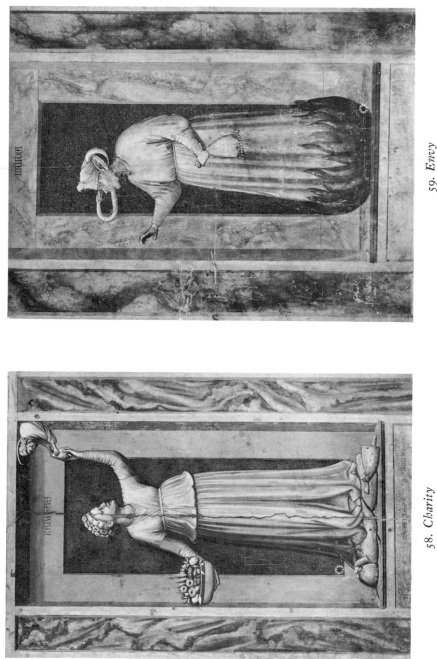

58. *Charity*

59. *Envy*

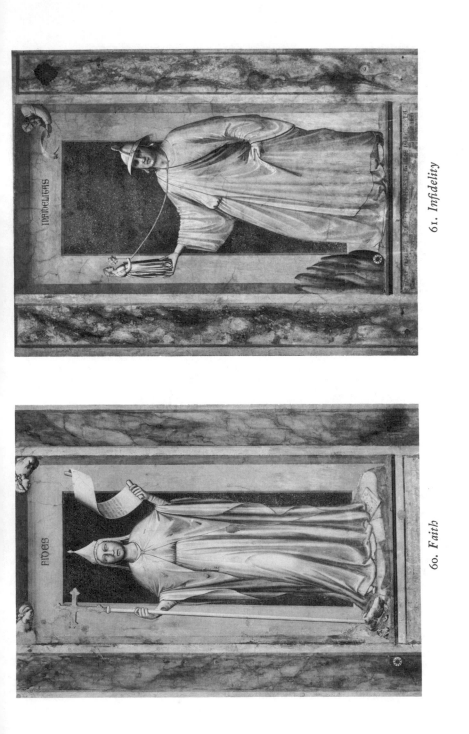

60. *Faith*

61. *Infidelity*

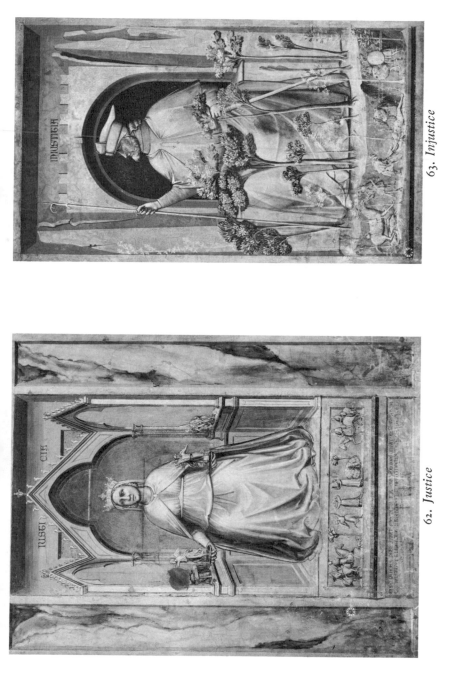

62. *Justice*

63. *Injustice*

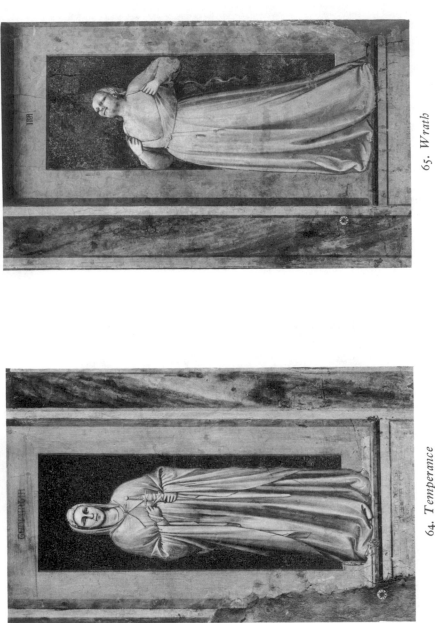

64. *Temperance*

65. *Wrath*

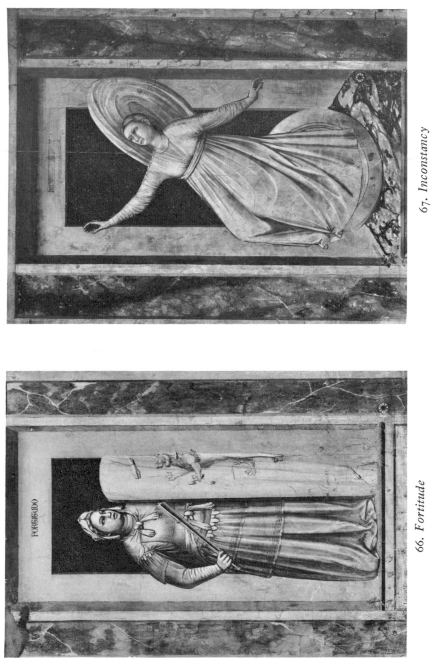

66. *Fortitude*

67. *Inconstancy*

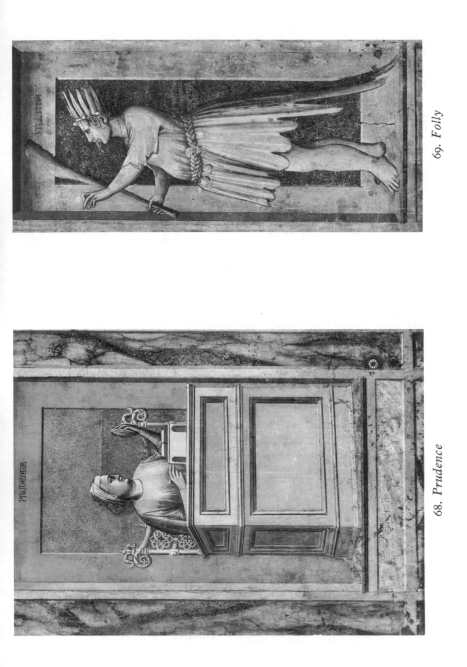

68. *Prudence*

69. *Folly*

70. Painted Chamber on the Left Side of the Triumphal Arch

71. Painted Chamber on the Right Side of the Triumphal Arch

72. Decorative Frieze with Lioness and Cubs

73. Decorative Frieze with the Creation of Adam

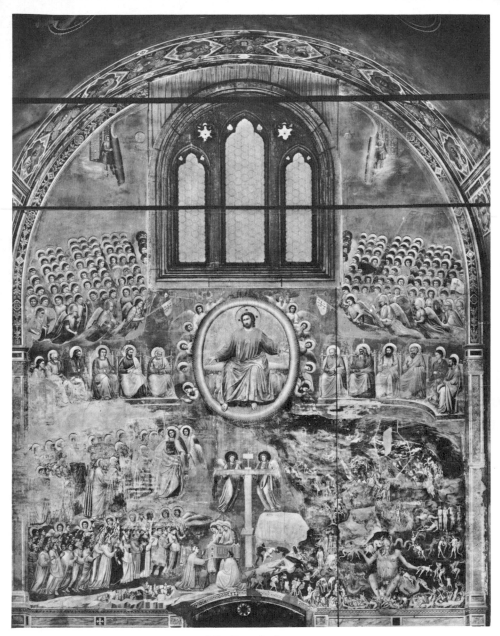

74. *The Last Judgment*

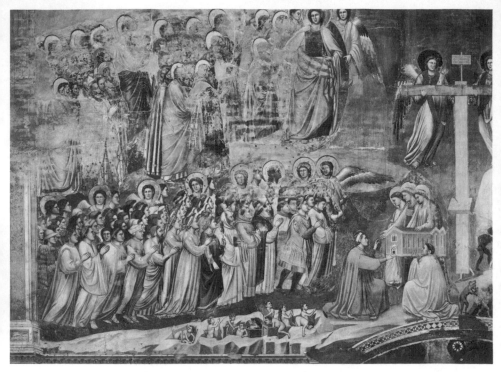

75. Detail of the Blessed from *The Last Judgment*

76. Detail of the Damned from *The Last Judgment*

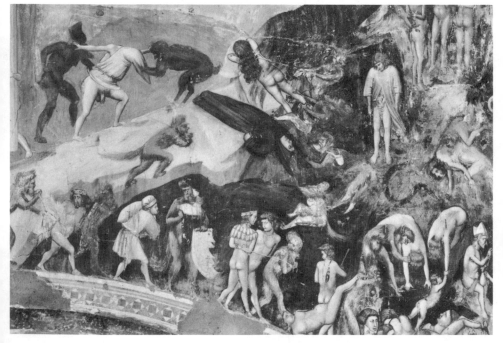

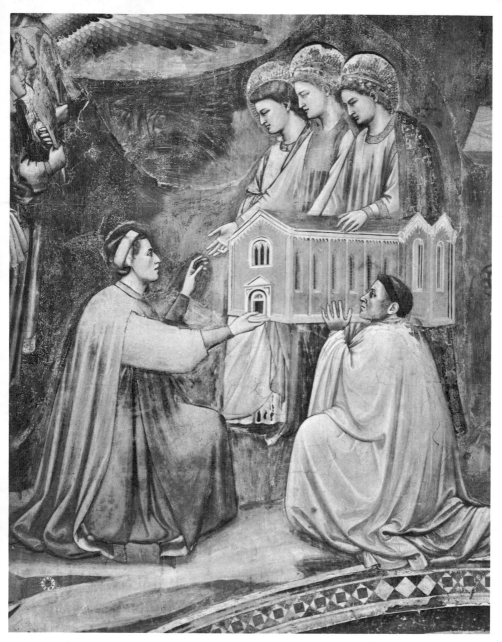

77. Enrico Scrovegni Offers the Chapel to the Virgin; detail of *The Last Judgment*

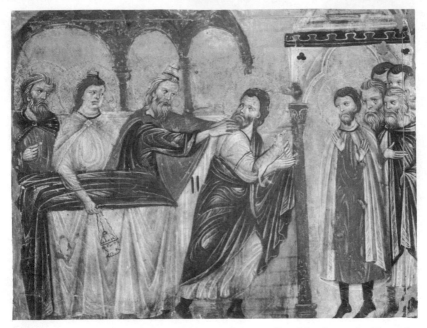

78. The San Martino Master, *The Expulsion of Joachim from the Temple;* detail of an Altarpiece, Museo Civico, Pisa

79. Duccio, *The Last Supper;* detail of the *Maestà*, Opera del Duomo, Siena

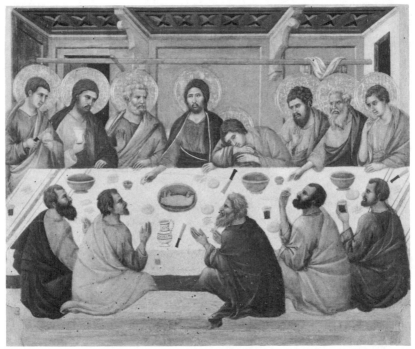

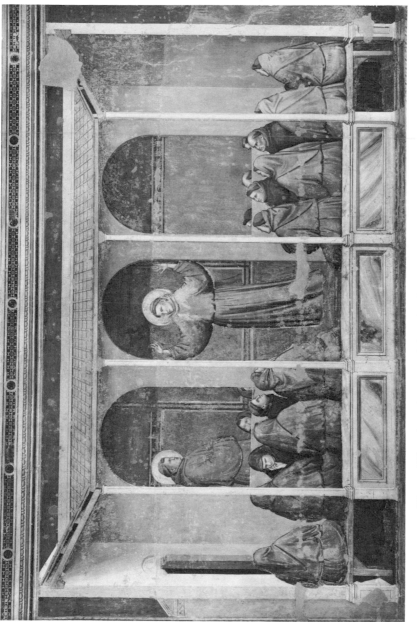

80. Giotto, *The Apparition at Arles*, the Bardi Chapel, Santa Croce, Florence

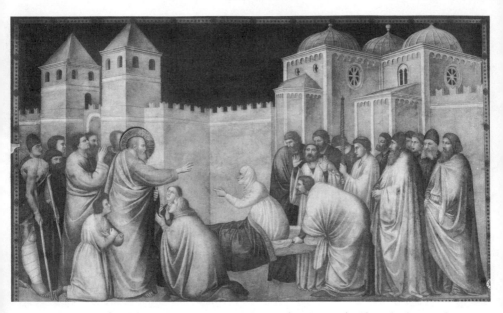

81. Giotto, *The Resurrection of Drusiana*, the Peruzzi Chapel, Santa Croce, Florence

82. Giotto, *The Feast of Herod*, the Peruzzi Chapel, Santa Croce, Florence

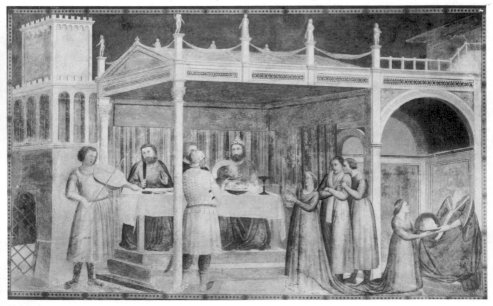

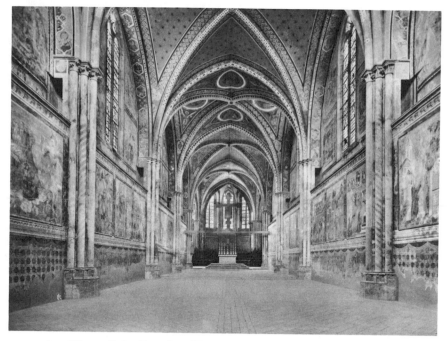

83. View of the Interior, Upper Church, San Francesco, Assisi

84. Roman School, *St. Francis Renounces his Earthly Possessions*, detail, Upper Church, Assisi

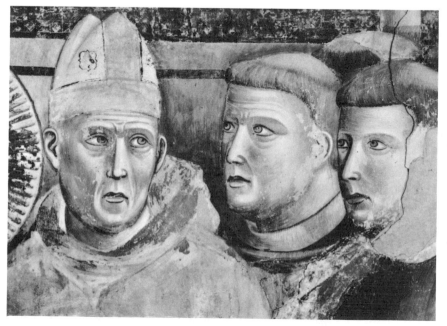

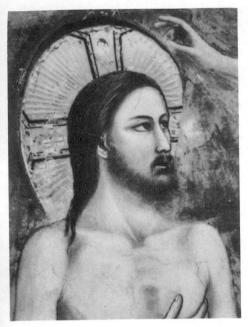

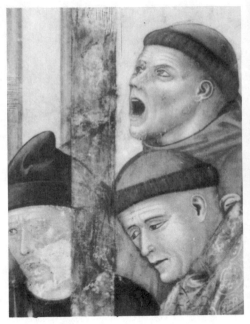

85. Detail of *The Baptism* (fig. 32)

86. Detail of *The Miracle at Greccio* (fig. 89)

87. Detail of *The Raising of Lazarus* (fig. 34)

88. Roman School, *St. Francis Preaching before Pope Honorius*, detail, Upper Church, Assisi

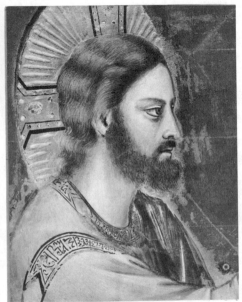

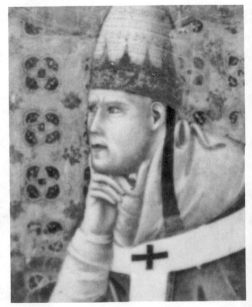

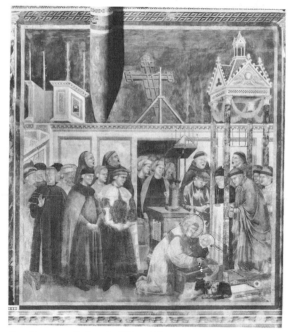

89. Roman School, *The Miracle at Greccio*, Upper Church, Assisi

90. Roman School, *The Clares Mourning St. Francis*, Upper Church, Assisi

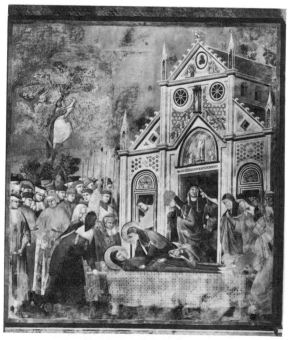

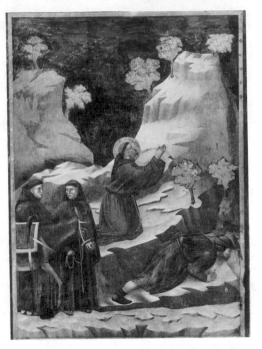

91. Roman School, *The Miracle of the Spring*, Upper Church, Assisi

92. Roman School, *St. Francis Gives his Cloak to a Beggar*, Upper Church, Assisi

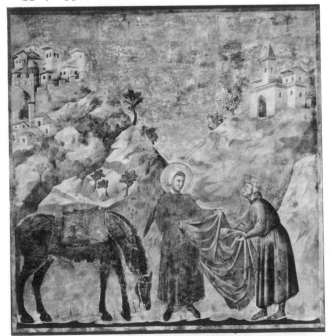

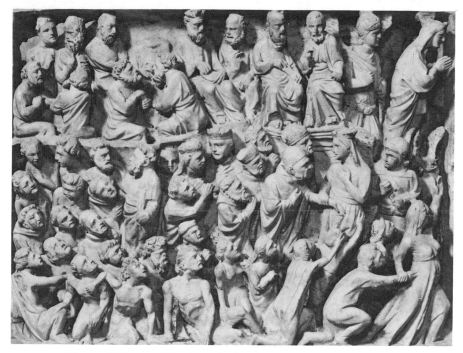

93. Giovanni Pisano, *The Last Judgment* (left half), Cathedral, Pisa

94. Giovanni Pisano, *The Last Judgment* (right half), Cathedral, Pisa

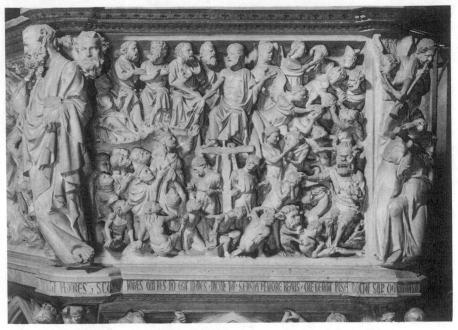

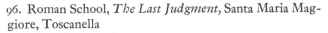

95. Giovanni Pisano, *The Last Judgment*, Sant'Andrea, Pistoia

96. Roman School, *The Last Judgment*, Santa Maria Maggiore, Toscanella

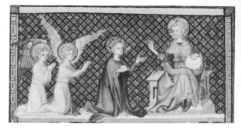

97 (left), 98 (above). School of Paris, *Les Miracles de la sainte Vierge* (ca. 1320-1350), by Gautier de Coincy, Bibl. Nat., nouv. acq. fr. 24541, Fol. 59ʳ and Fol. 61ᵛ

99. Detail of the Facade, Santa Maria Novella, Florence

100. Exterior View of the Sacristy of the Arena Chapel

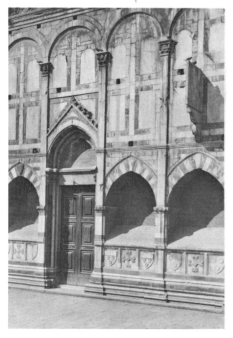

101. Interior of the Sacristy toward the Southeast and the Southwest

102. Andreolo de Sanctis, Statue of Enrico Scrovegni, Arena Chapel Sacristy

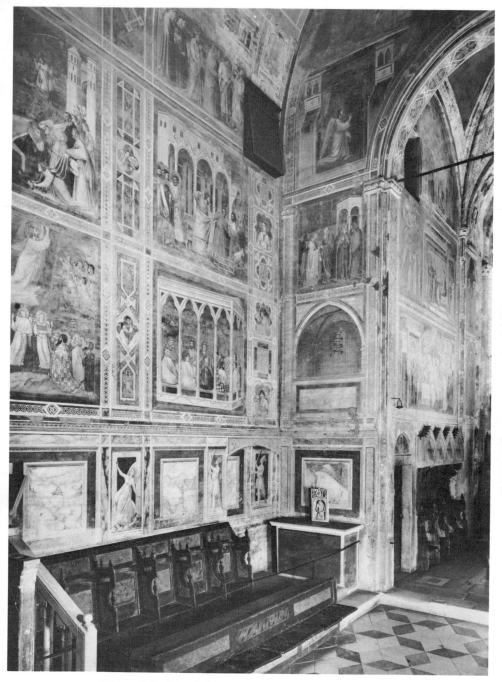

103. View of the North Wall and the Choir of the Arena Chapel

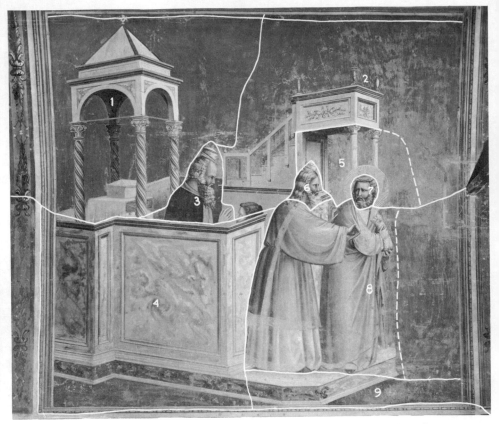

104. Work Patches in *The Expulsion of Joachim from the Temple*

105. Joachim and the High Priest; detail of fig. 104

106. Young Man and Priest; detail of fig. 104

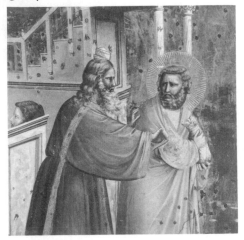

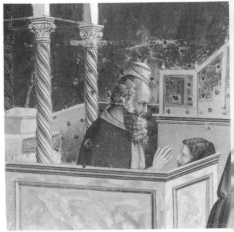

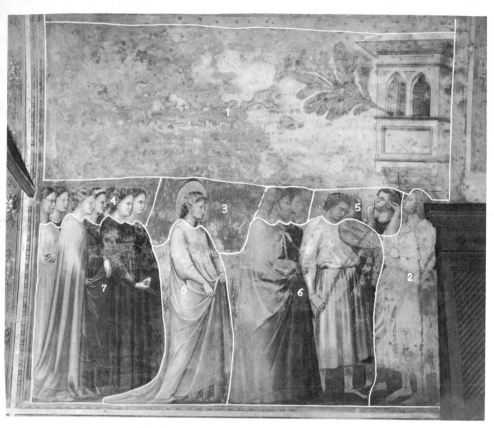

107. Work Patches in *The Virgin's Return Home*

108. Detail of Draperies from fig. 107

109. A Mantle Repainted by Giotto; detail of fig. 107

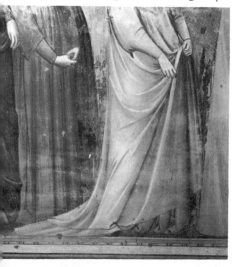

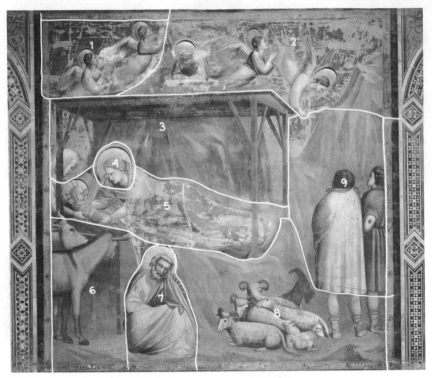

110. Work Patches in *The Nativity*

111. Work Patches in the Archangel Gabriel

112. Work Patches in the Annunciate Virgin

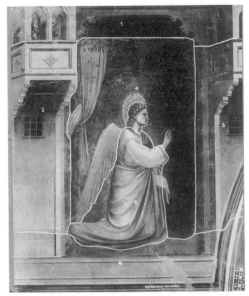

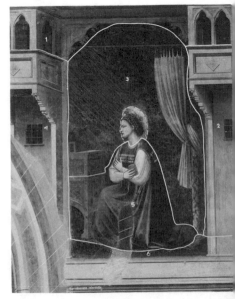

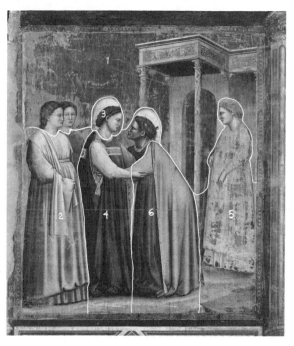

113. Work Patches in *The Visitation*

114. Work Patches in *The Expulsion of the Merchants from the Temple*

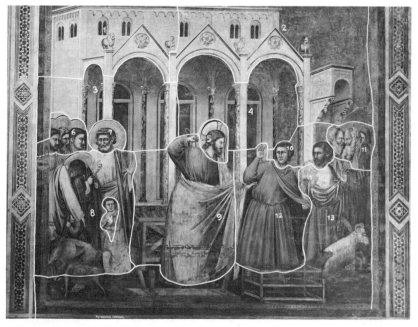

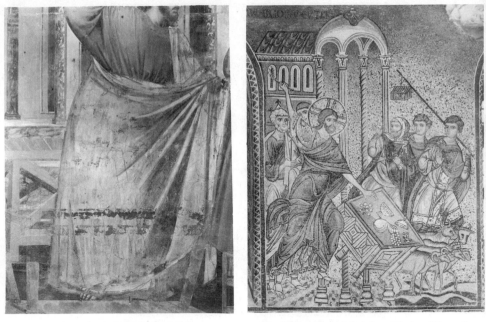

115. Skirt of Christ; detail of fig. 114

116. Byzantine Mosaic, *Christ Cleansing the Temple*, Cathedral, Monreale

117. Child with Dove; detail of fig. 114

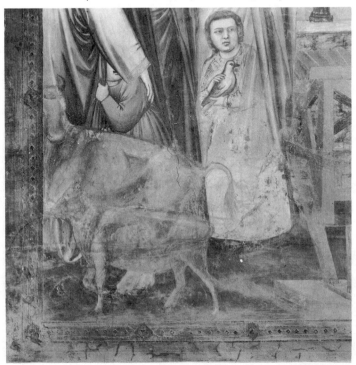

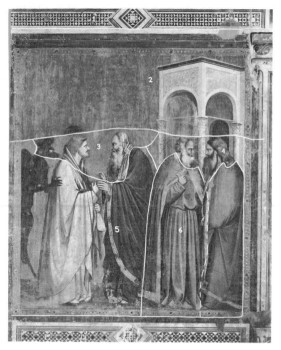

118. Work Patches in *The Pact of Judas*

119. Judas, the Devil, and a Priest; detail of fig. 118

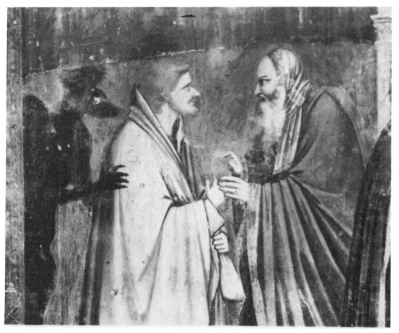

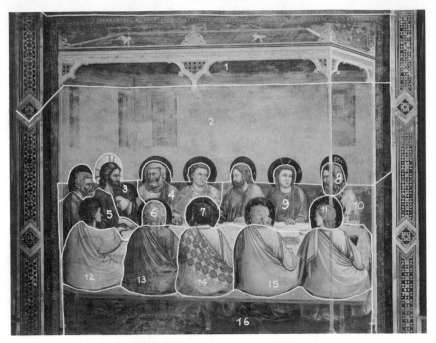

120. Work Patches in *The Last Supper*

121. Work Patches in *The Pentecost*

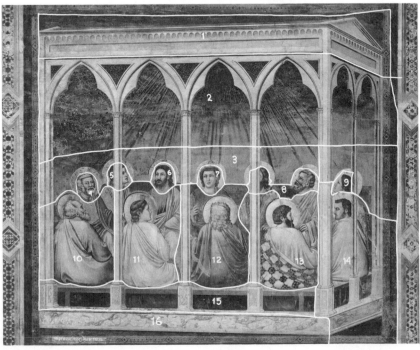

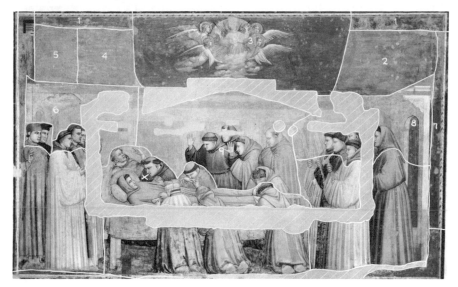

122. Work Patches in *The Death of St. Francis*, the Bardi Chapel, Santa Croce, Florence

123. St. Francis; detail of *The Apparition at Arles*, the Bardi Chapel, Santa Croce, Florence

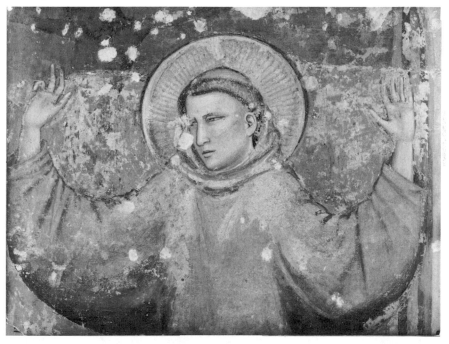

124. Detail of Heads and the Palace in *St. Francis Renounces his Earthly Possessions*, the Bardi Chapel, Santa Croce, Florence

125. Work Patches in *The Ascension of St. John the Evangelist*, the Peruzzi Chapel, Santa Croce, Florence

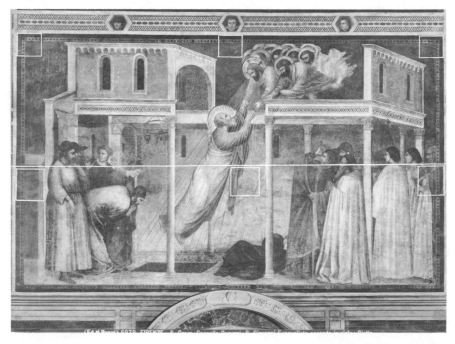

GIOTTO AND THE ARENA CHAPEL FRESCOES

As with any historical figure of genius, there is something legendary about Giotto. No amount of art historical research or factual documentation can ever quite eliminate this superhuman dimension. And in the same way there is an almost mythical quality about his frescoes in the Arena Chapel in Padua. Exalted as the artist and the frescoes are, we nevertheless must take the measure of both in order to find out why they have been held in such esteem ever since Giotto's time. More than that, though, we want to know what was so revolutionary in his style that he alone should have shaped Italian painting for a century and why, more than any other artist, he should have had a determining influence on everyone who followed. The Arena Chapel is the most effective place to make such a study, for in this fresco program Giotto revealed the full scope of his artistic revolution. Although these frescoes were painted early in his career, they contain his fundamental contribution and already reveal the germ of the mature artist.

Giotto was born in Colle di Vespignano, a village not far from Florence, probably in 1267. He was most surely an apprentice of Cimabue, the most celebrated painter of the preceding generation. Much has been written and hypothesized, but little is known for certain about Giotto's early period in the last part of the thirteenth century and the factors in the formation of his new style. Vasari's account of Cimabue finding the shepherd boy Giotto drawing a sheep on a rock is an anecdotal interpretation of what was probably fact. That his works look so different from Cimabue's must be due in part to Giotto's absorption of other traditions—Roman fresco painting and French Gothic sculpture. His genius welded a wholly new style from all these elements. An awareness of this synthesis must have led Dante to write his famous lines in the *Purgatorio*:

> Cimabue thought that in painting
> He commanded the field, and now Giotto has the acclaim . . .
>
> (Credette Cimabue, nella pittura,
> Tener lo campo, ed ora ha Giotto il grido . . .)

Curiously, there is no universal agreement about the *oeuvre* of Giotto, despite the clarity of his artistic personality. Many a panel painting has been attributed to the master, although the exalted superiority of the one certain autograph panel, the Ognissanti *Madonna*, should warn us against such conjecture. Many critics, often good and perceptive ones, attribute to the young Giotto the St. Francis cycle in the upper church of Saint Francis at Assisi, a cycle which has considerable merit and much lively charm. But despite resemblances inevitable between contemporary works, the Assisi frescoes reflect a fundamentally different approach from Giotto's in countless points of style and psychological outlook.

We are on firm ground, however, when we turn to the frescoes in the Arena Chapel in Padua. To be sure, no document of commission has been preserved—and there must originally have been a number of written statements about so large and important a commission. The earliest references to Giotto's having worked in the Arena Chapel are in a rather vague list of his various paintings written sometime between 1312 and 1318 by Riccobaldo Ferrarese (page 110), and a description of Giotto's figure of Envy (fig. 59) written by Francesco da Barberino between 1308 and 1312 (page 109). Nevertheless, there has never been any doubt about the authorship of these frescoes in all the intervening centuries, and we may unquestioningly accept them as his own. They represent the chief masterpiece of his early maturity.

In 1300 the wealthy Enrico Scrovegni of Padua purchased a piece of land from the Dalesmanini family (page 103), a property which included an oval area that had once been a Roman arena. On the perimeter of the arena Enrico built the family palace, a sprawling edifice that was remodeled during the Renaissance and torn down in the nineteenth century (fig. 2).

Next to the palace Enrico built a chapel dedicated to the Virgin of the Annunciation, Santa Maria Annunziata. The family wealth had been amassed by Enrico's father, Reginaldo, whom Dante singled out as the arch usurer in his *Inferno* (page 108), and there is a good deal of evidence to suggest that the Arena Chapel was erected as a means of expiating the father's sin of usury which hung over the family.

One early document (page 106) alludes to the fact that permission to erect the Chapel was granted before March 1, 1302, while still another document (page 105) tells us that the site was dedicated in March of 1303. Work apparently proceeded swiftly; in March of 1304 Pope Benedict XI granted indulgences to those who visited "Santa Maria del Carità de Arena" in Padua (page 105). This is the first

information we have that the Chapel built by the Scrovegni was also dedicated to the Virgin of Charity, an appropriate choice for a donor who sought to associate the family name with more desirable qualities than the greed and miserliness associated with usury. Evidence suggests the Chapel was formally consecrated on March 25, 1305, on the Feast of the Annunciation. In the deliberations of the High Council of Venice for March 16, 1305, it was agreed to lend tapestries to Enrico Scrovegni on the occasion of the dedication of his Chapel (page 107).

Another document of 1305 throws a curious light on developments in regard to the Arena Chapel (page 106). The monks of the Eremitani Church, just a stone's throw from the Arena, complained about the inordinate pomp of the Arena Chapel, which they found objectionable, especially since Enrico Scrovegni had previously stated that he wished only to erect a small chapel to be used solely for worship by members of his family. It is not known exactly what effect the complaint had, although various hypotheses have been advanced, some of which will be discussed below.

For many years the drama of the Annunciation had been enacted in front of a chapel, also called Santa Maria Annunziata, which had formerly stood on the site of the Scrovegni chapel. These performances had probably taken place as early as 1278 and had featured two boys dressed as the angel Gabriel and the Virgin Mary. Thus, the emphasis on the Annunciation was a tradition at this site, and we shall see how Giotto enhanced it in his decorative program for the Scrovegni chapel.

In all the documents about the Chapel, the name of Giotto is never mentioned, but we are nevertheless able to glimpse the progress of his work there. The granting of indulgences to visitors in 1304 suggests that Giotto may have begun his painting as early as sometime in 1303; the consecration of the Chapel in 1305 leads us to suppose that Giotto had substantially finished his frescoes by that time. Despite this evidence, some critics believe the work was done somewhat later and that, in fact, Giotto was called in by Scrovegni only after the monks of the Eremitani had objected in 1305 to an earlier, more grandiose scheme. For such critics, Giotto's frescoes represent a simpler, if not more austere, program devised to placate the neighboring monks—a program that would then have been executed between 1305 and about 1310. This theory overlooks the fact that Giotto's frescoes cannot easily be described in those terms, since they constitute so rich and colorful a decoration to almost every inch of the interior. Were not the monks objecting, perhaps, to precisely that splendor of pictorial decoration that has made the Arena Chapel a mecca for art lovers

to this very day? And would not the fact that the artist was probably already famous have indicated to them how ambitious Scrovegni was for his Chapel?

Besides these considerations, however, such a theory overlooks one very fundamental point about the architecture of the Chapel. The Arena Chapel may very well have been designed to Giotto's specifications. It is so simple an interior space, so devoid of any true architectural interest, as to stand apart from any other structure of the time in Italy. It is peculiarly bare; in fact, it is little more than a skin of blank walls seemingly designed for some already-determined scheme of painted decoration. No columns, pilasters, niches, or other architectural or sculptural embellishments are to be found. Furthermore, it has the unusual feature of a row of six windows along the south wall of the nave and none on the opposite north wall. This sort of asymmetry was unheard of and was not repeated in other chapels or churches. Nor is it by chance that the windows are on the south side; south light means good illumination of the interior and of the paintings therein. The Arena Chapel is thus a kind of viewing box; its success is demonstrated by the fact that the entire scheme of decoration is visible and can be clearly read from the moment one enters the Chapel. It would be hard to adduce a comparable example of building and decoration so ideally suited to each other. With these considerations in mind, it is difficult to accept the theory that Giotto was called in after the Chapel was finished and the Scrovegni had decided on a simpler scheme of decoration with fresco following the complaint of the Eremitani monks. On the contrary, it is more reasonable to suppose that Scrovegni retained the painter early in the planning of the Chapel and that Giotto had a more or less decisive voice in its design. According to this viewpoint, Giotto would have begun his frescoes at the earliest possible moment and, working with assured concentration, would have finished his work in time for the consecration of the Chapel on the Feast of the Annunciation in 1305.

II

Giotto's one overriding intention in the Arena Chapel was to tell a story: the scenes flow across the walls with extraordinary ease, a quality that has often been appreciated. The narrative is deployed around the walls in three bands, always proceeding from left to right on the south wall and then on the north. In the top band is the story of the Virgin's parents, Joachim and Anna, and the early life of the Virgin. The life and Passion of Christ occupy the middle and lower register of scenes. The insertion of windows on the south wall in these lower two rows results, of course, in a reduction of the number

of scenes to five (fig. 5). To balance the windows, Giotto introduced decorative bands opposite them on the north wall, and these contain little vignettes or heads in quatrefoils (figs. 6, 72, 73), which symbolically echo the episodes in the large scenes nearby.

Beneath the three rows of narratives, on the lowest part of the two long walls of the nave, there are six Virtues and six Vices (figs. 56–69) set between painted imitations of marble paneling. The triumphal arch contains an elaborate rendition of the Annunciation: at the top God the Father dispatches Gabriel to announce to the Virgin that she will conceive (fig. 21), while beneath on either side of the arch, the angel and the Virgin enact that Annunciation (figs. 22, 23). The west wall contains the theme traditionally placed there, the *Last Judgment* (fig. 74).

In the uppermost band, the first set of six scenes revolves around the elderly couple, Joachim and Anna, before the birth of the Virgin. Nothing of this story could be gleaned from the New Testament; instead, Giotto had to rely on the apocryphal writings and popular stories which filled the gap left in the Gospels. In all probability the artist followed the text of *The Golden Legend*, which Jacobus de Voragine published in the middle of the thirteenth century and which offered artists elaborate scenarios for a long time to come (see pages 112–126).

In the first fateful episode Joachim is expelled from the Temple in Jerusalem (fig. 7), his offering of a lamb deemed unacceptable because he and his wife are childless. Joachim is quite literally pushed from the premises, a pained expression on his face, a figure of embarrassed reluctance. For ironic contrast a younger man, presumably a father, whose head appears beyond the marble-paneled wall, is accepted into the Temple. The scene involves, then, the opposite conditions of acceptance and rejection, and the contrast is emphasized by the difference between the security of the enclosed space of the young father and the perilous void into which Joachim is shunted. There is a distinctly melodramatic flavor to this scene in which our sympathies for Joachim and therefore our interest in the story to follow are quickly aroused.

It is revealing to compare Giotto's way of presenting such a scene with that of a Pisan master working in the 1280's, the so-called San Martino Master. *The Expulsion of Joachim from the Temple* (fig. 78) on an altarpiece by this minor master has numberless ties to medieval pictorial idioms, whether in manscript illumination or sculpture, in which space and forms and gestures are rendered schematically. This scene is crowded with ten figures, and the viewer actually has to examine all of them, canceling out those which do not actively par-

ticipate in the scene. It is less easy here to concentrate on the main action than in Giotto's simple and economic representation. In the Pisan work, Joachim, could be interpreted as someone eager to escape, in contrast to Giotto's Joachim. And gone from Giotto's scene is the elaborate pantomime and exaggerated expression and gesture that animated so much of thirteenth-century painting. In their stead is a wholly new kind of representation of states of mind and even psychological nuance.

Critics used to speculate about the sizable void at the right side of Giotto's *Expulsion of Joachim*; we now know that no figure or object ever occupied that area. Giotto intended the literal void to suggest the figurative and psychological void that follows Joachim's expulsion and rejection. But the emptiness at the right also suggests that there is something to follow. It is as much as anything an invitation into the next scene (fig. 8), where we find Joachim moving slowly and solemnly into the country, accompanied by the little trees that cross the landscape in stately file.

We grasp the situation at once. Joachim, although rich-robed and noble-looking, embodies utter disconsolation. The shepherds, stoop-shouldered rustics, are too simple-minded to fathom their master Joachim's vast preoccupation. The lively jumping and barking of the little white dog goes unheeded. It is characteristic of Giotto's approach that the simplest and most familiar states of mind and reactions should do so much to carry the story, even such a one as this, in which divine forces will so soon intervene.

The third scene (fig. 9) reveals Joachim's wife Anna in her bedroom at home. Distraught at the disappearance of her husband, she kneels in prayer. The authentic atmosphere of the room is achieved by such elements as the trousseau chest, or *cassone*, the curtain hung from a traverse rod around the bed, the striped coverlet, and the utensils on the wall and on the shelf. It is unusual for Giotto to enrich a scene with such detail; the effect here is to contrast the homely comfort around Anna with the austere and lonely setting in which Joachim is carrying out his vigil. And, in fact, the sharp distinction between these two scenes emphasizes the separation of Joachim and Anna so necessary to the narrative: only now while she is alone can the angel appear—as in a vision, through the window high on the wall—and announce that she will be favored by God and bear a child. Like Sarah who bore Isaac in her old age and Rachel who bore Joseph when she was elderly, God chose Anna for this special honor. To these lofty words of the angel, signifying the mysterious ways of God, the old woman listens raptly, and a servant girl working with a distaff on the porch strains to hear.

The next two scenes take us back to Joachim in the countryside. First (fig. 10) he sacrifices an animal whose skeleton is seen on the altar. This brings him favor with God whose hand appears in the sky above. And then, in the next scene (fig. 11), the sleeping Joachim has a vision in which an angel appears to tell him that his wife Anna has conceived and that the daughter to be born will be called Mary and will be the mother of the Most High. There is hardly a scene in the Arena Chapel to match this one for lyrical beauty. The swift, gracious flight of the angel is in keeping with the visionary words he brings to Joachim. And the gliding movement of the angel is echoed in the descending curve of the hill, which leads us to the slumbering figure of Joachim. At the left, shepherds tend their flocks. One of them looks up into the sky, leading our glance to the angel, though he could scarcely see an angel who appears only in Joachim's dream. We suppose it is nighttime not because of a darkened sky—an impossibility in that period of art—but because one shepherd has drawn a cowl over his head and the other has donned a great straw hat as protection against the chill and dark of night. At the conclusion of his speech, the angel tells Joachim that he can now go home and that he will meet his wife at the Golden Gate of Jerusalem. It is this meeting which we see (fig. 12) in the last episode in the top row on the south wall.

Although there are a number of scenes in the Arena Chapel, of either farewell or reunion, none is more famous than the touching reunion of Joachim and Anna. Their stout figures form a sort of pyramid that isolates them from the nearby onlookers (fig. 13). As they fling their arms around each other's neck they exchange a glance of love and natural relief compounded with the strange and awesome knowledge which they now share. While their emotion is deep and wordless, that of the onlookers is vastly different. The young women emerging from the Golden Gate frankly enjoy the spectacle of reunion, gawking in a romantic and sentimental fashion as young girls will. Their behavior is contrasted with that of the more prudent older woman at the center, who veils her face as though it were not quite proper to watch the couple. Again, Giotto makes us aware of the varieties of human responses and emotions.

The meeting at the Golden Gate marks the happy outcome of a story that began so darkly with the expulsion of Joachim from the Temple and followed him in his lonely vigil in the country. After the anxiety-filled separation comes joyful reunion, as out of the rejection had come acceptance and favor in the eyes of God. In this simply told, altogether human tale, divine inevitability and the wonder-working of the Almighty are somehow made comprehensible.

The selection of the episodes for the telling of this story is in itself a marvel of narration. If we look at the sequence in the Pisan altarpiece referred to above, Giotto's mastery becomes even clearer. The thirteenth-century altarpiece contains a much larger group of scenes so that, for instance, we see the episode of Joachim Giving Alms, which in some accounts of the life of the Virgin follows Joachim's expulsion from the Temple. After *The Vision of Joachim* we have a separate scene of Joachim Returning Home. Furthermore, in *The Vision of Joachim* we see him twice: at the left he lies asleep, and at the right he tells the shepherds of his vision. The Pisan master may have been influenced by a manuscript cycle of the Joachim story, for this kind of expansive narration is more familiar in manuscript illumination than in painting. It was, however, ill suited to the monumental style of fresco decoration, where, inevitably, the selection of scenes had to be reduced. Above all, the way in which Giotto chose to reduce the elements is what gives his narrative such dramatic force. This does not mean Giotto always selected the most important episodes. As far as the Joachim story is concerned, it is surely more important to include the episode of Joachim Giving Alms than to show him trudging off into the countryside after his expulsion. But for Giotto the greater drama lay in the latter. This choice is not an isolated instance in the Arena Chapel; elsewhere traditional scenes are eschewed in favor of some quiet interlude with which Giotto deepens the dramatic and human values in the story.

The great gate of the city looms up, creating a visual barrier here at the end of the wall and the conclusion of the story. It allows the spectator a pause to adjust before he takes up a new chapter of the story, one which begins on the opposite wall of the Chapel.

The life of the Virgin Mary is told in six scenes on the opposite wall, unfolding from the west end toward the triumphal arch at the east. In the first scene we see *The Birth of the Virgin* (fig. 14), which takes place in the same setting as *The Annunciation to Anna*. Despite minor modifications, we recognize the homely atmosphere of Anna's bedroom. In the foreground we find nursemaids bathing the infant, a curious but popular borrowing from representations of the birth of Christ where the bathing had, as we shall see, a special symbolism. This scene is followed by the justly celebrated *Presentation of the Virgin in the Temple* (fig. 15). As had been ordained, the three-year-old Virgin Mary was taken by her parents to live in the Temple. Dressed in white, the demure figure of the Virgin stands at the top of the stairs, where the old priest receives her into the temple precinct. Giotto emphasizes her diminutiveness by enlarging the figure of her mother, Anna, who is further contrasted with the Virgin by her

deep red robe and becomes a kind of great protective force behind her tiny daughter. Although a most significant part of the story was the fact that the very young Virgin had climbed the fifteen steps of the Temple unaided and without looking back, in Giotto's representation there are only ten steps, not the mystically significant fifteen; quite clearly he is more intent on another aspect of the story—the emotion of Anna and the trepidation of the Virgin at this separation.

It is curious from a traditional standpoint that all four of the following scenes involve events surrounding the betrothal of the Virgin. The expansiveness of this account must be explained as the result of Giotto's approach to the narrative. According to the legend, suitors for the hand of the Virgin were to bring rods to be placed on the altar of the temple. It had been foretold that the rod which burst into flower and on which a dove should rest would indicate the suitor who would win the hand of the Virgin. In the first of these scenes (fig. 16) the marriageable men arrive, carrying rods. In the next (fig. 17) they wait, watching the rods in prayerful intensity.

The scene depicted in *The Watching of the Rods* had no place in a traditional iconographic scheme for the representation of the life of the Virgin. It actually illustrates the idea that the one suitor who should have placed a rod on the altar—Joseph—did not do so, thinking himself too old. Thus nothing happens or could happen in the scene; this quality of expectation, not realization, is precisely what interested Giotto—this and the reticence and seemly modesty of Joseph, the haloed figure at the very left of the scene. An earlier artist giving a full account of the life of the Virgin would not have included the Watching of the Rods. He would instead have shown an episode of more positive significance, such as the subsequent moment when Joseph's rod, having finally been presented, bursts into flower. Thus the whole approach to telling a story undergoes a change in the hands of Giotto. New subtleties and nuances are possible; the spectator is invited, indeed required, to exert his imagination to fill in the intervening elements of the story. Only after these two scenes are we allowed to see the Betrothal itself (fig. 18), in which the couple pledge their troth before the High Priest.

In the last scene from the early life of the Virgin, we see her returning to her home (fig. 19) accompanied by the seven virgins assigned to her, while musicians play the procession tune. Joseph, meanwhile, returns to Bethlehem to prepare for the wedding. Like *The Watching of the Rods*, this scene involves no new action or development of the story and is, in fact, anticlimactic to the Betrothal scene. And yet, despite the slightness of the theme, this is one of the

triumphs of the Arena Chapel, not only in the charm of the mood and the beauty of the groupings but as a stately finale to that part of the life of the Virgin before she assumes her role as the mother of Christ.

Such scenes as *The Watching of the Rods* and *The Virgin's Return Home* do more, however, than fill out the narrative. To some extent they de-emphasize the more formal aspects of the narrative contained in such scenes as the Birth, the Presentation, and the Betrothal of the Virgin. And in doing so they put greater emphasis on human motivation and the natural responses of individuals to specific situations and experiences. This mode of narration is indeed a far cry from the old Byzantine tradition of representing only the standard feast scenes without variation or innovation. It is one of the signal ways in which Giotto broke with the Italo-Byzantine tradition.

While *The Virgin's Return Home* concludes one part of the story, it serves as well to lead us forward to the momentous events that commence with the Annunciation. It is appropriate that *The Annunciation* should enjoy such prominence on the triumphal arch of the Arena Chapel (fig. 21). In the first place, the theme had often been used on triumphal arches; one example not far from Padua is the twelfth-century Byzantine mosaic in the Cathedral of Torcello. An analogous use is the placing of the Annunciate figures in the spandrels of arched panel paintings, a number of which can be dated to the late thirteenth and early fourteenth centuries. Even more significant, however, is the fact that the Annunciation is a dedicatory theme of the Chapel itself. Thus it is fitting that the Annunciate Virgin should be placed in so prominent a position in the Chapel. Surely Giotto was aware of the annual pageant which took place in the arena in front of the Chapel—in all probability he had witnessed it himself. And, as has been pointed out, the architectural settings of the two figures of the Annunciation resemble the sort of simplified stage settings that would have been used for the ceremony. Finally, *The Annunciation* is well placed from the viewpoint of the narrative, serving as a bridge from the top row to the middle row, which contains scenes from the life of Christ.

In the Arena Chapel the Annunciation is magnified by the inclusion of the prelude (fig. 21) in which God the Father dispatches Gabriel on his mission to the Virgin. This unusual theme decorates the upper area or lunette on the triumphal arch. Simply conceived, it contains only the enthroned figure of God and the surrounding clusters of angels. It is less an episode, in any conventional sense, than it is a representation of celestial forces at work.

The actual Annunciation (figs. 22, 23) enacted on the two sides of the arch below is to be seen as the carrying out of divine will.

As for this *Annunciation*, it would be hard to find so powerful a representation of the scene anywhere else. Gabriel's gesture sends his message vibrating across to the Virgin, who is superbly poised to receive it. She is a far different creature from the Virgin of the Betrothal and Procession scenes; now she is unflinching, majestic, and entirely capable of the awesome fate in store for her. The angel kneels and gestures, the Virgin kneels and receives the Word, each with an unparalleled concentration that gives the scene great drama and enough momentum to carry across the physical space of the Chapel.

Beneath the Annunciation figures Giotto inserted two other episodes on the triumphal arch, *The Pact of Judas* (fig. 38) on the left (to be discussed later) and *The Visitation* (fig. 24) on the right. The location of *The Visitation* at this point is visually suitable for purposes of narrative continuity: from it the spectator turns to the adjacent south wall with its scenes of the childhood of Christ. That reason aside, however, *The Visitation* is appropriate for a prominent position on the triumphal arch because it is so rich in symbolic allusion. When Elizabeth, as the mother-to-be of John the Baptist, visited the Virgin, who bore the Christ Child in her womb, two worlds met—the old represented by the prophets, of whom the Baptist was the last, and the new represented by Christ, who brought the era of grace. In their embrace these two women bridge the gulf between the Old and the New Testaments—a fitting moment to be depicted just before the cycle of Christ's life commences.

The life of Christ, traditionally divided into four parts, commences with the Infancy cycle, which is followed by the Mission or Teaching cycle, comprising the principal events and miracles of his adult life. The third cycle is that of the Passion, and finally come the scenes of Christ's appearances after his death, which make up the Resurrection cycle.

The five scenes Giotto chooses for the Infancy cycle depend to a large extent on the popular legends that through the ages had enlarged the sparse account in the Gospels of the New Testament. Thus in *The Nativity* (fig. 25) appears St. Luke's description of the swaddling clothes in which the Child is wrapped, the manger in which He was placed, the angels, and the shepherds. But nowhere in Scripture is there a reference to the ox and the ass, ubiquitous elements in representations of the Nativity for many centuries. An old tradition held that the ox stood for the New Testament and the ass stood for the Old, and together they symbolized the contrast between those who see and know and those who are blind to the new light that came with Christ. Popular legend had long sanctioned the notion.

Giotto's *Nativity* includes many of these familiar elements. And

yet, perhaps just because the formula for this episode was so well known and so rigorously adhered to, the innovations Giotto did make are startling. He omits from the background the cave that in all earlier paintings of the subject had represented the grotto in Bethlehem in which, according to tradition, the Child had been born. The cave was also thought to refer to the tomb in which the shroud-wrapped body of Christ was laid after his death. In Giotto's scene the Virgin and Child are sheltered only by a shed open to the elements on all sides. It is significant that Voragine in *The Golden Legend* tells us that the Nativity took place in a shed or "a shelter against the uncertainties of the weather." Even more surprising, Giotto merely alludes to the traditional episode, or subplot, of the first bath of Christ in which two nursemaids bathe Him in a chalice-shaped vessel in the foreground of the scene—a bath that was understood to refer to and symbolize the rite of baptism. A high degree of pathos is to be read into this picture where the Virgin (fig. 26), exposed to the chill of the elements, relinquishes her Child to the servant woman who will take Him to be bathed, beyond our field of vision. If Giotto changes traditional iconographic details, as in the first bath of Christ, he does so for the purpose of infusing the painting with a heightened dramatic tone that had been beyond the means or devices of earlier painters and traditions.

As the Virgin shifts on her bed she casts a long, sad look at the Infant. We may suppose that with her power of prescience she is gazing into the future to the time when she must give Him up to his fate. Later on in the narrative, in *The Pietà* (figs. 50, 51), Giotto juxtaposes the figures of the Virgin and the dead Christ in such a way that the spectator involuntarily recalls *The Nativity* where, similarly, the Virgin bent over her Son as she handed Him to the servant. Giotto views the Nativity in an entirely new light—that of intense human drama; in that sense such an element as the cave or the explicit presentation of the first bath of Christ no longer serve him as they had so many earlier generations.

The second scene, *The Adoration of the Magi* (fig. 27), takes place in the same setting as *The Nativity*, but the setting seems transformed now by the regal presence of the Virgin. As in so many of these episodes, traditional folklore filled out the bare account in the Gospels. The three Magi, for instance, had long since acquired names, Gaspar, Balthasar, and Melchior. In *The Golden Legend*, Voragine reports the elaborate symbolic meanings of the gifts they brought—gold being a proper tribute for royalty, frankincense referring to the incense in divine worship, and myrrh, used for the burial of the

dead, recalling Christ's mortality. Voragine also interprets the importance of this episode: the Magi, he says, were not Jewish but had nevertheless come from afar to worship the Child and this act, in turn, posed a threat to the rule of Herod Antipas, tetrarch of Galilee.

The Presentation of Christ in the Temple (fig. 28) illustrates a passage in St. Luke. According to old Jewish tradition, a newborn male child belonged to the Temple and had to be presented to the High Priest, whereupon he could be purchased back by his parents for two white doves. Joseph, standing at the left, holds the doves. Luke tells of the prophetess Anna, who witnessed the scene, and of the old priest Simeon, to whom it had been revealed that he would not die until he had seen the Redeemer. Voragine reminds us of the significance of this episode: in submitting to the old Jewish law, the Virgin signified her humility and, furthermore, demonstrated that her Son had come not to destroy the old law but to fulfill it.

The next episode, *The Flight into Egypt* (fig. 29), is occasioned by Herod's order to slay all Hebrew male children under two years of age in an effort to destroy the Christ Child. In *The Flight into Egypt* Giotto presents psychological differences of a complex nature. The young boys (said by tradition to be the sons of Joseph by a previous marriage) express the urgency of the flight by a kind of physical burst that differs considerably from the fear expressed in the face and figure of the Virgin. With her foreknowledge she realizes that she must keep safe the Infant strapped to her bosom—safe for the ultimate and terrible doom. Everything in the scene enhances the idea of flight: the swift tramping of feet, the line of brooding rocks, the gesturing angel in the sky.

By contrast, the tumult of agitated figures in *The Massacre of the Innocents* (fig. 30) conveys a sense of broad melodrama. The horror of the event over which Herod presides is expressed in the exaggerated shudder of the spectator at the left and by the irony of placing the scene before an octagonal structure of a type reserved for baptisteries, like that in Florence where innocents such as these received baptism. With this pictorial explosion, Giotto terminates the cycle of Christ's Infancy.

Along the middle row of the opposite wall Giotto depicted the Teaching or the Mission of Christ's life. The first episode is that of the twelve-year-old Child discoursing with the elders in the Temple (fig. 31), astonishing them with his wisdom. He is discovered there by Joseph and Mary, who think of Him as a child who has strayed. He, on the other hand, has begun his earthly mission and says to them, "I must be about my Father's business." *The Baptism of Christ*

(fig. 32), which follows, shows the moment during St. John's baptism of Christ in the River Jordan when the Holy Ghost descends to Christ and God acknowledges Him as his beloved Son.

Of all the deeds and miracles performed by Christ, the most significant and the most frequently illustrated are the two which Giotto presents following the Baptism, that is, *The Marriage at Cana* (fig. 33) and *The Raising of Lazarus* (fig. 34). In the first, Christ is invited to a humble wedding feast at Cana and, discovering that there is no wine, causes the water in the jars to turn to wine—a clear allusion to the mystery of the Last Supper when Christ will equate the wine with his own blood, which will be shed for the redemption of mankind. The next episode deals with the revival of the dead Lazarus, brother of Martha and Mary Magdalen. More than another proof of his miracle-working, the Raising of Lazarus is a clear parallel to Christ's own resurrection. The reference would be inescapable, but it is made even more explicit by Giotto's placing the Resurrection of Christ directly beneath the Lazarus episode (fig. 6).

The Entry into Jerusalem (fig. 36), which follows next, is of importance as an expression of the inevitability of the events to follow, as an indication that Christ is the instrument of God's will, and as a demonstration of Christ's willingness to go forward toward his fate. Giotto's scene includes the traditional elements of the multitude coming forth from the gate to greet Christ, the boys cutting palm branches to strew in his path, and the others who spread their garments before Him, and, alongside the ass on which Christ is riding, the foal of the ass, of which the Gospels speak.

The scene of the Entry may either conclude the Mission of Christ or begin the Passion. In Giotto's cycle, another scene is interjected before the beginning of the Passion: *The Expulsion of the Merchants from the Temple* (fig. 37), an episode which probably reflected Enrico Scrovegni's desire to atone by confessing a comparable sin. Whereas at the beginning of this series on the north wall a youthful Christ had discoursed quietly in the Temple, now He angrily expels those who traffic in sacrificial birds and animals in the temple precincts. Thus the cycle of Christ's earthly mission, which began so calmly, comes to a tumultuous and violent ending.

Throughout the Mission cycle a new sense of drama and purposefulness is built up. One sign of it is the posture of Christ, which is contrived to achieve a certain effect. After the first scene of the Christ in the Temple, He is invariably faced toward the right, the direction of the narrative development, and his arm is raised in a number of gestures, depending on the sense of the particular episode and varying in intensity from scene to scene. Thus, in the Cana

episode the gesture is so inconspicuous as to suggest that Christ is engaged in a sort of sleight-of-hand. In the Baptism it signifies acceptance, in the Lazarus scene it is one of command and miracle-working, in the Entry it is a blessing and greeting, and in the Expulsion it is denunciatory. The recurrence of the raised right arm together with the posture of the figure and the pure profile face of Christ in the last four scenes unites the parts of the story and give it a momentum almost as strong as that which will prevail in the Passion which follows. By this repetition of the posture something is conveyed of the inevitability with which Christ now moves toward his ultimate and foreordained fate.

Having arrived once again at the triumphal arch, we find an episode that serves as a transition to the next row of scenes below. This is *The Pact of Judas* (fig. 38), located just beneath the Annunciate Angel and directly across the triumphal arch from the Visitation. Just this one time in the Arena Chapel, Giotto placed an episode out out of sequence. Properly, the scene should follow the Last Supper and the Washing of the Feet. That it occurs here may be explained in several ways. Like the Visitation, it involves a meeting between two people, but the augury of good inherent in the meeting between the Virgin and Elizabeth is far different from the evil and clandestine encounter on the other side of the arch. The Devil, a shadowy form of gliding malevolence, has Judas in his grip. The immense gulf between the two scenes must have made them seem appropriate opposites for Giotto. Furthermore, since the Passion cycle in the lowest of the three registers hinges on this one act of evil, the scene serves to introduce that cycle, just as the Visitation led us into the cycle of the Infancy of Christ.

The notion that the prominent position of this scene served as an acknowledgment of the sinfulness of usury reinforces the appropriateness of this theme for the triumphal arch. It will be recalled that the Scrovegni had amassed their wealth by means considered just as wrongful as those by which Judas got his thirty pieces of silver. To expose the family sin was to go a long way toward expiation of it, even though, in this instance, expiation may have required some ecclesiastical urging. It is not coincidental that the episode with Judas follows immediately after *The Expulsion of the Merchants from the Temple*. The merchants and the money-changers were guilty of greed in much the same way as usurers. In so selective a cycle of scenes as we have in the Arena Chapel, the inclusion of the Expulsion of the Merchants and the conspicuous placing of the Pact of Judas, proclaim in no uncertain terms a preoccupation with the sin of usury.

Proceeding to the south wall, we find the first five episodes of the

Passion cycle: *The Last Supper, The Washing of the Feet, The Betrayal of Christ, Christ Before Caiaphas*, and *The Mocking of Christ*. In the first of these, the Supper (fig. 39), which took place on the Feast of the Passover, Christ announced that one of the disciples present would betray Him. He then made what may be his most momentous pronouncement—that the bread they ate stood for his body and the wine they drank stood for his blood, shed for the remission of sins. The scene is unassertive, even meditative. It is characteristic of Giotto to begin each series with a relatively quiet scene and to build the drama as the story unfolds along the wall. The feeling of quiet reverence and communal sharing among these men continues in *The Washing of the Feet* (fig. 40), as described by St. John, in which Christ tells the disciples He is setting an example for them.

The storm breaks with fury in the central scene, *The Betrayal of Christ* (fig. 41), in which a multitude with swords and staves come out to arrest Christ. Christ, almost lost from sight in the midst of the mob and all but covered by the yellow robe of the traitor, nevertheless stands out because of the fiery magnificence of his head (fig. 42). It is an altogether Olympian cast of face: Giotto has here magnified the noble brow and given Him an even finer, straighter nose than in the other scenes. Judas, on the other hand, is like some lower order of primate, with short brow, deeply inset and dishonest eyes, curved nose, and small chin. His lips are pursed in a mixture of brazen insolence and cowardice. Once again, Giotto has drawn the sharpest possible contrast between two figures and two states of mind.

This dramatic confrontation between Christ and Judas gains emphasis because nothing in the scene is allowed to interfere with it. Giotto places Peter and the soldier Malchus to the left of the scene, behind Christ's back. Peter, it will be remembered, cut off Malchus' ear in a moment of anger, whereupon Christ caused a miraculous healing, warning that those who take up the sword will perish by the sword. Most often in representations of the Betrayal, Christ effectuates the cure at the very moment when Judas bestows the kiss, causing the spectator's attention to be divided between the two incidents. It is typical of Giotto to reduce the importance of the subplot for the sake of greater dramatic unity.

In the next scene, *Christ Before the High Priest Caiaphas* (fig. 43), Christ finally turns his head and looks back. From the early scenes of his Mission, Christ had been in profile, facing right with his arm raised. The posture continued in *The Last Supper, The Washing of the Feet*, and *The Betrayal*. Now as He turns away from the obese, raging Caiaphas, Christ seems to cast a long and sorrowful look at the perfidious world that has brought Him here. For all the power of

this representation, it is, in a way, only a preparation for the haunting face of Christ in the following scene (fig. 45). In *The Mocking of Christ* (fig. 44), the soldiers have clad Him in a purple robe, given Him a reed for a scepter, plaited a crown of thorns about his head, and now they mock Him, crying, "Hail, the King of the Jews!" Christ's glazed eyes, the crown of thorns, the trickle of blood, the tautly yanked hair all contrast to the spiteful, harping faces of his tormenters and the cruel, hard features of the officer at the right and make this image very poignant.

The Passion cycle continues onto the north wall in the lowest row of scenes: *The Road to Calvary, The Crucifixion, The Pietà,* and *The Resurrection.* The program then concludes with *The Ascension* and *The Pentecost.* It is curious to see how Giotto varies the pitch of his drama from scene to scene. The scenes of *The Road to Calvary* (fig. 46) and *The Crucifixion* (fig. 47) are played in a low key in contrast to the surging drama in the following two episodes. For Giotto, as indeed for many later Florentines, the Crucifixion was interpreted almost as a meditation on the Passion of Christ. In the entire scene only one figure, that of a partly hidden soldier, even glances toward the figure of Christ. To the right the soldiers are engrossed in the division of his robe; to the left the Virgin and St. John and those standing with them are caught up in a heavy burden of grief (fig. 48), the agony of which is emphasized by the high-pitched cries of the angels in the sky. Dominating every pulsation in the picture is the slack figure of Christ in the center (fig. 49).

The emotions held in check in *The Crucifixion* are released in the next scene, *The Pietà* (fig. 50), that is, the mourning over the dead body of Christ. Its dirgelike rhythms make it one of the most famous of the Arena Chapel tableaux. Not the least achievement of this scene is the arrangement of the figures. Least involved and least emotional are the two stalwart figures of older men at the right—Nicodemus, who took Christ from the cross, and Joseph of Arimathea, who provided the burial tomb. At the feet of Christ the Magdalen is seized with passionate weeping, while above her St. John the Evangelist expresses a loftier, more soaring grief, arms outflung, quite like the eagle, which is his symbol. Closest to Christ is the Virgin (fig. 51), who cradles his shoulders and head in her lap, a juxtaposition that recalls *The Nativity* (fig. 26) and that earlier moment when she had had to yield Him up.

Giotto's scene of *The Resurrection* (fig. 52) combines two separate narrative episodes: at the left the angel sits on the tomb as a witness to the fact of the Resurrection while, at the right, Christ and the Magdalen enact the *Noli Me Tangere.* In the medieval tradition the

Resurrection had generally been alluded to through either the Three Marys at the Tomb or the *Noli Me Tangere* or both together. It is a later tradition to represent the act of resurrection itself, in which Christ is seen rising up out of the tomb. Giotto eliminates the three Marys to whom the angel is usually seen announcing the Resurrection. At the right, in his first appearance on earth after the Resurrection, Christ shows Himself to Mary Magdalen who becomes, in effect, the first witness to that resurrection. At the same time, since He is risen —a fact symbolized by his white robe and the banner inscribed "Victor over Death"—but not yet ascended; He forbids the Magdalen to touch Him, with the words: *"Noli me tangere."* This supramundane situation is much enhanced by the way the soldiers at the left, sprawled in a trance deeper than sleep, are incapable of witnessing the Resurrection themselves.

After Christ had appeared to the disciples a number of times and forty days had elapsed, He ascended into Heaven. Giotto's representation of *The Ascension* (fig. 54) is one of the earliest examples in Italian art of the human figure in supernatural levitation. The white-clad figure of Christ being wafted upward must have been a startlingly new kind of image. After Giotto, the Ascension of Christ and the Assumption of the Virgin were among the most popular representations in later fourteenth-century painting.

The last scene is that of *The Pentecost* (fig. 55), which took place fifty days after the Crucifixion when all the apostles were gathered together. In a somber interior, the Holy Ghost descends upon the apostles, and to each there comes a "cloven tongue like as of fire," symbolizing the gift of the many tongues in which they will thenceforward speak. With this solemn mood in which the apostles make ready to teach all nations Giotto brings his epic to a close.

The lowest part of the nave walls in the Arena Chapel is decorated with a painted frieze of Virtues and Vices alternating with panels in imitation of polished, multicolored marble (figs. 5, 6). The six Virtues are on the south wall and the six contrasting Vices are opposite. These allegorical personifications are painted in monochrome, giving them a neutral character so that they do not compete for attention with the brighter narratives in the main fields above. Furthermore, this chalky gray tone creates the illusion of carved stone. They have the quality of relief plaques set into the wall between the equally illusionistic plaques of veined marble. This entire lower register of the Chapel has, therefore, a strongly architectonic and plastic quality that emphasizes the weight-bearing function of the walls above. This row of painted decorations is also noteworthy inasmuch as it harks back to a system we associate with ancient Roman painting, a system

in which the surface textures of marble paneling and of moldings and frames are imitated to such an extent that they give the illusion of being an extension of the architectural system of the room itself.

The essential idea in the allegorical figures themselves is a magnified contrast between a Virtue and its corresponding Vice. Thus, most typically, Hope (fig. 56) sublimely floats upward, ripples of that movement echoing throughout the figure, while Despair (fig. 57), depicted as a suicide, sags downward in an opposite rhythm. Almost always the Vices are shown off balance so that vice of any sort seems to involve a loss of individual control, a disorder of the motor mechanics of the body, and, as well, a loss of intellectual and spiritual self-control. In the remarkable conception of Inconstancy (fig. 67) the figure is rendered as whirling out of control on a disk. Fortitude (fig. 66), opposite Inconstancy, is in easy balance, sturdy, assured, and full of righteous vigilance.

The enthroned and crowned Justice (fig. 62) is an impressive figure. Of the diminutive figures in the scale she holds, the one on the left reaches out to crown a figure seated at a desk, while the one on the right is apparently in the act of decapitating a figure on the arm of the throne. The small scene at the bottom shows us the benefits of life under Justice and contrasts vividly with the scene of rape and robbery under the figure of Injustice (fig. 63). Even the Gothic canopy over Justice contrasts sharply with the strange rocks and castellations which, in the panel opposite, powerfully convey the sense of the danger and terror of life where injustice lurks behind every tree.

How suggestive are such features as the bloated figure, the monstrous costume, and peculiar stance in revealing the nature of Folly (fig. 69)? Is not the obese image of Infidelity (fig. 61), swaying a little off balance and yoked to the false idol, a perfect realization of the pagan world that had no ear for those, such as the small prophet in the upper-right-hand corner, who brought the truth? And is not the figure opposite to this (fig. 60), with her sumptuous drapery and noble poise, luminous with faith? Wrath (fig. 65) tears her garment in a flood of unreasoning anger—that is, anger which is itself unreason. Temperance (fig. 64), on the other hand, is a figure of grace and balance who binds up the sheathed sword she need not use.

An enormous Last Judgment (fig. 74) fills the entrance wall of the Arena Chapel; indeed, it was traditional for this theme to be placed in the west end of a church either in fresco or mosaic on the interior or in sculpture on the exterior. By its very nature a Last Judgment is didactic and lacks the kind of narrative drama we associate with the other scenes Giotto painted along the walls of the nave. A Last Judgment has a large, programmatic theme: the arranged hier-

archies of celestial beings, the time-honored contrasts between the Saved and the Damned, the depiction of the infernal regions, the representation of Christ as Judge of the World. Altogether it is overwhelming in the weight of its dogma.

Giotto's primary source was surely the vast mosaic of the Last Judgment in the Baptistery in Florence, a work which he would have known since childhood. From the mosaic he must have taken the posture of Christ, his right foot placed on the *mandorla*, his right hand turned up in acceptance of those to be saved, his left turned down in rejection of the Damned. And memories of the mosaic are found also in the grouping of angels, of apostles, and of the Saved and the Damned. Naturally, there are differences: the Christ in the mosaic is in the old Italo-Byzantine mold, whereas Giotto's Christ is more human and therefore conveys an even greater sternness than the static image in the Baptistery. Giotto's Christ far exceeds the earlier example in the grandeur of the concept.

In a number of iconographic particulars Giotto's *Last Judgment* has no prototype. For one thing, there is an extraordinary emphasis on the punishment of usury in the lower area of the fresco (fig. 76), an emphasis which Giotto must have been instructed to make for reasons relating to the Scrovegni family. For another thing, there is an unusually elaborate participation of the Virgin in this fresco. Ordinarily she is represented to Christ's right, in a position of precedence over all others. In the Arena Chapel fresco she appears just below the *mandorla* of Christ at the head of the procession of the Saved (fig. 75), clearly serving in her role as intercessor for mankind before the Judge. And in the lower center of the fresco, where Enrico Scrovegni presents the model of the Chapel (fig. 77), we see her again, but this time as the Annunciate Virgin, the nearest of the three figures behind the model. The farthest figure, then, has been identified as the Archangel Gabriel, while, at the center, the taller figure represents the Virgin in that other role she plays in the Arena Chapel, as Saint Mary of Charity. In any case, it is the central figure of the three which extends an arm toward Enrico Scrovegni in a gesture of acceptance and forgiveness, as though in return for so splendid a homage as he gives her in the form of this Chapel.

III

One of the major points of Giotto's style—fundamental for all subsequent Italian art—is his definition of the human figure in all its bulk and weight as an object occupying a certain amount of space. At first glance Giotto's figures seem to be inordinately bulky, but this appearance is the most superficial aspect of the artist's endeavor to

give the figures a three-dimensionality. The figure of Joachim in the first scene, *The Expulsion from the Temple* (Fig. 7), is undeniably bulky. In the figures of both the priest and Joachim in that scene the notion of some underlying cylindrical form asserts itself through every manipulation of the bodies and their covering drapery. The solidity of the figure of the priest is accentuated by the long, parallel folds of the drapery. The columnar quality of the figure of Joachim is confirmed by the white highlight descending from his right shoulder to his foot; from the light axis there is a progressive darkening of the figure toward the sides, especially along the back, as those parts of the figure recede from us. All this reinforces the sense of volume in the figure. The network of drapery folds on the front of the figure, streaming down over the various parts of the thigh and leg from their bunching at the waist, suggests the quality of fabric stretched over an underlying form. These little white lines highlighting the drapery folds are extremely active ingredients in the definition of the parts of the body as well as its volume. This function is still more apparent when we examine the conventional highlights scattered over the draperies in the painting by the San Martino Master (fig. 78). Inherited and perpetuated endlessly through the various traditions of medieval art, these patterns were often of extraordinary decorative beauty, although they seldom worked successfully to define the figure beneath. In the Pisan painting the flat patterns of the drapery confirm the weightlessness of the figures quite as much as their dancing postures do. Just as clearly, the drapery on Giotto's figures enhances the sense of their being rooted by the force of gravity.

One is reminded in Giotto's drapery of French Gothic sculpture of the thirteenth century—the graceful curve of the· folds and the large, smooth planes between the folds. But if Giotto was influenced by a mode or style which was inundating all of Europe, his use of it was fundamentally Italian: every plane and every fold of his drapery makes one more statement about the plastic structure and the organic quality of the human figure.

In *The Vision of Joachim* (fig. 11) there is an impressive concentration on the figure of Joachim. He is like a personification of sleep, of a person drawn in upon himself and utterly lost to the world of consciousness. Even in this posture, in which the figure is reduced almost to a pyramid, with the head and an arm resting on a raised knee, the entire organic structure of the body is revealed. The volumes of his left shoulder and left knee press convincingly against the drapery, which is highlighted at the area of greatest protuberance and falls into slack folds and shadows where the body does not press outward. It should not be thought, however, that Giotto is so exclusively

interested in rendering plastic values as to ignore anything else. The drapery which falls from the right hand, besides accentuating the void between the legs in terms of light and shadow, is treated with sumptuous detail and an eye for the graceful cascade of folding forms.

Everything about this entranced figure corroborates the idea that this is the moment of his vision; everything demonstrates Joachim's passivity and his curious role in the story of the Immaculate Conception.

One aspect of Giotto's genius is, as we have already observed, his ability to suggest different types of people and even their conditions in life. A good example of this is the youngest of the three Magi in *The Adoration of the Magi* (fig. 27), a figure which embodies youth, beauty, and regality. His figure is ramrod straight; the simple robe has folds as carved and regular as the flutes of a column. Like Piero della Francesca in a later age, Giotto assimilates such a figure to an abstract, geometric form—a way of idealizing the young king and lifting him above the common man. In contrast, the groom just behind him, in an ill-fitting costume, is shown in a foreshortened view, more realistic and more mobile—all this because he represents a servant type. An even greater contrast to the young Magus is afforded by the two shepherds in the preceding scene of *The Nativity* (fig. 25): their shifting gait, irregular hems, hunched-over shoulders, and the entire stance of these figures is at a far remove from the proud, elegant perfection of the young Magus.

Or again, Giotto can convey something very different in his treatment of the figure, as in *The Betrothal of the Virgin* (fig. 18). Perhaps the single most enchanting figure in the Arena Chapel is the Virgin in this scene. Demure yet smiling, she exudes a glow universally recognized as the particular quality of a bride. All this is confirmed by the harmonious lines of her white gown falling in a graceful train behind her. This lyrical mood persists in the representation of the Virgin in the next scene, *The Return Home* (fig. 20). Here again the beauty of the figure depends to a great extent on the flowing rhythms of the gown, enhanced now by the delicate sway of the Virgin as she moves along to the tune of the musicians and daintily lifts the drapery in front.

The composition of *The Betrothal*—with the cluster of rejected suitors at the left and the grouping around the Virgin on the right—involves the important artistic principle of isocephaly, that is, of all heads being on the same level. An indispensable device in the sculpture of Antiquity and, later, in the fullness of the Renaissance, it was usually ignored in the medieval world. Essentially it is a device that

unifies the composition by confirming the existence of all the figures in the same space and standing on the same ground plane. Isocephaly strongly controls *The Betrothal* scene, as, indeed, it does *The Virgin's Return Home*, which follows. In both instances the chief danger of isocephaly—a too monotonous, friezelike arrangement of figures—is avoided by the cadences of the groupings, the turning of certain figures to face the other way as a means of relieving strict regularity, the drapery folds which corroborate the moving and standing of the figures—all elements that unite the figures while giving them variety and naturalness. In one of his moments of keen insight in regard to these frescoes, John Ruskin compared *The Virgin's Return Home* to the Parthenon frieze. Certainly Giotto understood those same compositional ideas which make the classical relief one of the most impressive creations in the history of art.

Farther on in the series, in *The Crucifixion* (fig. 47), there are several figures that must stand as among the greatest Giotto ever painted, illustrating as they do the broad range of expression of which the artist was capable. As always in Giotto, a particular expression is conveyed not only in a face or a gesture but throughout the figure. The dramatic Virgin Mary (fig. 48) illustrates this principle: her face is contorted by grief, so much so that she becomes strikingly unbeautiful, and this change is reflected in the awkward, almost painful twist of her body. Giotto's interpretation of the Christ in this scene (fig. 49) is even more astonishing. The head sagging in death, the eyes firmly closed, the hair falling forward to cover a good deal of the head, the far cheek not clearly visible, the chin almost nonexistent— the concept here is far removed from the full vigor of Christ's head in, say, *The Betrayal of Christ* (fig. 42). Not only has life fled from the flesh; it is as though the form were atrophying before our very eyes. It is true that earlier Italian artists had created powerful images of the dead Christ in crucifixes of the thirteenth century; by contrast, though, theirs were conventionalized masks of death. And again, in the head of Christ in *The Pietà* (fig. 51), Giotto gave another dimension to the look of death: the head falls back indicating the loss of all life, and the half-open eyes have the stare of death.

One of Giotto's most poignant figures is that of the Magdalen in the *Noli Me Tangere* (fig. 52). Christ, in his first appearance after resurrection, meets the Magdalen, who reaches out to touch Him. Kneeling and stretching out her arms toward Christ, her entire figure conveys a sense of almost unbearable yearning and emotion (fig. 53). The very idea that she cannot, must not, touch Him is used by Giotto to suggest the idea of not only the transcendent nature of Christ but

the very human tragedy of two people at a fateful and final moment, separated by an enormous gulf although they are close enough to touch.

The figures of the Magdalen and Christ in this episode are typical of the way in which Giotto made his statements about the human form. As we have seen throughout the Arena Chapel, every part of a figure expresses an idea of movement, feeling, and emotion, so that it is not just a turn of the figure or a way of draping it and certainly not a mere expression on the face, but all these things in a hard-to-define whole that give the figure its essential meaning. Every fiber of the Magdalen's being is concentrated on her desire to touch the Master, so that there is little emphasis on the details of anatomical structure, of joints, or of the neck, but a great deal on the forward swaying of the figure, on the rapt, attentive face, and on the fingers groping in the empty air. By contrast the energetic figure of Christ is shown in *contrapposto*: as He moves off to the right He turns, twisting his torso around toward the Magdalen as his arm sweeps back in a gesture of denial. Thus *contrapposto* is a vehicle not only for the expression of a very complex movement but also for the emotion behind the movement, Christ's tender regard for the Magdalen and the necessity, at the same time, of departing from her. *Contrapposto*, a life-infusing device in the representation of the human figure, was a cornerstone of Antique art from the time of Polyclitus. By and large it died out during the Middle Ages just because it conveyed so strongly the idea of corporeality, of dynamic torsion in the figure. It was natural that as the Renaissance in Italy developed, *contrapposto* was one of the foremost means by which the artist created the new naturalism, and already with Giotto the time for it had come again.

IV

In Giotto's paintings the settings are extensions of the narrative; they are environments arranged to enhance the figures and the actions. The scenery in Giotto never has an independent existence but serves instead as a rhythmic accompaniment to the figures. This rule is clearly established in the very first scene, *The Expulsion of Joachim from the Temple* (fig. 7).

In this scene Giotto uses compositional devices that will serve him throughout the Arena Chapel. Most important is the almost austere economy of the setting. An enclosed space, a canopy over the altar, and a pulpit—so much and no more is represented of "religious edifice." Thus the spectator is never diverted from the principal narrative point by any unnecessary embellishments. The empty area on the right is, as has already been suggested, both the physical and the

psychological void into which Joachim is cast as a result of his rejection from the Temple.

Giotto sets his scene on a narrow shelf, one which is clearly defined and measured. The figures, accompanied by architecture or landscape, are invariably deployed in a left-to-right movement across this stage, and the consequent balance between depth and the surface plane is very Classical in feeling. To a large extent it is architectural settings which generate convincing space in Giotto's frescoes in the Arena Chapel. In *The Expulsion of Joachim* the platform and the architectural parts on it tilt away from the picture plane, propelling our glance into depth. By contrast, the earlier San Martino Master (fig. 78) places every object parallel to the picture surface in one of several overlapping planes, all of which can be read as two-dimensional surface decorations, but none of which actively recede backward or forward into one another. Giotto's new oblique angle of architecture in *The Expulsion* is only the first step in the evolution the artist underwent while he painted in the Arena Chapel. Even so, it is of momentous importance for Italian painting.

In the second episode (fig. 8), where Joachim goes out into the wilderness, the power of the scene depends on the psychological separation of the slow-moving Joachim from the puzzled shepherds approaching him. On closer look, we observe how Giotto firmly knits these figures together by the landscape. The rocky ledge starts as a foil behind the figure of Joachim, glides slightly downward behind the shepherds' heads, and then rises swiftly to the top of the scene at the right. At every turn it echoes the figures as it leads us effortlessly across the composition. The rock also establishes the shallowness of the space, properly adjusted to contain the figures, but not allowing our glance to seek out too deep a space which would distract us from the action itself. And this rocky ledge reinforces the left-to-right flow of the narrative; here, as in all Giotto's compositions in the Chapel, the friezelike composition does little violence to the wall surface and, indeed, insofar as the murals positively enhance the two-dimensional wall surface, they are among the most successful in the history of art.

Two scenes farther on, in *The Vision of Joachim* (fig. 11), the same setting is used. But now the rocky ledge slopes more precipitously, echoing the down-sweeping figure of the angel and leading us to the figure of Joachim, asleep in the corner at the right. Giotto has here molded the physical properties of the landscape to suit the needs of the story; the rock of the background exists only in its relation to the angel and Joachim. And the pyramidal figure of Joachim is emphasized and magnified by triangulations in the roof of the hut placed

behind him and by the pyramidlike rock rising in the background. If we may say that every element in the picture focuses on Joachim, we may also say that the figure of Joachim conditions and shapes everything around it.

The landscape of *The Pietà* (fig. 50) enhances very much the pathos in this most famous scene in the Arena Chapel. The ledge of rock, descending from the upper right to the lower left, guides us to the focal point of the scene, the heads of Christ and the Virgin. As we have observed in the several Joachim scenes, the rock is conceived of as a rhythmic echo of the figures; in *The Pietà*, even more than in the earlier scenes, the rock absolutely controls the entire composition. Unimaginable as a true configuration of nature, it takes its shape and, indeed, exists only in tangency to the figure of Christ and the group of mourners.

In the episodes around the Betrothal of the Virgin—*The Presentation of the Rods* (fig. 16), *The Watching of the Rods* (fig. 17), and *The Betrothal* itself (fig. 18)—a large niche on the right side frames and emphasizes the principal action and point of interest in each scene. This apselike shape, symmetrical and of monumental proportion, is eminently suitable to suggest a religious edifice. It is axiomatic for Giotto to repeat a setting when the story in any way allows it; we have seen how the countryside terrain is used with only small variations in several of the Joachim scenes. Now, in the several scenes telling the story of the Betrothal of the Virgin, one architectural set recurs almost without change in three successive episodes. Its repetition makes for continuity in the story; quickly grasped in the first of these scenes, it offers the spectator no new embellishments or distractions in the following scenes, so that the reading of them is so much the easier.

The settings of the two figures of *The Annunciation* (figs. 22, 23) on the triumphal arch illustrate once again that Giotto's settings exist for the figures and not the other way around. The angel and the Virgin are each set into a small stage flanked by architectural segments accentuated chiefly by balconies. These simple settings are slanted in such a way that the sides converge forward whereas by the most elementary rules of perspective they should recede into depth. The effect here is to catapult the figures of the angel and the Virgin toward each other across the open void of the choir, uniting them in a more intense drama than would have been possible if the perspective had been normal.

Farther down on the two sides of the triumphal arch Giotto depicted two enigmatic, empty rooms (figs. 3, 70, 71). The normal perspective viewpoint in these spaces is very different from the distorted

perspective of the buildings in the two parts of *The Annunciation* above. Rather, these vaulted chambers seem like continuations of the space of the Chapel itself, their walls and vaulting ribs being angled in such a way as to suggest to some critics that they were conceived in one unified spatial system and rendered with a thorough knowledge of one-point perspective. Actually, there are some faults in the perspective, and all orthogonals do not converge to a single vanishing point—an achievement not to be attained until Brunelleschi a century later. Even so, the degree of spatial exploration in these two vaulted areas is as unusual in Giotto's art as it is elsewhere in the fourteenth century. Such perspective depth would have interfered with—even destroyed—the carefully restricted spaces of the narratives in which a shallow stage, a friezelike grouping of figures, and a constantly reiterated left-to-right movement are essential ingredients of the Arena Chapel decoration.

It is in the development of interior settings that Giotto made one of his important contributions. The earliest type is that found in *The Annunciation to Anna* (fig. 9) and *The Birth of the Virgin* (fig. 14), each of which contains a sort of doll's house with the front wall removed. Properly speaking, we should perhaps call it an inside-outside view since we are given a full glimpse of the interior while, at the same time, we can see the outside of the wall at the left and the roof above. The side of the structure is tilted in such a way that we can see the diagonal recession into depth—a device that emphasizes the three-dimensionality of the house.

This setting, however, did not completely satisfy Giotto, and, indeed, the most interesting thing of all about his settings in the Arena Chapel is the evolution the artist underwent while he was painting there. Thus, the setting for *Christ Disputing with the Elders* (fig. 31) is nothing if not exploratory. As a matter of fact, Giotto did not repeat this exact formula in any other setting. Here Christ is seated at the center under a curved apse shape, on either side of which is another, smaller arch. At right angles to these, two more arches on either side come forward. We may speculate that this ecclesiastical interior with its domes, half domes, and elaborate system of arches was inspired by the impressive interior of San Marco in Venice. Be that as it may, it is the presentation of enclosed space that interests us. For one thing, the interior stretches to the frame of the picture so that it is no longer an inside-outside arrangement; as we shall see later, this change is important in the development of Giotto's space. Furthermore, while his space is to be read as three-dimensional, since it has side walls and a back wall, it can also be read as an arcade of irregular arches from left to right. Such a two-dimensional reading

of the setting is encouraged by the two great swags that dip across the scene at the top. In the same way, the two groups of elders who recede into the depth and confirm the architectural recession can also be read as a left-to-right frieze of figures. Giotto here essays the difficult task of integrating three-dimensional recession with the autonomy of the picture surface. It is just this sort of spatial complexity and monumental, centralized scheme which he will elaborate upon some twenty years later in, for example, *The Apparition of St. Francis at Arles* (fig. 80) in the Bardi Chapel. At the same time, it is so radically different an approach to composition from the one he used in *The Expulsion of Joachim from the Temple* (fig. 7) at the beginning of the series that we must believe it is an indication of the evolution of his ideas.

When we turn to an examination of the setting in *The Marriage at Cana* (fig. 33), we see that Giotto is continuing to explore an architectural arrangement encompassing the entire area of the picture, one that strongly organizes and unifies the various elements of the scene. The back wall and side walls form a U-shaped interior partially covered by a kind of balcony in lieu of a ceiling. Giotto was careful not to let these convincing spatial suggestions destroy the picture surface. Accordingly, the side walls are not at right angles to the back wall but are splayed out. In consequence the top edge of the striped hanging and the decorative band on the rear wall are in an absolutely straight line across the picture, yielding a two-dimensional reading of the various elements. Giotto achieves here a striking balance between surface design and the illusion of depth, always a major preoccupation in Italian painting.

It is instructive to compare the way Giotto's Sienese contemporary, Duccio, created an interior setting in the scenes on his *Maestà*, painted just a few years after Giotto worked in Padua. In *The Last Supper* (fig. 79) on the *Maestà* the interior setting also fills the picture space, and it has a good deal of conviction in the sharp angle of recession of the side walls, the fully presented ceiling held up by corbels, the openings at the side and the rear. Such stage sets in the *Maestà* contain remarkable sensations of space, and it is little wonder that Duccio's picturesque vocabulary of settings inspired many an artist throughout Europe in the fourteenth century. If, as is likely, he was inspired by the developments of Giotto in creating such spaces, he was not at all interested in the kind of integration of figures and setting so important to Giotto; indeed, Duccio often seems to be exploring spatial possibilities independently of the figures. Giotto, on the other hand, in *The Marriage at Cana*, places the figures within a setting that exists only to surround and locate them.

Nothing could be more indicative of Giotto's evolving concepts of architectural settings than a comparison between an early scene, *The Annunciation to Anna* (fig. 9), and a later one, *The Last Supper* (fig. 39). At the earlier stage of the work in the Arena Chapel Giotto had placed a doll's-house structure within the scene, but it did not quite fill up the space. By the time of *The Last Supper*, Giotto's interior setting fills up the entire width of the picture space, the roof is squeezed up to the very top of the picture area, and the fullness of the interior is increased by the removal of the wall at the right. Furthermore, in *The Annunciation to Anna* the side wall on the left was placed on a diagonal to generate a sense of three-dimensionality, while the front of the structure was strictly parallel to the picture plane. In *The Last Supper* the front of the structure is shifted ever so slightly out of plumb with the picture plane so that the oblique angle of the entire building yields an even greater sense of depth. The most significant detail of the later scene is the slender colonnette on the right side (the paint has flaked off where the colonnette overlapped the figure). Unobtrusive as it is, it establishes a forward point behind which the figures are located. Their occupancy of the room space under the roof and between the walls and the column is now far more complete and convincing than in any earlier representation. It must have seemed to the artist, in retrospect, that his efforts in *The Annunciation to Anna* were less successful: although he had made a strong statement of the cubic space, the room lacked spaciousness and, anyway, the structure jarred too much against the picture plane. In *The Last Supper*, by contrast, the space is so easily achieved that Giotto can smooth out the juncture between the left and back walls almost to the point of its disappearing. Yet the space is still convincingly deep and the architectural setting plays easily with the picture plane.

Giotto continued to explore ways of rendering interior space in two other episodes. In *Christ Before Caiaphas* (fig. 43) the ceiling spreads over the entire scene and is marked off by an elaborate system of beams and corbels. These constitute orthogonals receding to a vanishing point left of center on the back wall—a far stronger assertion of the three-dimensional space than was the case in *The Marriage at Cana*. In the Caiaphas scene Giotto also introduces the idea of using architectural parts to serve as framing; the front edge of the ceiling and the pilasters on either side serve such a double purpose. As a result the architecture now contains the scene absolutely, but in the process it begins to endanger the surface design. Giotto was seldom again to allow the architecture to assert itself so strongly.

In *The Mocking of Christ* (fig. 44) Giotto essays one more archi-

tectural setting, an open courtyard. Again, the columns at the side serve as framing elements, and the architecture thus envelops the entire composition. The narrow strip of ceiling around the edges of the court recedes convincingly, being turned sharply at right angles to the picture plane. It is a setting of enormous sophistication, elegant in its proportions, startling in its virtuosity and spatiality. At the same time it is reticent: to a remarkable degree it does not interfere with the drama played within its confines. The architectural setting of *The Mocking* is the most extraordinary in the Arena Chapel; perhaps more than any other, this one helps us to understand the artist's further development in the frescoes of the Bardi and Peruzzi Chapels.

BACKGROUND AND SOURCES

Note: the Latin texts, of subsidiary interest to the general reader, are for the most part omitted here; for those who wish to consult the original text a reference is given in each case.

DOCUMENTS

The Purchase of the Land—February 6, 1300[1]

Enrico Scrovegni purchased the area of the Arena from the Dalesmanini family in 1300, and the document describes both the transaction and the property as it then was. The old mansion of the Dalesmanini was apparently razed to make way for the more splendid edifice of the Scrovegni. In the fifteenth century the palace, which was considered one of the most princely in Italy, was owned by the Foscari family of Venice. It was then that its façade was remodeled in the graceful Venetian Gothic we still see in an engraving made before the palace was demolished around 1820 (fig. 2).

In the name of Christ in the year of his birth 1300, thirteenth indiction, sixth day of the month of February. In Padua in the borough of the principal street above the Cathedral at the home of the abovementioned Lord Enrico Scrovegni. Being present, etc.

* * *

For the sum of four thousand pounds in the small Venetian *denarii* in the usual and legitimate coin, which price and money Manfredo, the son of the late Lord Guezili de'Dalesmanini, made guarantee and acknowledged to have there received into his hands from Enrico, the son of the late Lord Reginaldo Scrovegni of Padua, for which money and price the same Lord Manfredo declared himself to be paid, recompensed, and fully satisfied, renouncing all further rights and claims, etc.

* * *

For which fixed and true price and in the name of a fixed and agreed sum, the aforementioned Lord Manfredo de'Dalesmanini gave, sold, ceded, turned over and sent to Lord Enrico Scrovegni and his property his own property consisting of the Arena, which is enclosed

[1] Parchment in the Foscari-Gradenigo Archives, Venice. A. Tolomei, *Scritti varii*, Padua, 1919, pp. 53–55; first published in Tolomei, *La chiesa di Giotto nell'Arena di Padova. Relazione al Consiglio Comunale dell'Assessore A. Tolomei*, Padua, 1880, Document II, p. 30.

by walls on all sides, except on the side of the Eremitani Brothers of Padua. Within this property there is a house enclosed by a large wall nearby from which hangs a sun awning made of slats covered with hemp. The aforementioned is located in the middle of the Arena. There is a tile-roofed colonnade adjacent to the back of the house and another house with a wall without a sun awning which contains a large fireplace and one room. There is another building, which would be the kitchen, with a slatted roof, not far from the gate which is in the middle of the Arena. There is also a dungeon above the gateway of the street and another walled dungeon with a beamed roof whose gate gives onto the river with the embankment above the river positioned outside the aforementioned gate. There are also arbors and fruit-bearing orchards located in this same Arena and walls surrounding this Arena, the which Arena is located in Padua, adjacent to the monastery of the Eremitani Brothers (under the rule of Bagoti) and adjacent to the river. Also a piece of land with a building on it, walled in the front and in the rear, in the aforementioned borough, opposite the Arena, etc.

* * *

On that same day in the borough of the Arena, being present, etc., the aforementioned Lord Enrico Scrovegni, in the presence of the said Lord Manfredo de'Dalesmanini, by his will and consent and by the power of the aforementioned sale contracted with Lord Enrico, exercising his authority, took tenancy and corporal possession of the aforesaid Arena with the houses and buildings located there and of the aforementioned pieces of property, with and without buildings on them, and, by the sworn oath of all those named above, paced over the boundaries of the Arena and of the properties, opening and closing the gates of the aforesaid Arena according to law and custom, and by occupying legally and taking corporal tenancy and possession of every and each of these properties, took ownership of them thenceforward as his own property.

I, Domenico, son of the late Prosdocimo, notary of the holy office, was present at each and all of these actions, and, being requested, willingly did note them down.

I, Francesco, son of the late Lord Giovanni di Centenario, of the borough of San Nicola, notary of the holy office which is located in the bureau of the Commune of Padua, at the desk of Stambeco, in the presence of the discreet and sagacious Lord Giacobbe di Alvaroti, judge and official of the city of Padua, at the aforementioned desk of Stambeco in the office of the noble soldier Lord Gerardo Dalmulla di Travissio of Padua, by his honorable power, received this document,

authentically written by the above-mentioned notary Domenico, and copied it faithfully by the authority of the aforementioned judge, neither adding nor subtracting anything which would change or alter the sense, either by altering letters or syllables or the arrangement of the letters. In the present year of our Lord 1320, first indiction, fourth day of the seventh month, September, in Padua, at the Communal Palace at the desk of Stambeco, being present the notary Pietro, son of the late Lord Padovano of Santo Zilio, the notary Antonio, son of the late Lord Francesco da Prato, and notaries, colleagues and others at the aforesaid desk, I transcribed the aforementioned words added to the document which had been omitted through error. I also added by my own hand to the document, other words said by Matteo which had been omitted through error.

Papal Bull Granting Indulgences for Visitors to the Arena Chapel—March 1, 1304[2]

In March of 1304 Pope Benedict XI issued a bull granting indulgences for visitors to the Arena Chapel. That this could have been done at such an early date speaks strongly for the swift completion of the Chapel. The document is the earliest reference to the fact that the Chapel was also dedicated to Santa Maria del Carità (the other dedication was, of course, to Santa Maria Annunziata).

Therefore. Eternal life, etc. since it should be praised. Accordingly, we beseech and through God exhort the universal community of the faithful, urging for the remission of your sins, insofar as you do visit, in the spirit of humility, the church of the Blessed Virgin Mary of Charity in the Paduan Arena, imploring God forgiveness of sins.

We therefore, as the faithful of Christ, almost as a salubrious reward, shall invite to these merits, by the mercy of the omnipotent God and his holy Apostles Peter and Paul, confident in his authority, those who, having confessed and being fully penitent, shall solemnly visit the aforementioned church on the feasts of the Nativity, of the Annunciation, of the Purification, and of the Assumption of the Virgin, to be granted a dispensation of one year and forty days, and for those who shall solemnly visit the church for one week immediately following the feast days, we mercifully give dispensation of one hundred days from the injunction of penance. Dated at the Lateran, on the first of March in the first year.

[2] Ch. Grandjean, "Le registre du Benoit XI; recueil des bulles de ce pape publiées ou analysées d'après le manuscrit original des archives du Vatican," in *Bibliothèque des écoles françaises d'Athènes et de Rome*, ser. 3, pt. 2, Paris, 1905, cols. 294–295, no. 435.

Complaint of the Eremitani Monks—January 9, 1305[3]

Early in 1305 the monks of the nearby Eremitani Church, probably inspired by a dislike of such a competitive enterprise just a stone's throw from their own church, complained about what they considered the excessive pomp and splendor of the Arena Chapel. Among other things the document is interesting for its reference to the "then Lord Bishop" who gave permission to erect the Arena Chapel. Since this can refer only to Ottobono dei Razzi, who died on March 1, 1302, permission for the Chapel must have been granted before that date.

In the name of the eternal God. In the year of his birth thirteen hundred and five, third indiction, ninth day of the month of January at the desk of the Episcopal Curia in Padua where court of the Bishop of Padua was convened by the Lord Vicar in the presence of the Lord Presbyter Tomasino da Casali of the Paduan Diocese of Lord Ugone; Lord Pietro di Guastallo of the borough of the Cathedral; Lord Finesio, son of Lord Bonfuoli of the aforementioned borough; the notary Bonomino, son of Lord Bonaventura, the notary of the Episcopal Curia; Lord Notary Guidoto, son of Lord Cermalli di Tencarola; and Prosdocimo of the borough of San Michele; Friar Nicolao Mascara; and Friar Giovanni Magistro, Superior of Sant' Agostino of Padua, and other witnesses requested and called especially for this case.

Friar Giovanni di Soleo, Mayor, and in the name of the Mayoralty of the Chapter and the Monastery of the holy Apostles Philip and James of the Eremitani of Sant' Agostino which are located in Padua in the borough which is called the Arena, presented the petition written within, the tenor of which is as follows: In your presence Reverend Lord Gofredino Vicentino, Vicar of the Lord General Pagani, Bishop of Padua by Apostolic grace and the grace of God, I, Friar Giovanni di Soleo, Mayor and representative of the Mayoralty of the Chapter and Monastery of the holy Apostles Philip and James of the order of the Eremitani Brothers of Sant' Agostino, which are located in Padua in the borough called the Arena as is contained in public record written by the hand of the notary Federico, son of the Master Giovanni, I say and put before you that since the Prior of the aforesaid Monastery has lodged a complaint in your presence, that the noble and powerful soldier, Lord Enrico Scrovegni the magnificent, citizen of Padua, had made and newly constructed a new bell tower in the

[3] Convento degli Eremitani, vol. 62: "Orto, et Forestaria," cc. 305–306, Archivio Comunale di Padova, quoted by O. Ronchi in: Padua. R. Accademia di scienze, lettere ed arti in Padova. *Atti e Memorie*, LII, 1935–36, pp. 210–211.

Arena at the church which is located there, in order to place huge new bells in it to the grave scandal, damage, prejudice and injury of the friars and monks who dwell in that place, or in other words of the aforementioned Monastery and those of the Order located there, and of the Convent and of the Church, and that, according to their sworn statements, there ought not to be a huge church in the Arena, but a small one with one altar in the manner of an oratory, and not with many altars, and further it ought to be without bells and without a bell tower according to the manner and form ascertained and contained in the document of the concession made of the aforementioned Lord Enrico by the then Lord Bishop of Padua. The form and manner of the concession is as follows:

That Lord Enrico will be allowed to construct in the Arena, or in that place which is called the Arena, without prejudice to the rights of others, a small church, almost in the manner of an oratory, for himself, his wife, his mother and his family, and that people ought not to be allowed to frequent this church. He should not have built a large church there and the many other things which have been made there more for pomp, vainglory and wealth than for praise, glory and honor of God. And again, these things have been done counter to the form and tenor of the concession of the Lord Bishop, whereby the aforementioned Prior in the name of the aforementioned Bishop begged you, according to the due power of your offices, to think us worthy to restrain the aforementioned and to let us see the document by which the concession of the Lord Bishop was made to the aforementioned Lord Enrico, that is, the document made or written by Lord Bartolommeo the notary, and diligently examine the tenor of this same document or concession and compel the aforementioned Enrico, by ecclesiastical censure, to observe the tenor of this document or concession and the pacts, conditions and manner contained or inserted in it and cause to be given to the above-mentioned Prior the aforementioned document or a copy thereof.

Deliberations of the Venetian High Council— March 16, 1305[4]

Enrico Scrovegni asked the Venetian authorities for the loan of wall hangings or tapestries for the occasion of the consecration of the Arena Chapel. There is every likelihood that the decoration of the interior

[4] "Deliberazioni del Maggior Consiglio," Archivio di Stato, Venice, in P. E. Selvatico, "L'oratorio dell'Annunziata nell'Arena di Padova e i freschi di Giotto in essa dipinti," *Scritti d'arte*, Florence, 1859, p. 284 n. 6; also in A. Moschetti, *La cappella degli Scrovegni*, Florence, 1904, p. 18.

of the Chapel was completed at this time. Nevertheless, while such hangings as he got from San Marco may have been desired simply as ornaments for this special occasion, they would surely have been needed for the choir, the walls of which were not decorated until much later.

Cum ser Henricus Scrovegni intendat facere consecrari quondam suam capellam Paduae, et requisierit quod commodetur sibi de pannis Sancti Marci, capta fuit pars quod possint commodari de dictis pannis.

Since Sir Enrico Scrovegni intends to have his chapel at Padua consecrated at some time, and he asked for such hangings from San Marco as might be useful to him, the number of such hangings which he needed was obtained.

DANTE,

from *The Divine Comedy: Inferno*—[*ca.* 1310][5]

As Dante glances about in the seventh circle of the Inferno where the usurers are clustered, he is able to identify individuals only by the heraldic devices on the moneybags they carry. Dante singles out the Paduan, Reginaldo Scrovegni (whose coat of arms includes a blue-colored, pregnant sow); he is the only one to speak and to be characterized physically. This passage is certainly indicative of the infamous reputation of Enrico's father, and it gives weight to the theory that his son was obliged to erect the Arena Chapel as a sort of expiation.

Thus I advanced along the extreme edge
 of the seventh circle all alone
 to where the sad souls were sitting.
Through their eyes their grief burst forth;
 on this side and that they used their hands,
 brushing off the fire and lifting themselves from the hot
 ground;
not otherwise are dogs busy in summer,
 now with their muzzles and now with their paws,
 when bitten by gadflies or fleas.
In looking at the faces of some
 on whom the painful fire was falling,
 I could recognize none, but I noticed
that from the necks of each a purse hung
 which had a certain color and design
 and on which it seemed that their eyes feasted.

[5] *Inferno*, Canto XVII, 43–78; translation by H. R. Huse, New York, 1954, pp. 83–84.

As I came looking at them,
 on a yellow purse I saw in azure
 the head and the form of a lion.
Then continuing the course of my glances,
 I saw another, red as blood,
 showing a goose whiter than butter.
And one who had a white sack marked
 with an azure pregnant sow,
 said to me, "What are you doing in this hole?
Now go away and, since you are still alive,
 know that my neighbor Vitaliano
 will sit here on my left side.
With these Florentines I am a Paduan;
 many times they deafen my ears,
 shouting, 'Let the sovereign knight come
who will bring the pouch marked by three goats.'"
 Then he twisted his mouth and stuck out his tongue
 as an ox does to lick its nose.
And I, fearing that to stay longer
 might annoy my master, who had admonished me
 to be brief, turned my back on those wearied souls.

FRANCESCO DA BARBERINO,
from *The Documents of Love*—[*ca.* 1308–1312][6]

Francesco da Barberino made what is probably the earliest known reference to Giotto's frescoes in the Arena Chapel when he spoke of the figure of Envy (fig. 59) in one footnote to his *Documents of Love*, an allegorical poem. The author must have seen the Chapel before he left for Provence in 1308; the *Documenti* seem to have been largely finished before his return in 1312.

Inimica: inimicatur enim patientibus eam unde Invidiosus invidia comburitur intus et extra hanc padue in arena optime pinsit Giottus.

Animosity: it suffers this, indeed, with endurance, as where Envy is consumed inside and out with enviousness—this Giotto painted excellently in the Arena at Padua.

[6] Società filologica Romana, *I documenti d'amore di Francesco da Barberino*, ed. F. Egidi, Rome, II, 1912, p. 165.

RICCOBALDO FERRARESE,

from *Chronological Compilation*—[*ca.* 1312–1318][7]

Riccobaldo's chronicle of outstanding events in the early years of the fourteenth century was written some time between 1312 and 1318. In the different manuscript and printed editions of the work the author's statement about Giotto varies, but in all of them the phrase about the Arena Chapel is the same.

Ioctus pictor eximius Florentinus agnoscitur qualis in arte fuerit testantur opera facta per eum in ecclesia minorum Assisii Arimini Padue et in ecclesia arene Padue.

Giotto is acknowledged as an excellent Florentine painter. What kind of art he made is testified to by works done by him in the churches of the Minorites in Assisi, Rimini and Padua, and in the church of the Arena in Padua.

SCARDEONE,

from *On the Early History of the City of Padua and Famous Paduan Citizens*—[1336][8]

Scardeone, writing the history of the city of Padua in 1560, transcribed the inscription which he read on the tomb of Enrico Scrovegni and which has since disappeared. The most important piece of information is the reference to the dedication of the Chapel on March 25, 1303. This ceremony suggests that the edifice was just being started or in any case could not have been very far along since, as opposed to the consecration of a finished church, a dedication is more like a ground-breaking ceremony. The inscription has been discounted by some who say that, since Palm Sunday and the Feast of the Annunciation did not occur on the same date in 1303 or in any year thereabouts, the inscription is untrustworthy. However, the inscription merely states that it was a year in which both holy days occurred during March.*

[7] *Compilatio cronologica*, Rome, 1474, f. 101ᵛ (quoted by P. Murray, "Notes on Some Early Giotto Sources," *Journal of the Warburg and Courtauld Institutes*, XVI, 1953, p. 60 n. 1).

[8] B. Scardeone, *De Antiquitate urbis Patavii & claris civibus Patavinis*, Basel, 1560, pp. 332–333.

* Annorum Domini tempus tunc tale notatur: Annis mille tribus tercentum Martius almae Virginis in festo coniunxerat ordine palmae.

This place, called the Arena by the ancients,
Becomes a noble altar to God, very much filled with divine majesty.
Thus divine power eternally changes earthly vicissitudes,
So that places filled with evil are turned to honest use.
Behold this which was the home of heathen, constructed by a great
 multitude,
Has been demolished with great wrath
And is now miraculously abandoned.
Those who led a life of luxury in happy times,
Having lost their wealth, are no longer even spoken of,
But Enrico Scrovegni, the knight,
Saves his honest soul; he respectfully makes for them a feast.
For he solemnly dedicated the temple to the mother of God,
So that he would be blessed with eternal grace.
Divine virtue replaced the profane vices,
The heavenly joys which are superior replaced earthly ones.
When this place was solemnly dedicated to God,
That time of the years of the Lord was noted as follows:
In the year thirteen hundred and three, March brought
The Feast of the Virgin and Palm Sunday into conjunction.

GHIBERTI,

from *The Commentaries*—[*ca.* 1450][9]

> In his *Commentaries*, a very abridged history of art written just
> around the middle of the fifteenth century, the sculptor Lorenzo
> Ghiberti had little to say about the Arena Chapel frescoes. Even the
> phrase he employed, "*gloria mondana*," is curious; one critic thought
> Ghiberti meant by it *The Last Judgment* in the Arena Chapel. How-
> ever, the words can only be a term of extollment, as when we speak of
> the "seven wonders of the world."

Dipinse nella chiesa, cioè tutta è di sua mano, della Rena di Padova.
E di sua mano una gloria mondana.

He [Giotto] painted, that is to say, it is all by his own hand, in the
church of the Arena in Padua. It is one of the glories of the earth
from his hand.

[9] *I Commentarii*: II, 3 in J. von Schlosser, *Lorenzo Ghibertis Denkwördig-
keit*, Berlin, 1912, p. 36.

VASARI,

"Giotto," from *The Lives of the Most Excellent Painters, Sculptors and Architects*—[*ca.* 1568][10]

> Although Vasari's treatment of the career and works of Giotto in his lives of Italian artists is comprehensive, his mention of the Arena Chapel frescoes is surprisingly brief. The phrase *"Gloria mondana"* is clearly taken from an earlier source, probably either Ghiberti's *Commentaries* or the *Codex Magliabechiano*, an early sixteenth-century history of art in which the Arena Chapel frescoes were described by the same phrase.

Appresso, andato di nuovo a Padoa, oltre a molte altre cose e cappelle ch'egli vi dipinse, fece nel luogo dell'Arena una Gloria mondana, che gli arrecò molto onore e utile.

Shortly thereafter, having gone again to Padua, besides many other things and chapels which he [Giotto] painted there, he made in the place of the Arena one of the glories of the earth, which gained him much honor and profit.

JACOBUS DE VORAGINE,

from *The Golden Legend*—[*ca.* 1260][11]

> The *Legends of the Saints*, as it was originally known, came in time to be called *The Golden Legend*, a tribute to the richness of the contents of this book. Its author was the learned theologian and Archbishop of Genoa, Jacobus de Voragine. Artists began to borrow ideas from the *Legend* soon after its appearance in the 1260's, and Giotto undoubtedly knew the text well. Since everything is arranged on a calendar basis, the passages given here are those for March 25, date of the Feast of the Annunciation, and September 8, date of the Feast of the Birth of the Virgin.

The Annunciation

MARCH 25

This feast is called the Annunciation of Our Lord, because on this day the coming of the Son of God in the flesh was announced by

[10] *Le vite de'più eccellenti pittori, scultori, ed architettori* (1568), ed. G. Milanesi, Florence, I, 1878, p. 400.

[11] *The Golden Legend of Jacobus de Voragine*, eds. G. Ryan and H. Ripperger, London and New York, 1941, pp. 204–208; 519–530.

an angel. And it was fitting that an angel should announce the Incarnation, because in this wise the fall of the angels was repaired. The Incarnation in sooth took place to repair not only the fall of man, but the ruin of the angels; wherefore the angels were not to be excluded from it. Whence as womankind was admitted to knowledge of the mysteries of the Incarnation and the Resurrection, so likewise was the angelic messenger: for God revealed the one and the other to a woman by means of an angel, namely the Incarnation to the Virgin Mary and the Resurrection to Magdalen.

The Virgin Mary dwelt in the Temple with the other virgins from her third year to her fourteenth, and there made a vow to preserve her chastity, unless God otherwise disposed. Then she was espoused to Joseph, God revealing His will by the flowering of Joseph's staff, as is told in the history of the Nativity of the Blessed Mary. And Joseph went to Bethlehem, his native city, to make all needful preparations for the marriage, while Mary returned to the home of her parents in Nazareth. Nazareth means flower. Whence Bernard says that the Flower willed to be born of a flower, in flower, and in the season of flowers.

And at Nazareth the angel appeared to her and greeted her, saying: 'Hail, full of grace, the Lord is with thee: blessed art thou among women!' Of this Bernard says: 'Three things invite us to salute Mary; Gabriel's example, John's joyous greeting, and the reward of being greeted in return.' But we must first see why Our Lord wished His mother to be espoused. For this Saint Bernard gives three reasons: 'It was necessary that Mary be espoused to Joseph, in order that by this means the mystery might be hidden from the demons, her virginity might be confirmed by her spouse, and her modesty and good renown preserved.' Another reason was that the espousal of Mary would take away the curse from every degree of womankind, namely from virgin, wife and widow; whence the Virgin herself was all of these.

Of the angel's greeting, *Hail, full of grace!*, Bernard says: 'In her womb was the grace of divinity, in her heart the grace of charity, upon her lips the grace of courtesy, in her hands the grace of mercy and generosity. And she was truly full of grace, for of her fulness captives have received redemption, the sick their cure, the sorrowful their comfort, and sinners their pardon; the just have received grace, the angels joy, and the Blessed Trinity glory and honour, and the Son of Man the substance of human flesh.'

Of the angel's words, *the Lord is with thee*, Bernard says: 'God the Father is with thee, Who engendered Him Whom thou conceivest; God the Holy Ghost is with thee, of Whom thou conceivest;

God the Son is with thee, Whom thou clothest and surroundest with thy flesh.' And again he says: 'Blessed art thou among women, that is, above all women, because thou shalt be a virgin mother, and God's mother.' For women lay under a threefold curse: shame for those who conceived not, whence Rachel said: 'God hath taken away my reproach'; the curse of sin for those who conceived, whence the Psalm says: 'Behold I was conceived in iniquities, and in sins did my mother conceive me'; and the curse of pain for those who brought forth children, whence Genesis says, 'In sorrow shalt thou bring forth children.' And Mary alone of all women is blessed, because she is virgin and fruitful, she conceives in holiness, and gives birth without pain.

And when Mary heard the angel's words, she was troubled at the saying, and thought with herself what manner of salutation this should be. Let us note that she was troubled at the words of the angel, and not at the sight of him; for the Blessed Virgin had often seen the angels, but had not ever heard them speak such things as these. And then the angel comforted her, saying: 'Fear not, Mary, for thou hast found grace with God. Behold thou shalt bring forth a Son, and thou shalt call his name Jesus (that is, Saviour), for He shall save His people from their sins. He shall be great, and shall be called the Son of the Most High.' This, according to Bernard, means that He, who is great God, shall be great, namely a great man, a great teacher, a great prophet. Then Mary said to the angel: 'How shall this be done, because I know not man?' By this she meant that she had made a vow never to have knowledge of man. And the angel answering, said to her: 'The Holy Ghost shall come upon thee, and the power of the most High shall overshadow thee.' By this is meant that the Holy Ghost would cause her to conceive; and this was to be for four reasons. The first is that the eminent charity of God might be made manifest, since by the ineffable love of God the Word of God was to be made flesh; for as we read in the Gospel of Saint John, 'God so loved the world as to give His only-begotten Son, that whosoever believeth in Him may not perish, but may have life everlasting.' And this reason is given by the Master of the Sentences. The second reason is that by the angel's words it might be evident that the Holy Ghost's conceiving proceeded from grace alone, not being preceded by any human merit: and this reason is given by Saint Augustine. The third reason is that the sole power of God wrought the conception, as Saint Ambrose says. The fourth reason is the motive of the conception; for, as Hugh of Saint Victor writes, 'The motive for a conception according to nature is the love of a

man for a woman and of a woman for a man. And therefore since a singular love of the Holy Spirit burned in the Virgin's heart, the love of the Holy Spirit wrought great things in her flesh.' And of the words, *the power of the most High shall overshadow thee*, the *Gloss* says: 'A shadow is formed by light falling upon a body. The Virgin, as a human being, could not hold the fullness of divinity; but the power of the most High overshadowed her, while the incorporeal light of the godhead took a human body within her, and so she was able to bear God.'

Then the angel added: 'And behold thy cousin Elizabeth, she also hath conceived a son in her old age; and this is the sixth month with her that is called barren.' And this he said, according to Saint Bernard, in order that the young maiden, hearing that her aged cousin was with child, might take thought to go and visit Elizabeth, and thus occasion be given to the unborn prophet to do honour to his Lord, and to the miracle of his conception another yet more wondrous be added.

And here, Saint Bernard adds: 'O Virgin, make haste to give thine answer! Answer a word and receive the Word, utter thine own word and receive the Word of God, pronounce a word that shall pass and embrace a Word that shall not pass, arise, run, be opened! Arise by faith, run by devotion, be opened by thy consent!' And then Mary, extending her hands and raising her eyes to Heaven, said: 'Behold the handmaid of the Lord; be it done to me according to thy word!' And at once the Son of God was conceived in her womb, perfect God and perfect man; and on the first day of His conception was in Him as much of wisdom and of power as there would be when He was thirty years old. Then rising up, she went into the hill country to visit Elizabeth; and when she saluted her cousin, the infant Saint John leaped with joy in his mother's womb. Of this the *Gloss* says: 'Since he could not manifest his joy with his tongue, he greeted the Lord with joyous heart, and so began his mission as precursor.'

A rich and noble soldier had renounced the world and entered the Cistercian Order. But he was so unlettered that the monks, ashamed of his ignorance, set a teacher to give him lessons. But the lessons were of no avail: he could learn nothing save the two words, *Ave Maria*, which he went about repeating all day long. When he died, and was buried with the other brethren, it came to pass that over his tomb there grew a lovely lily, on each of whose petals were inscribed in letters of gold the words *Ave Maria*. Deeply stirred by this great miracle, the monks cleared the earth from the grave, and saw that the roots of the lily sprang from the dead man's mouth. Thus

they understood the great devotion with which he had pronounced these words.

A highwayman had built a stronghold beside a road, and robbed without mercy all that passed by; but every day he recited the Hail Mary, and allowed nothing to prevent him from so doing. One day a saintly monk came down the road, and the brigand's men made ready to rob him: but the holy man asked to be brought to their leader, saying that he had a secret for him. He was led into the chief's presence, and besought him to call together all that dwelt in the fortress, that he might preach the word of God to them. But when they were gathered together, the monk said: 'You are not all here! There is someone missing!' And when he was told that no one was absent, he persisted: 'Look well, and you will see that someone is missing!' Then one of the brigands cried out: 'Sure enough, one of the varlets is absent!' 'Yes,' said the monk, 'and he is the very one for whom I am looking!' They therefore went in search of him; but when he came within sight of the man of God, he rolled his eyes in fright, threw himself about like a madman, and refused to come nearer. And the holy man said to him: 'In the name of Our Lord Jesus Christ, I adjure thee to say who thou art and why thou art come here!' The varlet made answer: 'Since I am forced to speak, know that I am not a man, but a demon, and I have lived at this brigand's side for fourteen years. Our master sent me to lie in wait when he would neglect to recite the Hail Mary; for on that day he would have fallen to us, and I was ordered to throttle him on the spot. Nothing but this daily prayer kept him from falling into our power. But I spied upon him in vain, for not once did he fail to recite it!' Hearing this, the robber was dumbfounded: and he threw himself at the feet of the man of God, begged his pardon, and was thenceforth converted to a better life.

The Nativity of the Blessed Virgin Mary

SEPTEMBER 8

The glorious Virgin Mary took her origin from the tribe of Juda and from the royal house of David. Matthew and Luke did not set down the generation of Mary, but that of Joseph, who, however, did not beget Christ; because the usage of the sacred writers was to describe the descendance of males, not that of females. Nonetheless it is most certain that the Blessed Virgin sprang from the family of David, as is manifest from this, that the Scriptures many times attest

that Christ was of the seed of David. But since Christ was born of a virgin mother, it is apparent that the Virgin herself was born of David's line, through his son Nathan. For among the sons of David were Nathan and Solomon. Of the line of Nathan, as John Damascenus affirms, Levi begat Melchi and Panthar, Panthar begat Barpanthar, Barpanthar begat Joachim, and Joachim begat the Virgin Mary. Mathan had a wife of the line of Solomon, of whom he begat Jacob. When Mathan died, Melchi of the tribe of Nathan, the son of Levi and the brother of Panthar, took the dead man's wife, who was the mother of Jacob, and of her begat Heli. Thus Jacob and Heli were blood brothers, Jacob being of the tribe of Solomon and Heli of the tribe of Nathan. Heli of the tribe of Nathan died without issue, and Jacob of the tribe of Solomon took his brother's wife, and raised up seed to his brother, begetting Joseph. Thus Joseph is by birth the son of Jacob and the descendant of Solomon, but according to the Law the son of Heli, and of the line of Nathan; for the Law considered such issue as being of the defunct brother. Thus Damascenus.

We read in the *Ecclesiastical History* and in Bede's *Chronicle* that all the genealogical books of the Hebrews and of foreigners among the Jews were guarded in the Temple, but that Herod ordered them to be burnt, thinking that he could pretend to noble birth if, in the absence of proof, it was believed that he was descended from Israel. But some of Our Lord's kinsmen, who were Nazarenes, sought out the order of Christ's generation as best they might, partly from the memories of their elders, and partly from certain books which they had kept at home.

Joachim, then, took to wife a woman called Anna, who had a sister named Ismeria. This Ismeria begat Elizabeth and Eliud, and Elizabeth in turn was the mother of John the Baptist. Of Eliud was born Eminen, and of Eminen came Saint Servatius, whose body is preserved in the town of Maastricht, in the diocese of Liége. Anna is said to have had three husbands, namely Joachim, Cleophas, and Salome. Of Joachim she begat one daughter, namely Mary the mother of the Lord, whom they gave in marriage to Joseph. At Joachim's death Anna became the wife of Cleophas, the brother of Joseph, and had of him another daughter, also called Mary, who was later given in marriage to Alpheus, and was the mother of four sons, namely James the Less, Joseph the Just (also called Barsabas), Simon, and Jude. When her second husband died, Anna took a third, namely Salome, of whom she had a third daughter, again called Mary, and given in marriage to Zebedee. This Mary bore two sons to Zebedee,

namely James the Greater and John the Evangelist. All this is set forth in the following verse:

Anna it is said conceived three Marys,
By husbands named Joachim, Cleophas and Salome.
These took as husbands Joseph, Alpheus and Zebedee.
The first gave birth to Christ, the second bore James the Less,
And Joseph the Just as well as Simon and Jude,
The third James the Greater and the winged John.*

Nor need we wonder that Mary was kin to Elizabeth, as we have said above. Elizabeth was the wife of Zachary, who was of the tribe of Levi. Now the Law prescribed that every man should take a wife from his own tribe and family; yet Luke affirms that Elizabeth was of the daughters of Aaron, while Jerome says that Anna was of Bethlehem, which was in the land of Juda. But we may note that both Aaron and Jojada the high priest took wives of the tribe of Juda, whence it is proven that the priestly tribe and the royal tribe were always conjoined by ties of blood. This kinship, as Bede says, could also have arisen at a later time, women being given in marriage from tribe to tribe, so that it would be manifest that Mary, who issued from the royal tribe, had bonds of kinship with the priestly tribe. And so it was that the Blessed Mary was descended of both tribes. The Lord willed that these two privileged tribes should have a symbolic relationship; for of them Christ was to be born, Who, being truly King and Priest, would offer Himself for us, and would rule His faithful subjects while they strove amidst the evils of this life, and would crown them after the victory. This is likewise suggested by the name of Christ, which means anointed, because in the Old Law only priests and kings and prophets were anointed; whence we also are named Christians, and are called a chosen generation and a kingly priesthood.

Saint Jerome tells us in his *Prologue* that in his early youth he read the history of the nativity of the Blessed Virgin in a certain little book, and wrote it down as he remembered it, after a long passage of time. He relates therefore that Joachim, who was of Galilee and of the town of Nazareth, took to wife Saint Anna of Bethlehem. Both were just, and walked without reproach in all the commandments of the Lord. They divided all their substance in three parts, allotting one part to the Temple and its ministers, and another to the poor and the pilgrims, reserving the third part to themselves and the uses of their household. Thus they lived for twenty years, and had no issue of their wedlock; and they made a vow to the Lord that if

* Translated from the original Latin [Ed.].

He granted them offspring, they would dedicate it to the service of God. For this they went to Jerusalem to celebrate the three principal feasts of each year. And once, when Joachim and his kinsmen went up to Jerusalem at the feast of the Dedication, he approached the altar with them, in order to offer his sacrifice. A priest saw him, and angrily drove him away, upbraiding him for daring to draw near the altar of God, and calling it unseemly that one who lay under the curse of the Law should offer sacrifice to the Lord of the Law, or that a childless man, who gave no increase to the people of God, should stand among men who bore sons. At this Joachim was covered with confusion, and was ashamed to return to his home, lest he have to bear the contempt of his kindred, who had heard all. He went off therefore and dwelt for some time among his shepherds. But one day when he was alone, an angel appeared to him, surrounded with dazzling light. He was affrighted at the vision, but the angel bade him be without fear, saying: 'I the Lord's angel, am sent to thee, to announce to thee that thy prayers are granted, and thine almsworks have ascended in the sight of the Lord. I have seen thy shame, and heard the reproach of barrenness wrongfully cast upon thee. For God indeed punishes not nature, but sin; and therefore, when He closes a womb, it is only that He may later open it more wondrously, and that all may know that what is born thereof is not the fruit of lust, but of the divine munificence. Did not Sara, the first mother of your race, bear the shame of barrenness until her ninetieth year, and yet bear Isaac, to whom was promised the blessing of all nations? Did not Rachel also long remain barren, and yet beget Joseph, who was the ruler of all of Egypt? Who was stronger than Samson or holier than Samuel? Yet both of these were the sons of barren mothers! Therefore believe my words and these examples: those conceived after long delay, and begotten of sterile mothers, are wont to be the more admirable! Thus Anna thy wife will bear thee a daughter, and thou shalt call her name Mary. In accordance with your vow, she shall be consecrated to the Lord from her infancy, and shall be filled with the Holy Spirit from her mother's womb; nor shall she abide without, among the common folk, but within the Temple of the Lord, lest aught of evil be thought of her. And as she will be born of a barren mother, so will she herself, in wondrous wise, beget the Son of the Most High, Whose name will be called Jesus, and through Whom salvation will come to all nations! And this will be a sign to thee: when thou shalt come to the Golden Gate of Jerusalem, Anna thy wife will meet thee there, who now grieves at thy tarrying, and then will rejoice to see thee!' And with these words the angel left him.

Meanwhile Anna wept bitterly, not knowing where her husband had gone. Then the same angel appeared to her, and revealed to her the same things which he had announced to Joachim, adding that as a sign she was to go to the Golden Gate of Jerusalem, to meet her husband at his return. Thus it was that, following the angel's command, they came face to face, and shared their joy over the vision which they had both seen, and over the certainty that they were to have offspring. Then they adored God and set out for their home, awaiting the Lord's promise in gladness of heart. And Anna conceived and bore a girl child, and called her name Mary.

When the Blessed Virgin was three years old, and was weaned from the breast, her parents brought her with gifts to the Temple of the Lord. Around the Temple there were fifteen steps, one for each of the fifteen gradual Psalms; for, since the Temple was built upon a hill, one could not go up to the altar of holocaust from without except by the steps. And the Virgin, being placed upon the lowest of these steps, mounted all of them without the help of anyone, as if she had already reached the fulness of her age.

When they had made their offering, Joachim and Anna left the child with the other virgins in the Temple, and returned to their home. And Mary advanced in every virtue, and daily was visited by the angels, and enjoyed the vision of God. In a letter to Chromatius and Heliodorus, Jerome says that the Blessed Virgin had set for herself the following rule: from dawn to the third hour she devoted herself to prayer, from the third to the ninth hour she worked at weaving, and from the ninth hour she prayed until an angel appeared, bringing her food.

When she had come to her fourteenth year, the high priest announced to all that the virgins who were reared in the Temple, and who had reached the age of their womanhood, should return to their own, and be given in lawful marriage. The rest obeyed the command, and Mary alone answered that this she could not do, both because her parents had dedicated her to the service of the Lord, and because she herself had vowed her virginity to God. The High Priest was perplexed at this, because on the one hand he could not forbid the fulfilment of a vow, since the Scripture said: 'Vow ye, and pay to the Lord your God'; and on the other, he dared not admit a practice which was unwonted in the Jewish nation. When the elders were consulted at the next feast of the Jews, all were of opinion that in so doubtful a matter they should seek counsel of the Lord. They all therefore joined in prayer; and when the high priest went in to take counsel with God, a voice came forth from the oratory for all to hear, and said that of all the marriageable men of

the house of David who had not yet taken a wife, each should bring a branch and lay it upon the altar, that one of the branches would burst into flower and upon it the Holy Ghost would come to rest in the form of a dove, according to the prophecy of Isaias, and that he to whom this branch belonged would be the one to whom the virgin should be espoused. Joseph was among the men who came: but to him it seemed not fitting that a man of his years should take so young a maid to wife, so that when all the others placed branches upon the altar, he alone left none. Thus nothing such as the voice of God had predicted took place, wherefore the high priest again took counsel with the Lord, Who said that he alone to whom the Virgin should be espoused, had not brought his branch. Being thus discovered, Joseph placed a branch upon the altar, and straightway it burst into bloom, and a dove came from Heaven and perched at its summit; whereby it was manifest to all that the Virgin was to become the spouse of Joseph. And when the espousals were completed, Joseph went back to his city of Bethlehem to make ready his house, and to dispose all that was needful for the wedding. Mary, however, retired to her parents' house in Nazareth, with seven virgins of her age who had been nurtured with her, and whom the high priest had given to her as companions because of the miracle. And it was in those days that the angel Gabriel appeared to her as she knelt in prayer, and announced to her that she was to give birth to the Son of God.

For a long time the date of the nativity of the Blessed Virgin was unknown to the faithful. Then, as John Beleth relates, it happened that a certain holy man, who devoted himself diligently to contemplation, each year on the eighth day of September heard the voices of the most joyous company of the angels, raised in solemn song. He therefore most piously implored God to reveal to him the reason of his hearing this on that day alone and on no other: and he received answer that on that day the glorious Virgin Mary had been born into the world, and that he should make this known to the children of the Holy Church, that they might join with the heavenly court in celebrating her nativity. When he had imparted this to the pope and to others, and they had fasted and prayed, and searched through the Scriptures and the testimonies of ancient times, and discovered his revelation to be true, they decreed that this day should be solemnized throughout the world in honour of the nativity of the Virgin.

The octave of the feast was not celebrated in times past, but was instituted by Innocent IV, who was by birth a Genoese. This came about for the following reason. When death took Gregory IX

from their midst, the Romans shut all the cardinals in a locked chamber, or conclave, that they might the more speedily choose a successor. For several days they were unable to reach an accord, wherefore the Romans beset them with all sorts of vexations. The cardinals then made a vow to the Queen of Heaven, that if by her merits they arrived at an agreement and were allowed to depart in peace, they would prescribe the celebration of the octave of her nativity, which had been neglected until that time. Thus they came to agree upon Pope Celestine, and were set free. But Celestine lived but a short time, and it was his successor Pope Innocent who fulfilled the vow.

We may note also that the Church solemnizes three birthdays, namely the Nativities of Christ, of holy Mary, and of Saint John the Baptist, and these three are symbols of three spiritual births. For we are reborn in water with John, in penance with Mary, and in glory with Christ. Of these three feasts only those of Christ and the Baptist have vigils, because contrition must precede the rebirths of baptism and glory, at least in adults, whereas penance is itself a vigil, and therefore the feast of our rebirth in penance needs no vigil. All three, however, have octaves, in imitation of the octave of the Resurrection.

A soldier who was mighty in war, and not less devoted to the Blessed Mary, was on his way to a tourney, but stopped at a wayside monastery of the Blessed Virgin, that he might hear Mass in her honour. Mass followed Mass, and he would forego none of them, for the honour of Mary, until at last he came out, and hastened with all speed toward the site of the tourney. And as he drew nigh, those who were leaving the tourney came abreast of him, and applauded him loudly for that he had jousted with such valour; and all who were there proclaimed this, and some, who said that he had taken them captive, came and offered themselves to him. Weighing all this in his mind, the soldier discerned that the courteous Queen had done him a courteous honour; and he revealed what had befallen, went back to the monastery, and thereafter soldiered for the Virgin's Son.

A certain bishop, who held the Blessed Mary in the highest reverence and devotion, once set out toward a church of the Virgin in the middle of the night, to pray to her. And as he approached, the Virgin of virgins, accompanied by the whole choir of virgins, came to meet him, tendered him every honour, and led him to the church whither he was going. Two of their number went before, intoning:

Let us sing to the Lord, companions, let us sing to honor Him,

The love of sweet Christ resounds on pious lips.*
Then the whole company of virgins took up these verses, and the first two continued with the following:

The first proud one was cast down to the depths by the great light,
Thus was the first man cast down to the depths when he became proud.*

Thus they led the man of God in procession to the church, the first two virgins intoning, the rest repeating the verses after them.

A certain woman who was bereaved of the comfort of her husband had an only son, whom she loved most tenderly. This son was captured by the enemy, chained, and thrown into prison. Learning of this, the woman wept inconsolably, and besieged the Blessed Virgin, to whom she was much devoted, with instant prayers for the deliverance of her son. But at length, seeing that her prayers profited nothing, she went alone into a church where there was a sculpted image of the Blessed Mary, and standing before the image she addressed it as follows: 'O Blessed Virgin, oft have I besought thee for the deliverance of my son, and as yet thou hast not come to my aid, forlorn mother that I am! I implore thy patronage for my son, and until now discover no fruit of my prayers! Therefore, as my son has been taken away, so also I shall take away thy Son from thee, and shall hold Him as a hostage for mine own!' Thereupon she drew nearer, and took up the image of the Child which the Virgin held in her lap; and returning to her house, she swathed the image in a spotless cloth, hid it in a cupboard which she locked with the utmost care, and guarded it well, rejoicing that she had so good a hostage for her son. And in the following night the Blessed Virgin appeared to the youth, and opened the door of the gaol and set him free, saying: 'Say to thy mother, son, that she restore my Son to me, now that I have restored hers to her!' And he went out of the prison, and came to his mother, and told her how the Blessed Virgin had set him at liberty. Overjoyed, she took the image of the Child, and going to the church she gave back her Son to Mary, saying: 'Thanks be to thee, Lady, for that thou hast returned my only son to me; and now I do the same for thee!'

There was once a thief who committed many robberies, but who nonetheless held the Blessed Mary in great reverence, and saluted her with frequent prayers. Once, while engaged in a theft, he was taken captive and sentenced to be hanged. But as soon as they hanged him, the Blessed Virgin appeared, and, as it seemed to him,

* Translated from the original Latin [Ed.].

bore him up with her hands for three days, so that he suffered no injury. Then those who had hanged him chanced to pass that way, and found him alive and cheerful of countenance. Thinking that the halter was not attached tightly enough, they set out to cut his throat with a sword; but the Blessed Mary warded off the blow with her hand, and they strove in vain to harm him. When they learned of him that Mary was aiding him in this wise, they were filled with wonderment, and took him down and set him free, for the love of the Virgin. And the thief went off and entered a monastery, and persevered in the service of the Mother of God as long as he lived.

There was a certain clerk, who loved the Blessed Mary devotedly, and was ever careful to recite her Hours. When his parents died, having no other heir, they left all their possessions to him. His friends therefore prevailed with him to take a wife and to manage his own inheritance. When the appointed day came, and he was on his way to the nuptials, he came upon a church by the road. He took thought of the service of the Blessed Virgin, entered the church, and was beginning to say her Hours when Mary herself appeared, and with a stern air said to him: 'O foolish and faithless, why dost thou abandon me, thy friend and spouse, and prefer another woman before me?' Filled with compunction at these words, the clerk rejoined his companions, and, concealing what had befallen, proceeded with the wedding; but in the middle of the night he left all, fled from his home, and entered a monastery, where he lived piously in the service of the Blessed Mary.

A certain parish priest, a man of upright life, knew no other Mass than the Mass of the Blessed Virgin, which he constantly chanted in her honour. Being accused thereof to the bishop, he was forthwith arraigned before him. When he avowed that he knew no other Mass, the bishop harshly upbraided him as an impostor, suspended him from his cure, and forbade him to chant the said Mass thereafter. The following night the Blessed Mary appeared to the bishop, belaboured him with reproaches, and demanded the reason of his ill treatment of her servant; and she further said that the bishop would die within thirty days, unless he restored the priest to his office. All atremble, the bishop summoned the priest and begged his forgiveness, commanding him to celebrate no other Mass than that of the Blessed Virgin.

There was a certain clerk, who, albeit he was given to worldliness and debauchery, nonetheless had an exceeding love for the Mother of God, and recited her holy Hours promptly and devoutly. One night, in a vision, he saw himself standing before the judgement seat of God, and heard the Lord saying to those who were

near: 'Do you decide what judgment this man deserves, who now stands looking upon you; for long have I borne with him, and I have yet to find any sign of amendment in him!' Then, with the approval of all, the Lord pronounced sentence of damnation upon him. But at that moment the Blessed Virgin arose and said to her Son: 'For this man, beloved Son, I beseech Thy clemency, that Thou mayest soften Thy sentence of damnation! Let him have life as a favour to me, though according to his own deserts he should be condemned to eternal death!' And the Lord answered: 'Because of thy pleadings I grant him pardon, if only he reform his life henceforth!' Turning to the man, the Virgin said: 'Go and sin no more, lest worse befall thee!' And when he awoke, he changed his way of life, and entered a monastery, where he finished his days in good works.

Bishop Fulbert of Chartres relates that in the year 537 there was in Sicily a man named Theophilus, who was the vicar of a certain bishop; and so prudently did he manage the affairs of the Church, that when the bishop died the whole populace proclaimed Theophilus worthy to succeed him. But he was content with his office, and desired rather that another be made bishop. But soon afterward, the new bishop dismissed Theophilus, who thereupon fell into such choler that, in order to recover his dignities, he sought the assistance of a certain Jewish sorcerer. The Jew therefore summoned the Devil, who appeared with all speed. At the Devil's command, Theophilus renounced Christ and His mother, forswore the Christian faith, and wrote down his abjuration in his own blood, sealing the paper with his ring, and giving it to the demon. Thus he gave himself over to the service of the Devil. On the morrow, by Satan's machinations, Theophilus was taken back into the bishop's favour, and restored to his honourable post. But at length, returning to himself, he bitterly lamented what he had done, and with all the devotion of his soul had recourse to the glorious Virgin, that she might come to his aid. Some time later, therefore, the Blessed Mary, appearing to him in a vision, rebuked him for his impiety, and commanded him to renounce the Devil, and to profess Christ the Son of God and the whole Christian faith. Thus she restored him to her favour and to the grace of her Son; and in token of his pardon she appeared to him again, and returned to him the paper which he had given to the Devil, placing it upon his breast, that he might no longer fear the bondage of Satan, and might rejoice at his deliverance by the Virgin. Receiving this, Theophilus was filled with joy, and recounted all that had taken place, before the bishop and all the people. They too were moved to admiration, and gave praise to the

glorious Virgin; and Theophilus, after three days, departed this life in peace.

A man and his wife gave their only daughter in marriage to a certain young man, and for the love of their daughter received her husband into their own house; and the girl's mother dealt with her son-in-law as kindly as if he were her own son. Meanwhile certain people of evil mind began to say that she did this not for her daughter's sake, but because she was trying to take her daughter's place in the young man's affections. The falsehood so afflicted the woman's spirit that, fearing lest it become common gossip, she promised twenty sols to two peasants, if they would secretly throttle her son-in-law. One day therefore, she hid them in the cellar, sent her husband somewhere on business, and hurried her daughter out of the house. Then, at her bidding, the young man went to the cellar to fetch wine, and quickly was strangled by the two miscreants. At once the mother-in-law laid him in her daughter's bed, and covered him with the bed-clothes as if he were asleep. When her husband and her daughter returned and sat down at the table, the woman ordered the girl to go and awaken her husband, and call him to his repast. And when she found him dead, and cried out the news, the household was overcome with grief, and the murdress feigned sorrow, and wept with the rest. But at length she repented her crime exceedingly, and confessed all to a priest. Some time later a dispute arose between the woman and the priest, and he accused her publicly of the murder of her son-in-law. When this came to the knowledge of the young man's parents, the woman was haled before the judge, and he condemned her to be burnt alive. Knowing therefore that her end was nigh, she turned for help to the Blessed Virgin; and going into her church, she prostrated herself, praying and weeping. After a little time she was dragged forth and thrown into a great fire; and all were astonished to see her standing therein, safe and unscathed. At this the youth's kinsmen deemed the fire too small, and hastily gathering faggots, they threw them into the flames; and seeing that this likewise failed to harm the woman, they attacked her with lances and spears. The judge, however, was dumbfounded at the sight, and restrained them from assailing her further. Then, examining her with care, he found no marks of the flames, but only the wounds of the lances. Her kinsfolk therefore carried her to her house, and restored her with baths and poultices. But God willed not that she should longer suffer disgrace and suspicion; wherefore, after she had lived three days, still persevering in the praise of the Virgin, He called her to Himself.

RIZIERI ZANOCCO,

The Annunciation at the Arena of Padua,
1305–1309—[1937]¹²

The sacred representation of the mystery of the Annunciation at the Arena of Padua is too well known in the history of Italian liturgical drama for me to treat it here, even though the present Jubilee Year reminds us of those distant spectacles of faith and piety.

What I cannot ignore, though, are the documents which came into my hands when I least expected it and which I have cause to believe escaped the notice of even the most penetrating researchers who had the opportunity to inspect the Register of Expenses of the Great Sacristy of the Cathedral of Padua. The documents are therefore unpublished.

I must preface this immediately by saying that I do not think it is a matter of such import that it will change substantially what has been gathered thus far, but it ought to modify to some extent the dates and conclusions.

It is generally admitted that the Feast of the Annunciation at the Arena began on March 25, 1306, during the podesteria of Poncino dei Picenardi of Cremona, according to the affirmation of the so-called Codex of Zabarella, and that on that day the celebrated frescoes of Giotto were, so to speak, inaugurated.

Moschetti of the Museo Civico of Padua, basing his conclusions on a deliberation of the Great Council of Venice, which is said to have given the hangings of the church of San Marco to Enrico degli Scrovegni on the 16th of March, 1305, so that the intended consecration of the church of the Arena, planned at that time, would assume greater dignity, thought that the Feast of the Annunciation took place in 1305 and not in 1306.

There were some who pointed out to him that that deliberation had been annulled by the Chancellor himself, by order of the Great Council, and that therefore there was no necessity to give up the traditional date.

Bruno Brunelli, in his very accurate "I Teatri di Padova," not only reaffirms the date of the Codex Zabarella, but he also shows the error of the authors of the past who attributed the first mystery play of the Arena to the year 1278. He shows this could not have been the date

¹² "L'Annunciazione all'Arena di Padova (1305–1309)," *Rivista d'arte*, XIX (1937), pp. 370–373.

reported by the Codex of Carrara and later by the Reformed Statutes of 1420, which definitively institute the Feast of the Annunciation on the 25th of March, or any other day determined by the Bishop.

Now without wanting to pronounce myself decisively in favor of the date 1306 or of the earlier origin of the mystery, that is, 1278, I would like to observe only that the following is written in the scrolls of parchment or paper of the Sacristy which are in the Archives of the Chapter of the Cathedral of Padua:

Expense sacristie facte post racionem factam in Capitulo sub millesimo trecentesimo quinto, indictione tertia, die mercurii vigessimo quarto marcii.	Expenses incurred by the sacristy after due discussion in the Chapter in the year 1305, third indiction, Wednesday, the 24th of March.
Item grossos venetos sex pro hastis XII emptis pro paliis portandis in festo annunciationis beate marie quando factum fuit officium angeli et marie ad arenam.	Item: six large *venetos* in order to purchase poles for the standards to be shouldered in the Feast of the Annunciation of the Blessed Mary when the ceremony of the angel and Mary was given at the Arena.

Therefore, since the notebook or parchment scroll bears the date 1305, third indiction, it is certain that the day following the discussion at the Chapter was precisely the 25th of March when the ceremony of the angel and Mary was given at the Arena.*

Therefore, even the church was in service in 1305.

It is true that here the play is called *officium*, but this is all the more reason for thinking it took place in the church and that, therefore,

* To those who might think that the *only expenses* belong to March 1305, while in reality the Feast took place in March 1306, I will point out that the expenses relative to the Feast of the Arena *precede* those of April of the same year, 1305, and therefore the Feast had actually to take place in March 1305.

I would like to point out to Brunelli that it is not the Reformed Statutes of 1420 which definitively institute the Feast of the Arena, because it was performed perfectly in 1305, as those statutes report. Therefore, the relative statute must have been made on *the occasion of* the Feast itself because I find there from 1307 the *broderii*, that is, the soldiers of the Podestà. Signor Gloria also arrives at this conclusion.

This does not mean that the date of the Feast at the Arena could not be much earlier, and could, in fact, even have given Scrovegni the inspiration for the name to give to his new church.

the church must have been finished in 1305, including the frescoes. But the expenses continue.

Item solidos octo pro spazatura ecclesie et claustri pro dicto festo annunciationis beate marie.

Item: eight *solidos* for the sweeping of the church and the cloister for the aforementioned Feast of the Annunciation of the Blessed Mary.

Item solidos XII denariorum parvorum causa faciendi depingi duas de predictis hastis pro portandis crucibus quando necesse est.

Item: 12 *solidos* of the small money for the purpose of having two of the aforementioned poles painted so that they can be used for carrying crucifixes when necessary.

Item solidos tres denariorum parvorum pro brocetis et cordonibus ad ornandum custodias angeli et marie pro predicto festo annunciationis.

Item: three *solidos* of the small money for the tassels and brocade to decorate the chairs of the angel and Mary in the aforementioned Feast of the Annunciation.

Item grossos venetos duos hiis qui portaverunt cruces nostras et reportaverunt ab ecclesia nostra cum processione ad arenam et e converso pro dicto festo annunciationis.

Item: two large *venetos* for those who carry our crucifixes and who carried them from our church in procession to the Arena and back again, for the aforementioned Feast of the Annunciation.

Item solidos tres parvorum causa faciendi toaleas lineas et sericas paliis et frixis, que toalee desute fuerunt a palliis et frixis ad hornandum dictas catedras angeli et marie.

Item: three small *solidos* in order to have made hangings of linen and silk for the standards and banners, which hangings were removed from the standards to decorate the thrones of the angel and Mary.

Item grossum unum pro ampullis ab altaribus.

Item: one *grossum* for the ampullae for the altars.

Even admitting that some of these expenses could pertain to the Feast of the Annunciation celebrated in the Cathedral, it is all too clear that the rest of them pertain to the Feast celebrated at the Arena, that one went there in procession from the Cathedral, that it is speaking of the chairs of the Madonna and the angel and that we see in this

neither more nor less than the ceremony fixed in 1420 by the Reformed Statutes.

I pass over the expenses incurred in 1307, in which they speak about a *rema longa* [a long pole], about *negotiis pro dicto officio ad adornandos pueros* [arrangements for adorning the boys for the aforementioned ceremony], about *hastis pro portandis paliis scolarium et pro ipsis aptandis* [standards to be borne on the shoulders of students and for adapting these], about *fustibus octo emptis, de fune pro ligandis stangis ad catedras marie et angeli* [the purchase of eight rods and of rope for tying the bars to the chairs of Mary and the angel], about *ferris necessarius ad stangas longas que posite fuerunt circa Mariam et Angelum* [the implements necessary for the long bars which were placed around Mary and the angel], in order to come to a detail noted, among other times, in the year 1309.

This says, in fact:

Item pro expensis factis pro festo marie et angeli quando fit festum annunciationis ad harenam libras XII, solidos novem et denarios quatuor, de quibus dominus henricus debet solvere libras sex et dimidium ut ipse promisit, nam predicte expense per ordinem sunt scripte super quodam folio bombacino.	Item: for the expenses incurred for the feast of Mary and the angel, when the Feast of the Annunciation is performed at the Arena, 12 *libras*, nine *solidos* and four *denarios*, of which Lord Enrico must pay six and a half *libras*, as he promised, of the aforementioned expenses which are listed in order on a certain rice-paper folio.

Therefore, the expenses for the mystery play of the Arena were divided between the Sacristy of the Cathedral and Enrico Scrovegni and they were kept in a rice-paper notebook. This is a detail which demonstrates the existence of this record at Padua long before it shows up in the city chronicles.

To conclude I will say that having proven the existence of the performance at the Arena in 1305, the question arises as to whether the Arena might not have been used to present the Mystery of the Annunciation even before Scrovegni built his church, and more precisely in 1278 as the authors who wrote about it in the past would have it since, in 1305, when they speak about the acquisition of poles, etc., there is no indication of anything new, unusual or extraordinary, but instead they speak of expenses incurred when *factum fuit officium angeli et marie ad arenam* [the ceremony of the angel and Mary was performed at the Arena], as if to justify the expenses incurred in

carrying the standards in the Feast of the Annunciation of the Madonna.

But I do not want to read too much into the documents and I will wait until I can strengthen the argument with further research.

I will close by noting that it is pleasant to think of Giotto as being present at the Feast of 1305 and being the object of warm demonstrations by the magnates, the clergy and the populace.

Was Dante there also?

How one wishes he too had been present!

CRITICAL ESSAYS

RICHARD OFFNER,
Giotto, Non-Giotto*

Part 1

The 1937 exhibition in Florence[1] held in Giotto's memory has served to raise the problem of this master to a peak of interest, from which a less distorted view of the artistic panorama and of Giotto's place in it should have been possible. That the prevalent notion of Giotto has wanted revising may be gathered from the conflicting attributions made to him, but chiefly from the recent revival of two, as of crucial importance—the St. Francis cycle in Assisi[2] and the Sta. Maria Novella Cross. It is with these two that I shall concern myself here. The imputation of these works to Giotto arises in a misconception of the structure of Florentine evolution in the fourteenth century encouraged by early sources[3] in themselves open to question; but above all in

* *The Burlington Magazine*, LXXIV, 1939, pp. 259–268; LXXV, 1939, pp. 96–113.

[1] This exhibition, the most important ever held for the completeness of pre-and-post Giottesque examples, brought together works scattered over many churches and galleries under a daylight never known to have entered the places for which these works had been painted. The shock of actually seeing them has in cases proved too great to insure sound judgment.

[2] The vast array of literature which learnedly champions Giotto's share in the St. Francis cycle has in recent years frequently prejudiced its conclusions by a touching wishfulness to attribute the cycle to a well-known master. In view of this, RINTELEN's merit in first demonstrating the impossibility of the attribution becomes considerable.

[3] The modern attribution of the paintings of the St. Francis cycle in the Upper Church at Assisi to Giotto reposes upon the authority of Riccobaldo da Ferrara, who in one of his three chronicles which runs to 1313, among other items dated about 1305, states broadly that Giotto painted in Ecclesiis Minorum Assisii. Sanguine partisans of this belief have been quibbling over Ghiberti's notorious ellipsis "Dipinse nella chiesa d'Asciesi nell' ordine dei frati minori quasi tutta la parte di sotto" as if it were an oracular equivocation. But Ghiberti, in speaking of the two churches as one, could by the closing phrase have meant only the Lower Church. As for his sweeping inclusiveness, so large a portion of the Lower Church was covered with

an inadequate reading of the works themselves on the part of writers
who, urged on by the irrelevant force of usage or patriotism, have been
taking too much for granted.[4] Hence, while their ardour is fierce, their
arguments are feeble. They have dug up the corpses, but have shrunk
from the uneasy task of unshrouding them.

In pursuing this enquiry, it is well to recall at the outset that the
artistic identity of Giotto rests securely upon uninterrupted and un-
disputed tradition of his artistic supremacy, which agrees with a

Giottesque frescoes, the statement is, for a Florentine particularly, a con-
donable hyperbole. Nevertheless from Pius II onwards literary tradition
(Vasari in his second edition only) attributes the St. Francis cycle to Giotto.

While a number of earlier writers, one (Padre della Valle, 1791) as far
back as the eighteenth century, see discrepancies between the different
scenes in the cycle, none seems to entertain doubts of Giotto's leading share
in their painting before RUMOHR, who in his *Italienische Forschungen*
[1827] attributes them to Spinello and his son. They have since been
questioned by relatively few. On the whole the majority of Italians have
held jealously, nay superstitiously, to the traditional attribution, whereas
isolated foreign scholars, like KALLAB [1900], RINTELEN [1912, 1923], PERKINS
[1918], WEIGELT [1925], MOLTESEN [1930], GY-WILDE [1930], MARTIUS
[1932] KAUFMANN [1937] incline to a Roman or Romanizing non-Giottesque
master.

It is only fair to add that while post-war opinion has tended to date
the frescoes not earlier than 1295 and as late as the second decade, the first
decade predominates in the dating. In fact several students, SUPINO [1920,
1924], SALMI [1937], COLETTI [1937], place them immediately before or
after the Paduan frescoes, some regarding them a less evolved, some,
strangely enough, a more advanced stage in Giotto's development. The
more timid attempt to reconcile the style with VASARI's chronology, which
places the frescoes between 1296 and 1304.

[4] The gusts of harried and self-conscious eloquence in recent argument
betray a certain sense of inadequacy, owing no doubt to the difficulty of
grasping the differentia of a master even of Giotto's repute. The power
to do this, as a condition to any constructive effort, presupposes a knowl-
edge of his artistic kin. But the crucial trouble arises from the despairing
vagueness as to the limits of personality. To evade the embarrassment
resulting from this, attributions have been risked on outward evidence or
on pure ratiocination. Often indeed divergencies are noted but instantly
explained as due to immaturity and accordingly relegated to the uncharted
period of a painter's life, namely his youth. The classical and consummate
instance of this method is SCHMARSOW's study on Masaccio, not to speak
of the more recent and equally remarkable integrations of Uccello and
Fra Filippo.

But art-historical scholarship has sounder bases. In known evolutions
the substance of a style remains constant, as indeed in the common lives
of men. For if expression is inevitably governed by the laws of the or-
ganism and structure, it can vary no more than the sensible aspects of our
mortal selves such as our glance, gait, voice, scent, etc., and the synthesis
they produce. And as in these, the changes in style are chiefly changes in
degree of tension and not in their essential nature or disposition. Indeed

stylistically harmonious group of unimpeachable works always as-
cribed to him; and second, upon the confirmation of his traditional
greatness and his authorship of certain of these works by early au-
thority. So secure, indeed, is this combined testimony as to justify
the confident assumption that he and none other painted: the frescoes
in the Arena Chapel, Padua; the cross in the same chapel; the frescoes
of the Bardi Chapel, Sta. Croce (with assistance); the Uffizi *Madonna*;
the frescoes of the Peruzzi Chapel, Sta. Croce.[5]

While there is a small number of works apart from these executed

the tendency in the development of the artist, whatever his capacities, is
towards expansion or relaxation of plan, of form and of a physical type
already present in his first maturity. And even then these changes are
subject to a largely predetermined and calculable course; and the greater
the artist the less he swerves from it. Whatever his native powers, his
growth and deterioration can neither be so rapid nor so capricious as to
render his production at any stage more diverse from the body of his
known work than from that of another master.

The general mental analogies, the direction, the orbit—if not the com-
position—of his thought, his taste and feeling remain the same.

And these factors of his style were more ineradicable and more evident
in the trecento than they are to-day. For it must be remembered that,
contrary to modern example, a painter of this period, whose formation
began at a tender age in an environment saturated with artistic tradition,
developed under the added restrictions of workshop practice as well as the
demands of a conventional society. His style accordingly tended to form
and canalize at an early age, and the work of his early maturity therefore
already contained and manifested (as indeed in all known instances) his
peculiar quality and method, even if these still betrayed his origins. If
valid in principle, how much more true is this of a mighty genius like
Giotto!

Thus, in dealing with attribution, we are not treading upon the quag-
mire of uncertainty, as so much of past criticism would lead one to believe.

And yet the affinities noted in recent literature between the St. Francis
cycle and Giotto's unquestioned works are often not those essential to the
attribution. To note analogy alone is not enough. For when all is said
one cannot escape the necessity of first subjecting the analogies discovered
between the two works to a critical analysis aimed at determining whether
such analogies may not result from influence or imitation. Only by exam-
ining what is left after the "imitable" terms have been disposed of can we
pretend to having touched the heart of the problem.

[5] I shall for reasons of brevity have to limit my discussion of Giotto's
style to the frescoes alone, since they afford at once a more homogeneous,
inclusive and consecutive view of his evolution. I have omitted the S. Pietro
mosaic from my list as, in its restored condition, it could hardly add to
our knowledge of the master's style. As for the angel in Boville Ernica, I
feel certain it would never have occurred to anyone to attribute it to
Giotto on grounds of internal evidence alone. It seems to me a work carried
out by Roman mosaicists on a design conceivably by him. Nor have I in-
cluded all such works as have only recently come to light.

under his immediate influence that might help us to envisage the master more completely, the foregoing series adequately measures Giotto's range and his evolution from his ripe manhood to the end. But what is more to the point, they harbour a *constant* among them and disclose the *variable* in his output. From first to last a certain method of shaping and ordering the forms runs through these paintings, revealing the same radical intention, the same power and organization, modified only by the normal change of human development.

I think the majority of students would agree that Giotto's qualities appear for the first time in their maturity, range and purity in the Paduan frescoes, which may safely be regarded also the earliest unquestionable work by him left to us. The initial condition of narrative lucidity apart, Giotto's concern here was with establishing the dignity of human fate through the material significance of the human figure [fig. 32]. This receives confirmation by being locked in an organic composition in which each by its predominant verticality and simplified contour, instantly relates itself, alone and in groups, to the lateral limits of the compartment. By the same principle the figures are deployed across its width in a continuity that brings them into harmony with the horizontal limits as well. The composition thus approximates a regular geometric pattern, which assures its assimilation within the rectangular frame. At the same time, the figures are massed solidly below—and more generally at the extreme ends of the lowest zone— to afford the upper parts of the composition support and resolution in a total mass of interrelated parts built up like a façade [fig. 47]. Adhering generally to this scheme throughout the Arena Chapel, Giotto modifies his arrangement and his perspective from scene to scene to give each its proper graduation of accents, which, while it serves a narrative and dramatic clearness, ultimately achieves a remarkable elasticity through a constant tightening and loosening of the thread of his story, a constant focussing and diffusion of the attention. Within the closely woven organization of the individual episode the figures announce the broad intent in their advance from left to right, or in a symmetry that arrests it. The composition moves and stops as the narrative progresses and pauses; its rhythms contract and expand, its masses rise, fall and incline as much in obedience to the requirements of the evolving story as to satisfy the plan of the individual picture. At the same time the figures and the events in their course respect the integrity of the surface, rarely taking the eye beyond the depth of the foremost plane. Thus there is no rivalry between background and figure. And indeed, where the space is not cut off by rock or architecture, it remains abstract and merely suggestive.

The composition being conceived as a system of interdependent elements, each figure is accommodated to the whole by being contoured and modelled large in order not to draw too much attention to itself by individualization or description of its physical character. To the same end it needs must be immobilized. The composition thus subjugates the individual form to a corporate order and equilibrium, which it brings into predominating evidence. This implies a nonnaturalistic treatment of the figure.

As there is no naturalism in the representation, so there is no effort to catch the action on the wing. If there were, it would tend to restrict the interest to the moment given, recalling at the same time those immediately preceding and foreshadowing those to follow, thus localizing it in a series. Similarly the master avoids sharpening the action to a climax. We find progressive emotion arrested at the stage at which it is consistent with deeper preoccupation, when the need or the impulse to act has been removed so as not to dim the great inherent issues. Thus the recognizable units and limits of time tend to fade, and the latent drama emerges in its spiritual implications.

For the same reason individual expression is moderated: it becomes the projection of an abiding inner state rather than that of a momentary impulse [fig. 32]. But by the same principle such expression is not confined to any single part of the figure. It may be said to pervade it. Expression resides to the same extent in gesture as in physiognomy, in the mass, posture, pattern and line as in grimace or pantomime, and by a rule of occupancy analogous to that evolved and professed by Leonardo. For with Giotto all expression seems to issue out of the depth of an inner necessity—a necessity that is assumed to penetrate all things—and remains, accordingly, implicit in every part of the body. This way of presenting the figure accords with Giotto's radical system of generalization and has the same end in view, namely to lay bare the larger spiritual idea personified by the figure, action and psychology being regarded primarily as a means of spiritual self-revelation.

It follows that the individual expression is, by reason of such a system, more readily resolved in the collective conduct of the personages. And so, while setting forth an actual occurrence, the figures are joined in a thought and a motive, and a force beyond their visible shapes. What the single figure does, seems, accordingly, dictated by the will of a larger economy, while the total action reflects an ideal order, heralded and prefigured in the visible structure of the composition. So closely are the content and the form involved in each other, that the organic correlation of the physical terms induces a sense of a more comprehensive stability: a stability directly symbolic

of an eternal, unshakeable world. Thus being is emphasized over doing, eternity over the moment, idea over fact.

Nor is it, considering Giotto's system of balancing of shapes and forces, astonishing that plasticity is not boldly urged for its own sake.[6] For Giotto's works show the master with sensitively operating instinct tempering plasticity in the interest of the larger unit. Thus, just as the spiritual analogies are tacitly communicated by the reciprocal adjustment of material shapes in composition, the physical weight of the figure serves to establish and to confirm its moral weight. Plasticity in Giotto, instinct with ideal suggestions, is ideal in its effect and meaning. Never absent from Giotto's statement, it attains to a pitch of refinement in the Paduan Cross that makes it felt essentially as a manifestation of the immaterial.

As the underlying tone in Giotto is moderation, so the predominant virtue is temperance. Man is neither as troubled nor as rebellious as he is in Cimabue, nor as susceptible to emotion as in Simone Martini. Perhaps the distinguishing trait of Giotto's man is a deep humility of spirit. He avoids violent or frenzied action. His gesture is not confused by a tension or struggle of the will, and the figure shows no sign of maceration. And the scale being in all respects human, there is an absence of heroic suggestion. There is no trace of pride, grandeur or self-exaltation. The atmosphere is accordingly one of unworldliness; man stands detached from earthly things and interests. Nowhere is human frailty so frankly postulated and so graciously condoned, and nowhere the doctrine of brotherly love so nobly affirmed.

The binding sentiment in the action is sympathy. The figures respond to the situation and to each other with inward participation.

But while the main expression is that of humble self-submission to a higher law, we are persuaded also that the figures are moved by positive qualities of sincerity and benevolence. Man represents the essence of virtue in an ideal world wherein Christ personifies the sum of goodness.

When we now shift our attention from the Arena to the Bardi

[6] And yet this quality in his works is often pushed too conspicuously into the foreground. For the criticism of art seems organically afflicted with a facile and vacant intellectualism that neglects the concrete artistic characters of the object in the process of conceptualization. In this tendency the view of Giotto's plasticity has been a fleshless or merely verbal fixation in the minds of some writers, forfeiting the formal qualities, which should always be retained within the critical focus. Possessed by this conventional fancy of Giotto's volume, the student has been discovering it everywhere in his painting. Hence any work not primarily plastic is not by Giotto, while overcharged plasticity, no matter how crude or external, can be due to Giotto alone!

Chapel, we find that not only their problems but their æsthetics vary. The story in the Bardi Chapel does not, as in Padua, unfold in a narrative moving progressively in a frieze-like continuity across the surface. The vertical form of the chapel in Sta. Croce better suited a system of superimposed scenes. This allows a greater width to the compartment, the story thereby becoming less fluid. These altered factors accord with Giotto's advancing interests, which give greater compass to the scene. For he comes to be concerned not so much as formerly with a concise, progressive disclosure of the fortunes of the protagonist, but rather with a symbolic presentation of the typical moments in his life.

The architecture is still largely bilateral, hypæthral and often gracile [fig. 80]. It remains arbitrary, stage-like and symmetrical, with the two-fold purpose of confining the figure-composition and the space to the foreground, and of affording an abstract background to the plastic figures. The setting is thus virtually as subordinate to the figures as in Padua.

The figures are still maintained at a relative immobility to the end of being instantly integrated in a façade-like composition. The regularity of this, and its deployment from left to right across a wider area than in Padua, offset the depth now contrived more consistently by overlapping and isocephaly (as, e.g., in the *St. Francis at Arles*). [See fig. 80.]

So far, then, and in all radical respects, the artistic laws remain the same as in the Paduan cycle. But they are relaxed towards a somewhat altered taste in the later frescoes. The binding principle, which in Padua kept the figures locked in a solidly and tightly organized fabric, has been stretched to admit spatial implication in the Bardi Chapel. The void has now become more deeply recessed and wider across from side to side. And the figures follow each other inward in a line that adheres to the perspective of the lateral limits of the setting by a rule already anticipated in Padua. By this means the forms at once create the void and cumulatively fill it. But above all the eye is now maintained at the level of the central zone of the composition, a device which implies a more deliberate isocephaly, and an overlapping stratification of the figures as they recede into space (contrast the *Last Supper* [fig. 39] and the *Descent of the Holy Ghost* [*The Pentecost*, fig 55] in Padua with *St. Francis' Appearance at Arles* in the Bardi Chapel [fig. 80].

In these changes are implied at once the permanence of the principles inherent in the Paduan frescoes and the chronological relation between the two cycles. At the same time, the persistence in the Peruzzi cycle of the tendency of these changes proves beyond a

doubt that the painting of the Bardi preceded that of the Peruzzi Chapel.[7] For while the Bardi Chapel still clings to the compactness of the Paduan composition, it already allows the figure more than the space necessary to carry its cubic volume to a fulfilment, pointing the way to the Peruzzi frescoes, in which we find not only a resolution of the earlier tendencies, but, as we shall see, new departures in space-composition as well.

Although the restored condition of the Peruzzi Chapel frescoes disguises the minor forms, the broader æsthetic intention is manifest at the first glance [fig. 81]. There is a greater plastic swell in the figure, a fuller space, and a larger amplitude in the total effect.

But this effect implies a modification in the main principles as we saw them in Padua, and the tight composition of the figures becomes relaxed in a distribution partly less regularly, partly less evident. The composition tends to conceal the central axis, and eschews the earlier stabilization through obvious symmetry still prevailing in the Bardi Chapel. The figures, in whom the proportion has been increased by having been furnished smaller heads, win additional breadth through movement. Yet this, far from serving merely to reveal the structure, generates sweeping line-rhythms from figure to figure in a continuous flow throughout the composition. The close organization of the Arena, which held the figures in a collective immobility, having relaxed, the resulting intervals provide room for the resolution of the gesture of the figure.

On the other hand, the intervals so created carry connotations of space—connotations conditioned by the rhythms communicated to these intervals by the figures. Thus the whole scene becomes replete with spatial implications. With the same purpose Giotto now avails himself of the wide compartment by reducing the scale of the figures, by drawing out both the figure-composition and the architecture from side to side, and by increasing the tangibility of the somewhat deeper space-limits. He introduces greater gaps between overlapping masses, and interposes air between them.

The insistent balance of the stage-like setting, which in Padua and the Bardi Chapel cuts off the ulterior space and by its symmetry immobilizes the composition while confining the space by its spread to the foreground, is uniformly avoided in the Peruzzi Chapel. The architecture becomes larger, less symmetrical, and its reach deeper [Fig. 81, 82]. Giotto's trick of swinging it inward at a sharp angle to the plane of the wall [fig. 55] is now used with clearer effect [fig. 82]. Its lines and masses move independently of the figure to a

[7] Among recent publications WEIGELT's dating of the Peruzzi Chapel prior to the Bardi is in opposition to my view.

greater depth, suggesting a void beyond what we see. Forfeiting its former discreet passivity, it becomes a more active agent in the generation of space.[8]

Thus, as movement pervades all the compositional elements, does Giotto's space for the first time become less measurable and less determinate.

Along with these changes and implicit in them is a perspective visually easier to justify [fig. 82]. For the first time in Giotto's works the composition is now seen from its own level as in actual experience, establishing a recognizable relation between spectator and space. The floor slopes more markedly upward, the roof downward, and the central zone, the zone of the figures, is fixed in sharp foreshortening. And the heads adhere to an isocephaly, even where the interval between the overlapping figures is considerable, as notably in *The Banquet of Herod* [fig. 82]. The three zones of the composition from lowest to uppermost are brought into an optical synthesis in order to approximate the experience of reality. Every architectural element subserves the same spatial purpose. How much more effectively the device of overlapping columns, for instance, is used than ever before may be realized by comparing this scene with *The Descent of the Holy Ghost* [*The Pentecost*, fig. 55] in the Arena Chapel, or *The Appearance of St. Francis at Arles* in the Bardi Chapel [fig. 80]. Whereas the early left-to-right evolution of figures now becomes complicated by a movement inward, their placing at greater distances in depth by this illusionistic law dramatizes spatial representation.

The Peruzzi frescoes thus receive the highest degree of compositional and spatial expansion known within Giotto's work, and reach the limit of his aims or at least of his achievement. The spiritual tone remains radically unaltered. It is as if the solemn hush and the implicit reverence in Padua had advanced to a more dramatic stage of the same action. The change is from a deeper to a rounder note. Yet none of the earlier gravity and moral significance has been sacrificed, and the ultimate postulates of conduct and of fate latent in the Arena Chapel have in no way diminished. The Peruzzi Chapel bears witness to the persistence of artistic principles first evident in Padua, thus confirming the singleness and permanence of an artistic purpose and personality fundamentally unchangeable.

But the question that now confronts us is whether the St. Francis cycle in Assisi contains the characteristics and the character inherent

[8] It is perhaps of interest to note that Giotto's placing of a large mass in the secondary plane of a gradual recession (the tower at the left in *The Banquet of Herod* [fig. 82]) is in principle descended from the overlapping rocks in *The Flight to Egypt* [fig. 29] in Padua.

in the constant and implied in the variable of Giotto's genius; whether, given the universal laws of human and the special ones of artistic personality, its change and its growth, it is possible that the master of the Paduan[9] and the Florentine frescoes could also have painted those in Assisi.[10]

The narrative of the St. Francis cycle [fig. 83] is set forth in a series of scenes beheld through a painted architectural framework consisting of an architrave, which runs in a continuous course around the nave, and rests upon twisted columns that separate the individual scenes. The intention, immediately perceived and sustained, is that this architectural framework should produce the illusory effect of actual architecture. It is therefore painted in perspective and in plastic simulation of stone, the *trompe-l'oeil* being carried out in a course of corbels below and in another above it. But this effect is abetted and continued by the actual architecture, by the advancing lower part of the

[9] In the critical demonstration that follows, examples from the Paduan frescoes chiefly will be used for purposes of comparison, for the following reasons: first, because they contain the essential elements of the later works; secondly, because they are in a far better state of preservation; and finally because they are avowedly closer to the Assisi cycle in point of date.

[10] I do not here intend to embark on a definite suggestion of the authorship of the Assisi cycle. I shall content myself with taking the only positive step that I consider wise under the circumstances, namely to review my reasons for the conviction that the gap between Giotto and the St. Francis series is unspannable.

In discussing the cycle as a unit I am assuming disparities of style within the series due to different executants. While they all adhere to the terms of a general plan—including the colour—laid down by a guiding mind, these disparities vary in degree. Thus scenes 1, 26–28 at the east end isolate themselves from the rest by the most evident divergencies. The remaining frescoes of the series fall into groups less dissimilar among themselves. But it is enough here to recall that the radical style has a single origin.

I do not hesitate in repudiating the cry of repaint raised in certain quarters. That some retouches of the several recorded repairs are left upon the wall cannot be denied, but these in no way disguise or conceal the original trecento character. I shall remind the reader only that in 1820 CARLO FEA (*Descrizione . . . della Basilica . . . di S. Francesco d'Assisi . . .*) "fece ricomparire all' umana vista la massima parte di tutti questi freschi." In 1863 (Assisi, Biblioteca Comunale, Descrizione del Santuario di S. Francesco d'Assisi Compilato . . . Membri della Commissione Artistica delle Provincie dell' Umbria), only one figure in the first scene is found wanting. In 1873 CARLO FELICE BISCARRA (*L'Arte in Italia*, etc.) claims a restoration of the original vivacità di colore to the frescoes by Cav. Guglielmo Botti. Even SACCONI's report (*Relazione dell' Ufficio Regionale per la Conservazione dei Monumenti delle Marche e dell' Umbria*, [1903] does not condemn the surface.

And yet it is often those very eyes that see repaint over the frescoes which discern Giotto under it!

lateral wall upon which the St. Francis series is painted, and especially by the stone mass of clustered columns that rhythmically divide the wall into bays. The same columns separate the scenes into three groups of three on either side of the nave and one group of four at the west end.

What the projecting lower wall achieves is first of all an emphatic detachment of the cycle from its rival claimants to the spectator's attention. But columns and framework in their architectural character, separated from the scenes themselves, become united in a rhythmic continuity, which instead of arresting the eye propels it along its course around the nave. On the other hand, within this continuity which joins the cycle to the church as a whole, the subdivisions of the bays command our attention and direct it to the three scenes contained in each.

This is accomplished not only by the clustered columns, which effectively articulate the sequence of scenes, but by the feigned perspective of the painted coffered soffit of the architrave and of the bases of the columns. The perspective converging on the centre of each bay places the spectator directly opposite, equidistant from its lateral limits. But the perspective is calculated also to feign its actual height from the spectator's eye. He is by this means immobilized periodically in his progressive reading of the wall.

At the same time it is the perspective of the projecting wall and of the protruding columns that begins to tempt the eye inward, while the simulated perspective of the painted framework carries out the same intention. But it goes further. By specifying the relation between spectator and perspective, the painted frame fixes its position on the wall with respect to the church interior. And so it is that while the actual architecture joins with the painted frame, the actual space of the nave passes into the painted space and continues into and beyond the wall. Likewise, this illusory scheme accords the episode a more definite place within the spatial organization, as if it were seen through a window.

The decorative plan in the Arena Chapel [fig. 3] is of another order of æsthetic and obeys a totally different purpose.[11] Thus for

[11] It is true that when Giotto chooses, he avails himself of a similar device at the east end, as well as in the *Virtues and Vices* [figs. 56–69], yet only where the narrative is otherwise interrupted by scenes of a specifically symbolic character or where the attention is deliberately held at rest. In the latter case such perspective is particularly happy as it converges upon the vista of the apse. A similar scheme occurs again, if only incidentally, in the Magdalen Chapel (containing frescoes among all those in Assisi closest to, but not by, Giotto himself), and never thereafter in paintings of a purely Giottesque character.

example the system of bands that subdivides the wall does not express an essentially organic relation to it. And if the lowest course, which serves as a base for the painted stripes above it, imitates stone, the divisions themselves are virtually flat. Far from creating a transition from the actual to the painted space as does the framework of the St. Francis cycle, the network of enframing bands in Padua remains largely ornamental and abstract. They rise vertically from the figures of *Virtues and Vices* as pedestals interrupting, and thereby in a sense punctuating, the march of the narrative. But the bands, while they enframe the scenes, serve also to organize the wall and ceiling by dividing the former into upright sections, the other into larger arched ones, thus helping to articulate the interior, without, however, spatially anticipating or expressing the scenes. Nor do they, in their abstract neutrality, induce a movement in any way resembling that of the solid painted frames of the Upper Church. They are scrupulously kept static, the principle of progression being in the scenes themselves, which are auspiciously free from the competitive interference of architectural elements.

Thus, the scenes, by contrast with Assisi, maintain an ideal and indeterminate distance from the spectator, like pictures in a dream.

It would be reasonable to assume, therefore, that had Giotto painted the St. Francis cycle he would have taken over the flat system of framing in the Old and New Testament series above it; since the problem in this cycle was essentially the same as in Padua, namely to deploy a cursive narrative around the wall of the nave.

Part II[1]

Now, the space implied in the architectural frames[2] that enclose the scenes of the St. Francis cycle is produced by the heavy painted architrave and the cumulative plasticity of the painted spiral columns, space being but a manifestation of form and solely by it rendered

[1] I hope the corroboration of some of the central points in my argument in Part I by so close and acute a student as Mr. Perkins (in the August issue of THE BURLINGTON MAGAZINE, p. 84–85) may lead others in the field who still dissent from our view to give the problem the attention due it.

I should like to draw attention to an omission in Note 5, Part I of my essay. The mosaic angel in the Museo Petriano should have been included in the opinion expressed of the angel at Bovile Ernica, both originally parts of the same larger work. There is considerable reason to doubt that these originally belonged to the Navicella.

[2] The illusory architectural elements of the painted frames around the scenes of the St. Francis cycle in Assisi, discussed in Part I and illustrated there in a general view of the church interior, may be studied to better advantage in figs. 89, 90 and 92.

sensible. It will be found that form and space in the scenes, like those of the frame, being interdependent, governed accordingly by the same radical law, express a similar artistic purpose. Hence, although the perspective of the scenes is of a freer and more complex variety than the geometric perspective of the frame, the figure declares its occupancy of the space with the same remarkable definiteness.

This is due to the fact that the figure [fig. 84] is bounded by planes that render the third dimension by starkly differentiating the lighted from the shaded side of the solid, by emphasizing the dark planes carried uniformly into the depth, measuring the depth along the wall of the nose, along the receding cheeks, in the cavity of the ear—as indeed consistently along every receding surface throughout the figure. No form, as indeed no plane, is allowed to exist without fulfilling a plastic function, without affirming its relation to the depth. But to confirm its occupancy of the space still further the form is so treated as to produce not volume alone, but also solidity. Every detail, however small, being accorded the same treatment, every stroke set down to the same end, the form takes on, not only a plastic definiteness, but also the raw hardness and consistency of stone, its weight and atomic density. For the artist conceives the form in terms of stone and its properties. And indeed he deals with it as if stone were the material of the mental image, so that the grooves in the forehead seem cut, the folds in the cheeks, the cavity of the ear, hollowed out, the hair traced, with the same imaginary chisel. The whole gets consequently the appearance of sculpture, and, as in round sculpture—of the kind at least in the mind of our painter—the weight is more explicitly given, more compactly gathered around a central axis, and the planes bound it more firmly. This method isolates the form from the space around it and sets off each emphatically against the other [fig. 91]. The space thereby acquires a more explicit emptiness in proportion as the form is more densely solid: space thus becoming a positive counterpart of the form.

But, insofar as the volume is rigidly delimited and circumscribed, it forfeits the ideal qualities of Giotto's plasticity; and if Assisi is sculptural and lapidary, Padua is as pictorial in its means and effect as was possible in its period [fig. 85]. For in Assisi the deep shadow sinks into the void while it holds the form solidly established within it; Giotto's form, on the other hand, by a system of modelling in light, emerges in a gradual swell. But in isolating the form plastically the Assisi master at the same time individualizes it. His system is accordingly more naturalistic in aim than that of Giotto.

Moreover, the picture-space in Padua betrays a purpose radically divergent from that in Assisi, where the compositional plan, the placing

of the figures, the intervals, obeying the same principle as the mass in the architectural frame, are governed by the same space-generating purpose. The figures and groups avoid that conformity of axis and contour to the boundaries of the area we have met with in Giotto, and are thus not as exclusively confined to the foreground picture-plane, moving more freely in a less rigidly determined void, without inducing that sense of predetermined position. Similarly the masses are placed at distances from each other calculated to make an active factor of the emptiness as opposed to the mere absence of cubic volume.

Yet we meet with noteworthy inconsistencies in the handling of the space in the Assisi frescoes. In contrast to Padua where the spectator's eye is uniformly assumed to be at the height of the foreground heads—a device that provides a sharper foreshortening and a completer overlapping to the end of achieving a more ideal space-illusion—in Assisi the composition is often sighted from above (as notably in *Innocent III Approving the Charter of the Order, Francis Preaching before Honorius* [fig. 88], *the Canonization, the Burial of St. Francis,* etc.). On the other hand there are scenes in which, while the greater number of the heads are seen from the same level, some are raised arbitrarily above the multitude (as in *The Miracle at Greccio*) [fig. 89]. These anomalies clearly interfere with the illusion of depth, for they fail to carry out the rule of optical experience. Yet they occur so often throughout the series that they may be predicated of its style. But there is a further divergency of aim in the two cycles: in Assisi the space-mirage is evoked by a setting running back of and rising above the figures, and independent of them [figs. 91, 92]; with Giotto on the other hand the space is generated within the figure-plane (and at times a secondary plane directly subservient to it), which means that only so much space is conceded the figures as is required to establish them plastically [fig. 8].

Again, in Padua the composition tends to evolve from the sides inward towards the centre: to afford solid lateral supports for the structure of the composition and to form a recess for the display of the main event. This is seldom true of Assisi, where compositions are as frequently faced outward in an extended, unforeshortened view. And in instances the main event is placed in front of the mass of figures (as in *The Miracle at Greccio* [fig. 89] and *The Death of the Knight of Celano*) by an intention unknown to Giotto. Or again the action is shifted to one side with no figural elements on the other, as in *St. Francis Exorcizing Arezzo.* But Giotto's arrangement is subjected to an unambiguous system of organization in depth. By this system the body is first placed, wherever possible—and particularly

at the right and left extremes of the composition—at a sharp angle to the picture-plane. Such placing is calculated to abet a foreshortening of the mass as a whole by an alternation of differentiated values of light, but chiefly by a movement of the lines along the figure from the foremost plane rhythmically inward. Generally Giotto's scheme takes us from the well-rounded nearer shoulder to the cylindrical neck, which overlaps the farther shoulder, while at its base the opening of the dress, the folds, borders, ornament and so on, encircle and gauge the forms they enclose as they retreat in a continuous course. In such instances [fig. 87] the drapery is drawn across the torso in a way that makes us aware at once of the stretch of the stuff in its resistance to the bulk under it, and of the dimension it traverses. By such cumulative recession of solid shapes in close conjunction with foreshortening of the masses and the lines, Giotto accomplishes a synthetic and suggestive evolution of volume. The Assisi system [fig. 88] is less fluid and the form, even if at times it reflects a similar purpose, confronts us as a rigid statement of bulk.

Moreover, in contrast to Padua the objects behind and above the plane of the main action are allowed to arrest the eye in order to extend the space into the depth irrespective of the volume created by the figure, and so to lend the emptiness a more concrete illusion of existence. Accordingly the buildings, the rocks, the trees, are not, as in Giotto, primarily cubic abstractions, but assume a character proper and peculiar to them, with which not only our plastic reflexes but our associative faculties as well are invited to become preoccupied. The composition is thus accorded, besides a deeper space, a more authentic site and a sense of actual place. But in Giotto, it will be remembered, site is only summarily indicated in order to be taken in quickly and superseded.

Subject to the same governing intention and moving with the same purpose, the action in Assisi is naturalistically rendered. For contrary to Giotto's rule the primary aim in Assisi is to create the illusion of physical actuality, not only by imparting a physical existence to the figures, but by insisting also upon the physical terms of their demeanour [fig. 89]. And this is accomplished largely by keeping the figures alive to the physical world around them to which they respond by look, movement and gesture. Their glance, that carries more practical suggestions, is directed straight towards the object of their mental pre-occupation to the point of implying the distance or interval between them, thus corroborating the physical relation of the objects and figures in space and time as well as their physical reality. But this illusion is carried further by a psychology in the figures which specifies varying degrees of engrossment in a diffused and diversified

world of nature, and we find them now in casual converse, now relaxed or vehement, in states ranging from ingenuous or startled attention to frenzied despair. To this end the artist has arrested a typical stage in a progressive movement, as in the pope's fixed intentness on St. Francis' preaching, or the shocked and horrified surprise of the guests in *The Death of the Count of Celano;* or the lusty singing of the monks [fig. 86] at Greccio and in *The Mourning of the Clares* [figs. 89, 90], where we recognize the very pitch and timbre of the music in the effort of the strained throats and lifted heads. Or again the figures are presented simply as contentedly aware of their embodied selves or their gestures, busy with their own thoughts as they are barely mindful of what is going on (so especially in *The Approval of the Franciscan Rule* or *The Apotheosis*). It is thus that the focus spreads—and as much by this scattering of attention as by individual realism in expression. And thus is the shifting variety of the actual world imitated. But this very diversity of behaviour, before it has reached that climax wherein the collective attention is fixed in a single moment, in taking the scene out of the timelessness characteristic of Giotto, puts it (by presenting mental states preceding or following the conclusion of an action) within a measurable and recognizable span.

Such an approach, in striving to evoke the illusion of actuality in action, aims simultaneously at inducing a sense of veritable place in the scene of that action as part of the more comprehensive authentic world. This we see exemplified perhaps most typically in the way the artist makes the spectator's interest stray into the composition in *The Miracle at Greccio* [fig. 89], both by tipping and facing the cross on the iconostasis away from the spectator to embellish the nave beyond, of which we are otherwise made sensible by the swarming crowd that empties from it into the choir. In doing this the Assisi master goes much further than Giotto (see e.g., *The Presentation of the Virgin* [fig. 15] in Padua) not only by describing the site, but by specifying its whereabouts with reference to the rest of the church interior.

Insofar as the master of the Assisan cycle rings the changes upon human expression, the action everywhere diverges both in kind and degree from Giotto's, who, far from wishing to draw attention to the mental state or to urge its actuality, or again to intensify the emotion, is intent rather on revealing a spiritual truth, which is incompatible with just such transitory aspects of life as those the artist of the St. Francis cycle chose predominantly to represent.

But these essential and pervasive differences between the works of Giotto and the St. Francis cycle are attended by explicit ones. Perhaps

the most telling among these is in respect to type. Giotto's body betrays a more unquestioned susceptibility to movement, a greater range and ease of posture, than the stiff-jointed figures in Assisi with their awkwardly distributed weight. In spite of its implications of mortal flesh, its more flexible contours and proper consistency, it communicates chiefly a kind of noble forbearance in every line and pressure, so that we become aware of an ultimate indwelling meaning, as of a living spirit that directs the body and sets it in motion, rather than of its irreducible materiality as in Assisi. In Assisi the bodily frame is square and large-boned, of stout build and ample mould [see figs. 84, 88]. At times it is magnified to rhetorical impressiveness —uncongenial to Giotto—as in the grandiose *St. Francis Exorcizing Arezzo* or in the papal figures [fig. 88]. The head always sits firmly on a neck which in its posture declares a stubborn life-power as confident as the unwincing glance of the light-coloured iris. This harbours the rude knowledge of simple-souled men who live by forcing their bodily needs from the earth. But the conscience within them, like their type, is stolid and impenetrable compared to the spiritually evolved creatures in Padua [fig. 85]. Here the whole man belongs to a higher order of sentiency and his face, marked with graver human experience, betrays a deeper awareness. Full at once of passion and acquiescence, the face is of a softer consistency, the nose rounded, the mouth flexible, the features and intervening areas of a proportion that brings them into immediate physiognomic co-ordination. By contrast with Assisi, Giotto's eye is never pre-occupied with an outer object, but always reflects an inner state. The expression accordingly never responds to a moment, but is related to eternity. In Assisi the heads [fig. 84] are furnished with weighty jaws and rounded foreheads. The mouth is abundant but firm, with sensual lips bracketed by prominent folds, and a lump of flesh under it. The upper lip is long. Separating the cheek-bones, which project like flattened knobs over the weathered cheeks below, a straight and sturdy nose dominates the face. But most remarkable is the sharp unbroken arc that hangs from both corners below the mouth. The forehead is furrowed by straight channels cut into it by toil and exposure. The ear, generally small, has a deep, clean-edged hollow like a snail-shell. The eye drops back from the forehead into a shallow pocket delimited by a long sweep of brow. The hair is of a wiry fibre that makes a hard head-covering, subdivided in stiff, shiny strands separated by deep channels. Giotto's hair, on the other hand, is of a fine silken thread, soft and undulant, and the whole rests a downy mass upon the crown. The hands in the Assisi frescoes are oddly small and furnished with slim, cylindrical fingers. The master has a fondness for displaying the palm

in a forehortened view, reinforced by shadow (see particularly *The Glorification of St. Francis, The Miracle at Greccio* [fig. 89], *The Death of the Knight of Celano, St. Francis Preaching before Pope Honorius,* and *The Apparition of St. Francis at Arles*).

The drapery, since it occupies so much of the frescoed area, contains more abundant affirmation of the wide gap between the two cycles. In Assisi it has a metallic glitter and hardness broken by long sweeps of sabre-edged ridges and by deep finger-shaped channels that sink abruptly from the surface. At times the hanging skirt drops in stiff grooves like the fluting of a column, suggesting classic Roman example. Rarely, however, does the fabric seem to be taken into account, and we find in it a juxtaposition of light and dark not differing essentially in effect from that which we noted in the rocks.

It is true that Giotto's drapery is founded upon the same radical system. It shows the narrow folds and occasionally a similar surface, but by the side of these analogies the disparities become more conspicuous, and the intimate characteristics of each take on a more definite form. Giotto's drapery evokes the texture and the suppleness of the stuff, and renders its weight and its fall. Its handling is never as inflexibly arbitrary as that of the Assisi master, which has none of Giotto's refined adjustment between the nature of the fabric and its function of revealing the message latent in the presence, the posture, the gesture and the movement of the figure. As the mind is more collected, the body more relaxed, the mass broader, Giotto's drapery is more largely disposed and its lines communicate a dignity lacking generally in the Assisi cycle.

But the divergencies, as might be expected, reach other phases of the two cycles. In Assisi the angels are conceived as full-sized earth-inhabitants differentiated from humanity solely by their wings. In Padua they are small and gnome-like, and haunt the free spaces like creatures of the air, from which they seem to watch over the fortunes of men below with the friendly solicitude of familiar spirits. In flying, the lower part of their bodies vanishes in cloud, so that we are astonished to find them occasionally alight in their full height on human feet. But the Assisan angels retain their entire bodies even in flight. And their wings differ. The imbrication of the feathers and their graduation from dark to light endow the wings with weight, power and a kind of mysterious splendour. They look as if they were forged of fire and darkness when contrasted with the wings in Padua, which generally resemble those of huge birds.

It is surprising to find so explicit a difference in the handling of the halo in two cycles supposedly by the same master and of the same period. In Assisi the aureole is without exception a circular foil for

the head and is frontally placed. In Padua, on the other hand, it is foreshortened as a means of both accenting and differentiating the personages with the intention of achieving a clearer organization within the single scene and a rhythmic fluidity in the narrative. It should be noted that the foreshortened halo reappears in the specifically Giottesque frescoes of the Lower Church, all of them painted under the influence of Giotto's Paduan style. On the other hand, when Giotto's composition becomes more relaxed and continuity less essential, as in the Sta. Croce frescoes in Florence, the halo becomes frontal.

And the architecture shows radical divergencies. Whereas in certain broad aspects that in the Assisi frescoes is planned on contemporary principles shared with Giotto, its character and function are in deep opposition to his. In Giotto the architecture is consistently ideal and abstract. The buildings, being undersized, scarcely suggest human tenancy, but are simplified, abridged, carpentered properties that serve to set off the plasticity and arrangement of the figures. The buildings in the St. Francis cycle are, on the contrary, shown with rare exception in their architectural entirety, complexity and independence. Reared in several articulated storeys, they are more organic, and bear a more nearly credible proportion to the figures. This is true more particularly of the scenes by the St. Cecilia Master, but perhaps most of all of *The Mourning of the Clares* [fig. 90] and of *St. Francis Exorcizing Arezzo*. On the whole they are fairly naturalistic renderings of actual buildings. They simulate the materials of architecture in their weight, diversity and proper character, but also register the structural relation between downward pressure and the resistance to it, along with the appropriate ornament and texture. Finally, the Assisan architecture carries its total mass back into the space, away from the figures and independent of them.

The rocky background, again, is as different from Giotto's in function as it is cruder in treatment. The stony waste of the Assisi frescoes [figs. 91, 92] climbs in stratified stages of shining white levels, flashing back a cold light, and drops at edges of a lacerating sharpness into sheer dark declivities. In Giotto [fig. 8] the edges are worn to roundness and the planes flow into one another. Thus not only is the general form in Assisi dissimilar, but the flat and the vertical planes confront us in much more emphatic contrast. But the Assisan rocks become part of a more extended and integral landscape, instead of maintaining the subordinate rôle played by them in Giotto's compositions. By contrast to Giotto's method, the rock in Assisi creates landscape suggestions rivalling the figure, and a space far beyond that necessary to set forth the plastic content. It is thus that the landscape like the architecture encourages suggestions of life beyond the picture.

Nowhere do the styles of Giotto and that of the Assisi master appear less reconcilable than in the vegetation. Shrubs and ground growths occur rarely in either, but the trees, although drawn from a common formula, betray a different form-fantasy and execution. In Assisi [figs. 91, 92] they often rise from foot-shaped bases or little stony mounds, carrying heavy heads of foliage. The trunks show isolated limbs projecting from them, at times entire, at others lopped at their base, with only shallow spurs remaining. In Giotto [fig. 8], on the contrary, the trunk is with very rare exception straight and smooth, and ascends to the leaf-bearing crown without interruption. The Assisi leafage is almost always large and ragged, of a light hue and partly in shadow; in Padua it is of a crisp and dainty pattern and botanically differentiated. If the trees in Assisi are more heavily laden, in Padua one may see through the leaves to a greater depth among the branches.

But far the profoundest discrepancies separate the execution of the two cycles. This is directly conditioned by the form-image or the artists' conception of the objects of nature, the particular variety of which in Assisi, like the space and the perspective, arises in a more literal reading of appearance, subjected, as might be expected in a province, to a rigorous formalization. Here the prevailing procedure in the painting of the flesh—which is consistently *al fresco*—is the laying-down of a dark greenish ground, upon which is imposed a deep ruddy flesh-colour. Over this the lighted portions are hatched on with a very fine brush. Generally the streaking, fine and distinct, runs in one direction, following the curvatures of the surface, but the green shadow is allowed to show in large areas of receding planes, thus conferring upon the individual shape as well as upon the total form, the maximum volume. It is by this means chiefly that the whole takes on the three-dimensional quality and the density of round sculpture. The conception of form in Padua, on the other hand, is akin to that of relief. And this conception the painter expresses by beginning with a green underpainting which he proceeds to cover in the flesh-parts with a light colour, thereupon laying on the shadows in a slightly darker pigment over it; just as in working a flat slab of marble, the sculptor starts with an evenly lighted surface and models by chiselling into it. And, as in relief, a left-to-right plane variegated in light predominates, the shadow being for the most part relegated to a narrow band within the edges, at times limited to the heavy outer contour, which is made to serve also as a modelling agent [figs. 85, 87]. For in Giotto, deep shadow is avoided in the interest of the decorative unity of the picture, the form deriving its plastic swell largely from the flash of a shallow light-and-dark. Moreover, the underpainting is

scarcely ever allowed to appear under the flesh-colour, and when it does, it covers smaller areas and achieves less depth. Also, the medium, which is more fluid, is put on more broadly and is more glowing in its effect. Further, while in Assisi the hands provide the uncommon and noteworthy example of a modelling effected by visible streaks of whitish pigment running in almost every instance at right angles to the length of the fingers, in Giotto the light-and-shade is in less accentuated contrast and the hands are modelled by a shadow running with the long dimension of the fingers.

On the foregoing grounds, then, my original claim must stand. If the enumerated divergencies between the two cycles are necessarily selected out of a complex in itself ultimately incapable of essential definition, they are defensible as being at once representative and communicable. As there are students who still hold to Giotto's part in the painting of the Assisi frescoes chiefly because they fail to see the differences reviewed above, so there are some who, having perceived them, will persist in regarding them as characterizing two moments in a single artistic activity rather than as separating the work of two distinct masters. These I believe I have answered in the earlier part of this essay (see Part I, note 4). While the main part of their difficulty lies outside the range of art-history, I hope I have reached my conclusion on art-historical analogy alone. For, it may be stated categorically, in no known instance of the period in question are works by a single hand as unlike in kind and quality as the two fresco-cycles under discussion. To cite with dialectic insistence as many do, fourteenth and fifteenth-century instances of similar disparity is, other objections apart, to bark up the wrong tree of which the branches may indeed have a different appearance—especially to those in a barking mood—even though they spring from the same stock. But to point to the example of Cézanne or Renoir (whose early and late works show considerable disparities) or to the numerous periods of Picasso is inadmissible. For such disparities are largely external and, whatever else might be said of them, would have been immeasurably greater within the last hundred years than they were in Giotto's day; since in that period, let no one forget, a style began to form at a tender age in a uniform environment of sanctioned tradition after which it could neither be discarded nor altered at will.[3]

[3] The foregoing stylistic confrontation of the works of Giotto and the St. Francis cycle has been necessary before it becomes possible to deal with the positive aspects of either. The discussion of these aspects, which in no way touches the validity of my present findings, I shall leave to another occasion.

MICHEL ALPATOFF,
The Parallelism of Giotto's Paduan Frescoes*

Part 1

Giotto's Paduan frescoes are often reproduced one by one as a series of separate panel pictures.[1] Even Roger Fry, with his fine understanding of compositional values in painting, did not notice any co-ordination among them. "The design," he wrote, "is made up of the sum of a number of separate compositions. The time had not come for co-ordinating these into a single scheme, as Michelangelo did in the ceiling of the Sistine."[2] Wilhelm Suida,[3] and with him Dagobert Frey,[4] expressed a somewhat different judgment. In opposing Giotto to the Quattrocento masters, they declared that the series of his frescoes at Padua must be envisaged in a temporal succession; in fact they call Giotto's composition "successive." Indeed Giotto's Paduan frescoes have to be considered beginning with the events of the Virgin's life and finishing with Christ's Passion. Meanwhile, in examining them more attentively, one may find many hints as to the way Giotto himself wished his frescoes to be "read."[5]

Although many of Giotto's pictures correspond with the iconographical tradition,[6] we have every reason to suppose that he was not

* *The Art Bulletin*, XXIX, 1947, pp. 149–154. All references in this essay to figures refer to the line drawings included in the text, pp.158–159.

[1] H. Jantzen, "Die zeitliche Abfolge der paduaner Fresken Giottos," *Jahrbuch der preussischen Kunstsammlungen*, LX, 1939, pp. 187 ff., reproduces some of Giotto's Paduan frescoes together, but in order to establish the chronology of execution.

[2] R. Fry, *Vision and Design*, London, 1929, p. 165.

[3] W. Suida, "Giottos Stil," *Festschrift zum sechsigsten Geburtstag von Paul Clemen*, Bonn, 1926, pp. 335–337.

[4] D. Frey, *Gotik und Renaissance als Grundlagen der modernen Weltanschauung*, Augsburg, 1929, p. 46.

[5] C. A. Isermeyer, *Rahmengliederung und Bildfolge in der Wandmalerei bei Giotto und den Florentiner Malern des XIV J.*, Wurzburg, 1937, pp. 4–26, notices that a single point of view sustains the whole Paduan cycle, but he seems to ignore all relations between parts. W. Suida, *op. cit.*, p. 336, compares the position of the separate fresco in the Paduan chapel with that of an aria in Bach's *Passion*, but he too passes over the conception of the sustaining score.

[6] J. C. Broussolle, *Les fresques de l'Arena à Padoue. Etudes d'iconographie religieuse*, Paris, 1905. G. Millet, *Recherches sur l'iconographie de l'évangile aux XIV*, *XV* et *XVI* siècles, Paris, 1916. R. v. Marle, *Recherches sur l'iconographie de Giotto et de Duccio*, Strassburg, 1920. Millet, *op. cit.*, p.

bound by rules concerning the conception of the whole series of frescoes.[7] He gives a comparatively detailed story of Christ's Childhood and Passion, but limits the series with a short rendering of His terrestrial life, His preaching and His miracles, while excluding the Transfiguration. Among the scenes of Christ's life we do not find the Temptation of the Devil. Among the Passion scenes, the Flagellation and the Descent from the Cross are lacking. Among the events after Christ's Resurrection, the Incredulity of Thomas and the Supper at Emmaus are absent. All these are scenes represented by Duccio in his famous *Maestà*.[8]

It is necessary to account for Giotto's motives in composing his Paduan cycle—to explain his omissions in the complete illustration of the Gospel—and to determine whether chance or intention was involved. Apparently the painter started from the south wall of the Arena Chapel [text illus. 1]. This wall is divided by six windows into five sections.[9] Each section could accommodate two frescoes, so that the whole south wall included ten events of Christ's life. By keeping the same dimensions for the frescoes, Giotto decorated the north wall [text illus. 2] with twelve other pictures. Whether the uppermost series of frescoes and those on the triumphal arch [text illus. 3] were added later may be doubted.[10] For our purpose it is enough to say that the story of Christ contains twenty-three scenes and that of the Virgin fourteen. The numbers correspond to no dogmatic conception; nor do they derive from the iconographical tradition.[11] Evidently Giotto had

684, is disposed to overestimate the influence of Byzantine iconography on Giotto ("Cavallini, Duccio Giotto n'ont presque rien ajouté à l'iconographie byzantine"). In considering only separate iconographical motives and not the meaning of the whole scheme R. v. Marle, *op. cit.*, p. 229, affirms without proof "la tradition iconographique était trop bien établie pour que l'on put aller contre les habitudes consacrées par l'église."

[7] On the Christological cycles in Byzantine and Early Italian art: G. Millet, *op. cit.*, p. 15; H. v. d. Gabelentz, *Die kirchliche Kunst im italienischen Mittelalter*, Strassburg, 1907, pp. 89 ff.

[8] C. H. Weigelt, *Duccio di Buoninsegna*, Kunstgeschichtliche Monographien, xv, Leipzig, 1911. A reconstruction of the whole altar-piece by A. Lisini, "Notizie di Duccio pittore," *Bolletino senese*, v, 1898, pp. 67 ff.

[9] C. Weigelt, *Giotto*, Berlin and Leipzig, 1925, p. 2 and p. xxvii on the windows of the chapel.

[10] The problem of chronology of the Paduan frescoes after A. L. Rohmdal, "Stil und Chronologie der Arena Fresken Giottos," *Jahrbuch der preussischen Kunstsammlungen*, xxxii, 1917, pp. 3 ff., was studied recently by Baumgart, "Die Fresken Giottos in der Arenakapelle in Padua," *Zeitschrift für Kunstgeschichte*, vi, 1937, pp. 22 ff., H. Jantzen, "Die zeitliche Abfolge der Paduaner Fresken Giottos," *Jahrbuch der preussischen Kunstsammlungen*, lx, 1939, pp. 187 ff.

[11] E. Mâle, *L'art religieux du XIII⁰ siècle en France*, Paris, 1902, p. 215.

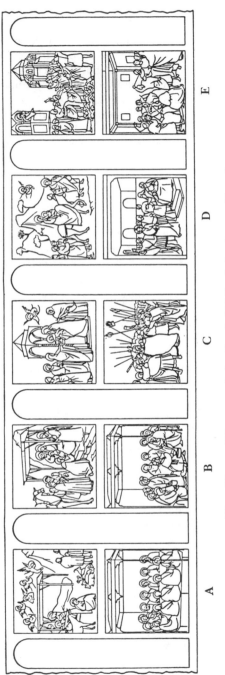

Text illus. I. Diagram of the South Wall of the Arena Chapel

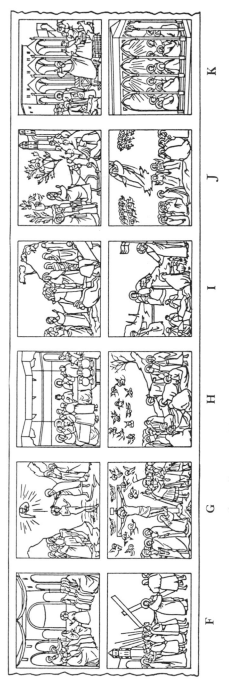

Text illus. 2. Diagram of the North Wall of the Arena Chapel

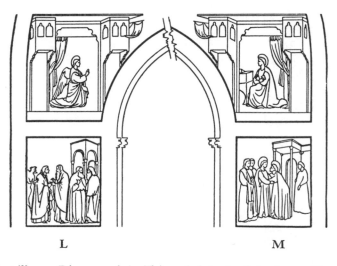

L M

Text illus. 3. Diagram of the Triumphal Arch of the Arena Chapel

himself to choose these thirty-seven events from the immense field of evangelical and apocryphal themes.

The uppermost series of the life of the Virgin was conceived as a single whole. Its disposition on the wall could not be co-ordinated with the rest because the number of these frescoes did not correspond with the two lower series. In the story of the Virgin such scenes as Joachim's experiences and the choice of the wooers were treated with many details in several frescoes.

The childhood of Christ and His Passion are related more briefly. In representing the life of Christ Giotto conceived his series as a continuous chain of events[12] in historical development.[13] But at the same time he did his best to co-ordinate the pictures of Christ's Childhood with those of His Passion. In almost all the frescoes of the two lower series this co-ordination is quite apparent.

Let us now consider the frescoes superposed by Giotto. The first vertical pair contains *The Nativity* and *The Last Supper* [text illus. 1A]. These two scenes have many points in common: *The Nativity*

[12] J. Ruskin, *Giotto and his Works in Padua*, London, 1854, p. 43: "I think also that Giotto desired to unite the series of compositions in one continuous action."

[13] F. Rintelen, *Giotto und die Giotto–Apocryphen*, Munich–Leipzig, 1912, considered Giotto's cycle as a natural narrative of the lives of the Virgin and Christ, affirming that in creating the frescoes Giotto had no symbolical or other intentions.

opens the story of Christ's childhood, *The Last Supper* that of His Passion. In the thirteenth century, pictures of the Nativity showing the Child in a manger on an altar alluded to Christ's future sacrifice.[14] Both scenes represent the mystery of incarnation: in the first of them that of the Second Person of the Trinity into human flesh, in the second, the transformation of bread and wine into Christ's flesh and blood. Moreover Giotto tried to emphasize the visual resemblance of both scenes. Despite the Byzantine tradition, followed by Cavallini and Duccio and many other masters of the thirteenth and fourteenth centuries,[15] Giotto re-established in his *Nativity* the shed of Early Christian iconography, with a parallel in the edifice of *The Last Supper*. Giotto placed Christ in *The Last Supper* and the Virgin in *The Nativity* at the left part of the composition and insisted upon their resemblance by emphasizing both the Virgin's and John's tenderness towards Christ.

A correspondence again appears between the pictures of the next pair, *The Adoration of the Magi* and *The Washing of the Feet*, in resemblances of composition and meaning [text illus. 1B] The *Adoration* shows the genuflection of the wise man before the feeble and poor Child, born in a stable among oxen and asses. *The Washing of the Feet* represents the genuflection of the Teacher before his disciples, of the God before feeble, sinful men. In order to underline this resemblance Giotto placed the Virgin not in the left half, as customary in Byzantine painting, but in the right, as Niccolò Pisano and many other Italian masters before him. Among the apostles of the *Washing* he set two young men with pitchers to correspond with the young King holding the incense-vessel in the *Adoration*. In the *Washing* he used a genre motif unknown to Byzantine masters,[16] an apostle lacing his sandal; in the corresponding part of the *Adoration* another genre motif appears—the servant curbing a camel.

In the next pair of frescoes Giotto attempted a more difficult correspondence. He omitted *The Hiring of Judas*, that in Duccio's *Maestà* preceded *The Kiss of Judas*,[17] and placed it on the triumphal arch [text illus. 3L]. In spite of the iconographical tradition he inserted *The Presentation of Christ in the Temple* between the *Adoration* and *The Flight into Egypt*; and he omitted *The Prayer on the Mount of Olives*. In this manner the *Presentation* could be paired with *The Kiss of Judas* [text illus. 1C]. Both scenes represent a meeting of groups of

[14] E. Mâle, *op. cit.*, p. 222.
[15] F. Noack, *Die Geburt Christi in der bildenden Kunst bis zur Renaissance*, Darmstadt, 1894, p. 32.
[16] G. Millet, *op. cit.*, p. 332.
[17] C. H. Weigelt, *Duccio di Buoninsegna*, p. 243; *idem, Giotto*, p. xix.

figures: in the *Presentation* the Virgin, Joseph, and a woman meet Simeon and Anna. In *The Kiss of Judas* Christ and his disciples encounter the traitor and the soldiers. Both meetings prefigure later events. In the *Presentation*, Simeon looking on the Child prophetically denotes his glorious future. In *The Kiss of Judas* Christ penetratingly divines in Judas' eyes the fatal conclusion of his terrestrial life. At the right in both scenes a person, with outsertched hand, draws attention to the principal action: in the *Presentation* it is the prophetess Anna: in *The Kiss of Judas* a bearded man.

In *The Flight into Egypt* and in *The Entry into Jerusalem*, the Virgin and Christ both ride asses. For this reason alone the two scenes might be juxtaposed. But Giotto preferred to follow the historical sequence of events. And he was concerned with more than the mere visual resemblance of scenes. Therefore he placed *The Flight into Egypt* over the *Christ Before Caiaphas*, and made apparent the affinity of their meaning [text illus. 1D]. In *The Flight into Egypt* the Virgin shows courage and peace of mind in spite of the danger menacing her Child. In the lower fresco Christ himself maintains a similar tranquillity although he stands bound before his enemies.

Next in order, *The Massacre of the Innocents* mirrors *The Mocking of Christ* [text illus. 1E]. The Massacre was performed according to the command of King Herod; his majestic figure appears in the upper part of the picture. The Mocking of Christ was committed in presence of imperial representatives, witnesses of the brutal scene. It is not by chance that these two most turbulent and noisy scenes of the Paduan cycle were placed by Giotto one over the other.

A further affinity appears in the next pair of frescoes on the north wall: the young *Christ in the Temple* [*Christ Disputing with the Elders*] and the *Bearing of the Cross* [*The Road to Calvary*], pictures of Christ beginning his activity as a preacher and of Christ beginning his way to Golgotha [text illus. 2F]. The resemblance of the frescoes is stressed by an incident common to both scenes—the parting of Christ from his nearest relatives. In the first scene the Virgin and Joseph enter the temple and bid Christ to return; in the second the Virgin is struggling to make her way through the crowd to her Son. This latter motif was unknown to Byzantine iconography, but appears in the fresco of Cavallini's school in Santa Maria di Donna Regina in Naples.[18] Giotto enhanced the parallel by placing the Virgin in both frescoes near the left border.

The correspondence between the *Crucifixion* and the *Baptism* is obvious [text illus. 2G]. Mediaeval iconography regarded Jordan's

[18] E. Bertaux, *Santa Maria di Donna Regina e l'arte senese a Napoli*, Naples, 1889, p. 44, pl. III.

water in the Baptism as the prototype of the blood shed by Christ on Golgotha:[19] but the Crucifixion was never juxtaposed with the Baptism. Giotto, chiefly interested in dramatic resemblance, placed the triumphant, nude figure of Christ just at the dominant center of each composition. The resemblances do not end with the figure of Christ. To His left in the *Baptism* we see angels holding his clothes; in the *Crucifixion* warriors ready to cast lots hold his clothes. Both motifs came from mediaeval iconography. But their juxtaposition has to be explained by Giotto's particular aims.

The iconographical tradition did not permit Giotto to establish correspondence between all scenes. However it is scarcely pure chance that instead of *The Descent from the Cross* Giotto placed *The Lamentation* [*The Pietà*] under *The Wedding in Cana* [text illus. 2H]. Both frescoes represent Christ among his nearest friends, but in one case he gives them and especially His Mother an unexpected joy by His miracle; in *The Lamentation* He is the source of their boundless sorrow. The Virgin bends over her beloved Son and looks in His eyes, as if hoping to find life in them. In opposition to the preceding pair with its verticals and in opposition to the usually diagonal composition of the Descent[20] a calm horizontal predominates in both frescoes.

The visual affinity between *The Resurrection of Lazarus* and *The Angels at the Sepulchre* is not strong [text illus. 21]. But by connecting in the lower picture the representation of the angels sitting on the empty tomb with the *Noli me tangere* above, Giotto gave the frescoes a certain resemblance. The frescoes represent Christ as the conqueror, first of Lazarus' death, and second of His own. In *The Resurrection of Lazarus* the sisters are prostrated before Christ in acknowledgment of the salvation of their brother. In the *Noli me tangere* we find one of the sisters in the same posture before the resurrected Christ, expressing her deepest love to Him.

The correspondence of *The Entry into Jerusalem* and *The Ascension* is beyond doubt [text illus. 2J]. Both frescoes represent Christ's triumph amidst his disciples. In the upper fresco He enters the terrestrial Jerusalem to the applause of its inhabitants. In the lower fresco He ascends to the celestial Jerusalem applauded by angels.[21] Giotto abandoned the symmetrical Byzantine type of Ascension with frontal Christ, adopting the western mediaeval type with Christ in profile.[22]

[19] H. v. d. Gabelentz, *op. cit.*, p. 105.

[20] G. Millet, *op. cit.*, pp. 467–488.

[21] On Jerusalem in its historical and anagogical meanings: E. Mâle, *op. cit.*, p. 270.

[22] N. V. Pokrovskii, *Evangelie v pamiatnikakh ikonografii preimushestvenno vizantiiskikh i russkikh*, St. Petersburg, 1892.

Only two angels accompanied Christ in the fresco of the Upper Church of San Francesco at Assisi,[23] but at Padua a great host of angels fills Heaven, as if echoing the crowds of Jerusalem.

Contrary to this, *The Cleansing of the Temple* [*The Expulsion of the Merchants from the Temple*] and *The Descent of the Holy Spirit* [*The Pentecost*] have almost nothing in common [text illus. 2K]. *The Cleansing* represents the purification of God's house, *The Descent* the purification of men's minds thanks to which the Holy Spirit descends on them.[24] But the visual effect of the scenes is quite different. Nevertheless Giotto took care to give a certain resemblance to their architectural backgrounds. *The Descent* is decorated with arches similar to those of the Temple in *The Cleansing*.

Finally the parallelism of two scenes on the triumphal arch [fig. 3] is clearly expressed.[25] Together with the *Annunciation* these two scenes are different in meaning and similar in form. They represent the meeting of two persons having something to communicate to each other. *The Hiring of Judas* [*The Pact of Judas*, text illus. 3L] was extracted from the Passion, where, according to the text, it would have appeared before *The Kiss of Judas*. It is bound with the adjoining *Cleansing* [text illus. 2K] because two Pharisees are repeated in both frescoes. The evil meeting of Judas with the priests is assimilated to the calmly joyous meeting of the Virgin with Elizabeth [text illus. 3M], which in turn has something in common with the Annunciation. The painter was interested not so much in the meaning as in the visual likeness of these two scenes, a likeness heightened by color. *The Hiring of Judas* is composed in the triad yellow, red, green, and *The Visitation* in green, red, yellow. These color relations securely bind both frescoes on the triumphal arch.

Fifteen years ago, when I first noticed this singularity of Giotto's Paduan cycle[26] I was in doubt whether the parallelisms among the frescoes were owing to mere chance. Indeed a strong regularity is lacking: some frescoes are visually very much alike, others are unlike, and still other pairs have almost nothing in common. However it is sufficient to imagine shifting the frescoes to remove this doubt. If *The Hiring of Judas* be transferred from the triumphal arch to its natural

[23] A. Aubert, *Die malerische Dekoration der San Francesco Kirche in Assisi: ein Beitrag zur Lösung der Cimabue Frage*, etc., Kunstgeschichtliche Monographien, VI, Leipzig, 1907, pl. 54. A. Nicholson, "The Roman School at Assisi," ART BULLETIN, XII, 1930, pp. 288–289, fig. 42.

[24] A similar contrast between the Christ in glory and the tumultuous healing at the foot of the mount appears in Raphael's *Transfiguration*.

[25] Already noted by C. H. Weigelt, *Giotto*, p. xix.

[26] This interpretation was first published in Russian. M. Alpatov, *Italianskoe iskusstvo epokhi Dante i Dzhotto*, Moscow, 1939.

narrative position, then all frescoes of the lower series must be moved over one place, and all our relationships immediately disappear.[27]

Giotto's attempt to establish a parallelism between the events of Christ's childhood and Passion probably came to his mind from the well-known mediaeval system of concordances between the Old and the New Testaments.[28] The basilicas of St. Peter and St. Paul at Rome were decorated with cycles of Old and New Testament pictures, executed partly in the early Middle Ages, and partly in the thirteenth century by Cavallini.[29] There is every probability that they attracted Giotto's attention during his activity in Rome. We may suppose that he himself followed a similar scheme in his latest frescoes in the Royal Chapel and at the monastery of Santa Chiara in Naples.[30] Concordances also appear in the decoration of the Sistine chapel, carried out by the outstanding Italian masters of the fifteenth century. On the north wall of the Arena chapel we find biblical prototypes in medallions on the frames of the pictures of Christ's childhood and Passion: Elias' Ascension is represented side by side with Christ's Ascension. The Appearance of God before Moses is shown next to the Descent of the Holy Spirit.[31] But Giotto left the execution of these medallions, with their traditional parallelism, to his pupils.[32]

The concordance between the two rows of Giotto's pictures of Christ's life is of a quite different kind. The aim of mediaeval typology was to show the mysterious relation between prophecy in the Old Testament, and its fulfillment in the New Testament.[33] By arranging his frescoes in pairs Giotto followed the traditional method of parallel correspondence or dittochaeum, but without finding prophecy of the

[27] In this case the frescoes form other pairs: *The Presentation* and *The Hiring of Judas; The Flight into Egypt* and *Judas' Kiss; The Massacre of Innocents* and *Christ before Caiaphas; Christ among Doctors* and *The Scourging of Christ; The Baptism* and *Christ Bearing the Cross; The Marriage at Cana* and *The Crucifixion; The Raising of Lazarus* and *The Lamentation; The Entry into Jerusalem* and *Noli me tangere*, etc. None of these pairs has any special meaning and visual resemblance.

[28] W. Molsdorf, *Führer durch den symbolischen und typologischen Bilderkreis der christlichen Kunst des Mittelalters*, Leipzig, 1920, p. 10.

[29] J. Garber, *Wirkungen der frühchristlichen Gemäldezyklen der alten Peters- und Pauls-Basiliken in Rom*, Berlin–Vienna, 1918.

[30] G. Vasari, *Le Vite*, ed. G. Milanesi, Florence, 1906, 1, p. 390.

[31] Similar parallelism: Laib and Schwarz, *Biblia pauperum*, Zurich, 1867, pl. xxxii; *Christ's Ascension* and the *Ascension of Elias*. Later examples appear in Tintoretto's pictures in the Scuola di San Rocco: E. v. Bercken and A. Mayer, *J. Tintoretto*, Berlin, 1923, pp. 168–172.

[32] C. H. Weigelt, *Giotto*, p. 97, figs. 57, 58 ff.

[33] A parallel between Christ's life and the fables of Ovid was drawn in an illustrated manuscript of the fourteenth century. F. Piper, *Mythologie der christlichen Kunst*, Weimar, 1847, 1, p. 148.

Passion in the events of Christ's childhood and preaching. Hence Giotto proceeded, not as an illustrator of common dogma, but as an innovator, emphasizing in his program the internal similarity of two periods of Christ's life. Having no forerunners for such an iconography, Giotto independently groped for a solution. The novelty of the task accounts for the juxtaposition of scenes, with different grades of resemblance, and that in some cases have little in common.

Part II

Thus Giotto gave a new meaning to the traditional pictures. Beyond the miraculous and dogmatic story of Christ's life Giotto brought forth its internal development and human meaning. These dramatic meetings of people, their tenderness for one another, the parting of people from their relatives, the perseverance of a hero in disaster, His worship as a deliverer from evil and His public triumph, all appear on the walls of the Arena chapel. For the first time in the history of art the eternal moral values were clearly expressed by Giotto in the traditional evangelical scenes.

No literary sources now support such an interpretation of the Paduan frescoes, and it may be doubted whether a text existed. Giotto himself solved these problems in his art,[34] and not as the simple illustrator imagined by van Marle and others.[35] An indirect confirmation of our interpretation of Giotto's frescoes may be seen in two passages of Dante's *Divina Commedia*. The first (*Purg.* x, 28–96) tells us how the poet considers the reliefs representing the famous examples of mildness: the Annunciation, King David with his wife, and the Emperor Trajan with the widow. The contemplation of these scenes will deliver the inhabitants of the Holy Mountain from vice. Dante describes the effect of the three reliefs with bright, picturesque words. The subjects are taken from the three chief sources of the Middle Ages: the New Testament, the Old Testament, and antiquity. Two figures predominate in each composition. The three scenes are united not by the development of events, but by their internal likeness. They show different aspects of the same virtue: the humble Virgin expresses her emotion with but a gesture as if saying "Ecce ancilla Dei"; David shows his submissiveness to God's will by a wanton dance, without

[34] R. Fry, *op. cit.*, p. 164.
[35] R. v. Marle, "Giotto narrateur," *Revue de l'art ancien et moderne*, L, 1926, pp. 229 ff.

regard to the disapproval of his wife; the powerful Emperor Trajan humbly listens to the widow's entreaty for justice.

Entering the third round of Purgatory Dante sees three images of mildness (*Purg.* xv, 85–114). In this case the poet speaks of his visions, but they are described as if they were a sequence of pictures. Dante does not mention the Virgin by name: we guess that the poet sees Her and the Child Christ in the temple among the wise men, as in the Paduan fresco, which was confronted by Giotto with Christ bearing the cross. Dante juxtaposes this scene with the mild Peisistratos of Athens, and with the young Stephen being stoned—confronting Gospel, Antiquity, and the Sacred Legend.

Dante wrote within ten years after the completion of the Arena chapel walls. The appeal of Virgil to his pupil to transfer his attention from one composition to another ("non tener pur ad un loco la mente," *Purg.* x, 46) shows how Giotto's contemporaries were accustomed to regard sequences of reliefs or frescoes.[36] But we have no reason to identify Giotto's aesthetic convictions with those of Dante.[37] It is well known that Giotto's Last Judgment differs in many points from the description of infernal tortures in Dante's poem. Giotto does not reinforce the moral and edifying meaning of the traditional scenes so insistently as Dante.[38] But it is worth recalling that Dante's interpretation of the Gospel has much in common with that of Giotto. In Byzantine and Western mediaeval iconography the Annunciation has always been considered above all as an illustration of the dogma of incarnation.[39] In juxtaposing it with David and Trajan, Dante had emphasized its moral meaning. Giotto too has attempted in his frescoes to show the human significance of the sacred legend.

These features of Giotto's cycle determine its outstanding place not only in the history of painting, but also in the history of ideas. We have never had an entirely clear view of Giotto's personality and his

[36] These characteristics were passed over by Dante's later illustrators (e.g., Franco de'Russi, fifteenth century, *L'Arte*, 1900, pp. 354–355, figs. 8–9).

[37] Earlier studies of the Dante–Giotto problem were based on the famous text, *Purg.* xi, 94–96, or on the allegories in the Lower Church at Assisi. E. Walser, *Gesammelte Studien zur Geistesgeschichte der Renaissance*, Basel, 1932, p. 266, denied the influence of N. Pisano's reliefs on Dante's strophes, *Purg.* x, 28–96, but did not mention Giotto's frescoes. Personal relations between the poet and the artist were suggested long ago. See A. Belloni, "Nuove osservazioni sulla dimora di Dante in Padova," *Nuovo archivo veneto*, n.s., xli, 1921, pp. 40 ff.

[38] As the *Art Bulletin*, iv, 1921–1922, is lacking in the libraries of Moscow the author could not consult J. Shapley's article, "A Note to Purgatorio x, 55–63."

[39] H. v. d. Gabelentz, *op. cit.*, p. 97.

opinions.[40] However, a collection of anecdotes about Giotto as a free-thinker[41] allows us to glimpse the historical reality noticed by his contemporaries—namely, his intimacy with the forward thinkers of his time who tried to understand the "spiritual meaning" veiled behind the "textual meaning" of the holy legend. Both the Averroists, defenders of natural religion,[42] and the Joachimites, investigators of the problem of regular, cyclical development of mankind,[43] agreed upon the interpretation of texts. The doctrine of the four meanings of the legend,[44] adopted by Dante,[45] does not contradict these ideas. Without entering into details I shall only mention now that Giotto's Paduan frescoes must be included among these problems.[46]

The "parallel" interpretation of the Paduan cycle points the way to a renewed appreciation of Giotto's art. In the nineteenth century the historians of Italian art studied its human, moral content. Later Giotto's plastic values were brought under analysis.[47] The composition of the whole Paduan program shows that Giotto attended to both tasks; he succeeded in showing the moral basis of the legend, and the spiritual significance of its events; and at the same time he sought to emphasize their visual resemblances. The most impressive juxtapositions, such as *The Washing of the Feet* and *The Adoration*, show Giotto's understanding of spiritual resemblance, achieved by the disposition of figures, the rendering of form, and by the deep conception and plastic rendering of visual reality. All these features were foreign to the old "Concordia Veteri et Novi Testamenti." In the light of these facts, B. Berenson's words about Giotto[48] gain a deep and

[40] A. Chiapelli, "Giotto poeta," *Nuova antologia*, cccxxx, 1927, pp. 129–143.

[41] J. Huizinga, *Wege der Kulturgeschichte*, Munich, 1932, p. 121, considers Giotto as a free-thinker. C. Frey, *Il Codice magliabecchiano*, Berlin, 1892, p. 227, Sacchetti, Boccaccio and others on Giotto.

[42] G. Toffanin, *Storia dell'umanesimo*, Naples, 1933, p. 102, considers two bearded men in turbans in the Paduan *Presentation of the Virgin* as types of Paduan Averroists, representative of unbelief.

[43] W. Windelband, *Geschichte der Philosophie*, Tübingen and Leipzig, 1900, pp. 151–156.

[44] E. Mâle, *op. cit.*, p. 170.

[45] K. Vossler, *Die göttliche Komödie*, Heidelberg, 1907–1910, pp. 197–198; *idem*, *Poetische Theorien in der italienischen Frührenaissance*, Berlin, 1900, pp. 6–18.

[46] Following H. Thode's *Franz von Assisi*, Berlin, 1904, Giotto's art has usually been connected with the Franciscan movement. See also H. Schrade, "Franz von Assisi und Giotto," *Archiv für Kulturgeschichte*, xvii, 1927, pp. 150 ff.; Rintelen, *op. cit.*, pp. 42–43.

[47] R. Salvini, *Giotto*, Rome, 1938, pp. xx–xxvii.

[48] B. Berenson, *Florentine Painters of the Renaissance*, New York–London, 1896, p. 19.

thoughtful meaning: "His thoroughgoing sense for the significant in the visible world enabled him so to represent things that we realise his representations more quickly and more completely than we should realise the things themselves."

DOROTHY C. SHORR,
The Role of the Virgin in Giotto's *Last Judgment**

Giotto's fresco representing the Last Judgment [fig. 74] covers the entire west wall of the Arena Chapel in Padua. Although it thus occupies the conventional place assigned to this subject in Byzantine churches, and although the composition is based on the conventional Byzantine formula, the event is represented in a new way and reveals a number of new aspects, some of which are unique. It will be shown that these new aspects have their literary origin in early Byzantine legend and that the unique way in which the event is represented reflects the personal requirements of the donor of the chapel who commissioned Giotto to decorate its walls.

In the first place, Giotto has eliminated the horizontal bands that divide the Byzantine composition into strips,[1] and has discarded the separate compartments in which various episodes of the Last Judgment are usually represented.[2] Instead, the entire scene has now been unified and the action develops in a sweeping upward and downward rhythm.

A second innovation is the emphasis upon the groups of the Blessed at the right hand of Christ seated in judgment, contrasting with the almost summary way in which the Damned are represented at the left of the throne. The Elect are shown as large individual figures, climbing upward to Paradise, whereas the Damned and the devils (with the exception of Satan himself), are seen as diminutive and unemotional figures precipitated downward into Hell in the fiery river of Byzantine tradition. The almost objective aspect of the latter scene is enhanced by the absence of the customary avenging angels

* *The Art Bulletin*, XXXVIII, 1956, pp. 207–214.

[1] The only remains of these strips are seen in the platform upon which the apostles are seated. But Giotto has curved the ends in a new way to give a sense of depth to these seated groups.

[2] A somewhat similar unification of the scene is met with on the four pulpits of Niccolo and of Giovanni Pisano (two in Pisa [figs. 93, 94], one in Siena and one in Pistoia [fig. 95]. This, however, may be due in part to exigencies of space.

enthusiastically driving the Damned to their doom. Lacking, too, are the sadistic details with which the artist commonly represents the various tortures of Hell with the intention of striking terror into the heart of the beholder. Instead, the fate of the lost souls seems inexorable and comparatively remote in spite of the activity of the little figures themselves and the naturalistic way in which they are represented. Borne downward by the rushing river of fire, they seem to be entirely unperceived by all the other participants in the event of the Last Judgment; only the left hand of Christ, turned downward in a gesture of rejection, and the anger reflected on his brow, reveal his awareness of these souls condemned to eternal punishment. The Savior's beneficent attention is concentrated upon the mounting rows of the Blessed at the right of the throne. It is toward them that his body, head, and glance are directed, toward them that his right hand is extended in a gesture of acceptance and welcome.

The most unusual feature, however, of this left side of *The Last Judgment* is the commanding figure of the Virgin, together with her action and the position that she occupies among the Elect, halfway between Heaven and earth [fig. 75]. For her regal form, isolated by her height and by the mandorla in which she seems to float, dominates the entire left side of the scene and is second in size only to that of Christ himself; while her action, as she turns her head to gaze downward with an expression of noble compassion at the kneeling figure whose arm she grasps, emphasizes in a particular way her close relationship to mankind and the intimate role that she plays in its salvation at the Day of Judgment.

This position of the Virgin among the Elect, halfway between Heaven and earth,[3] differs from that of the usual Eastern and Western representations of the Last Judgment. These show her standing, kneeling, or seated at the right of the throne, her hands raised in prayer as she intercedes for the salvation of mankind, while John the Baptist occupies a similar place at the left of the throne.[4] Giotto has omitted this representation of the Deïsis, placing the emphasis not on this customary formal act of intercession but on the relationship between the Virgin and those who look to her for their salvation.

To understand the idea underlying this unique representation of the Last Judgment, it is necessary to examine the history both of the

[3] For the motif of the Virgin standing among the Blessed, see R. Offner, *Corpus of Florentine Painting*, New York, 1947, III, sec. v, p. 257 n. 15.

[4] Occasionally John the Evangelist may replace the Baptist, especially in Gothic sculpture from the thirteenth century onward. See O. Gillen, *Ikonographische Studien zum Hortus Deliciarum*, Berlin, 1931, pp. 10–11.

Arena Chapel, for which the fresco was painted, and of Enrico Scrovegni, the donor who built it and commissioned Giotto to adorn its walls with scenes from the life of the Virgin and of Christ.

When the donor of a church or chapel dedicated his gift to Christ, to the Virgin, or to the titular saint, he probably did so with the implied, sometimes expressed, hope that they would remember him favorably at the Day of Judgment.[5]

Enrico Scrovegni was undoubtedly animated by this hope. A wealthy citizen of Padua, he had inherited a large and ill-gotten fortune from his father Reginaldo, a wealthy and unscrupulous usurer whom Dante had placed in the seventh circle of Inferno.[6] It is therefore not unlikely that when Enrico acquired for private family use the chapel adjoining his new palace, he did so chiefly in the hope of expiating his father's crimes. This probability is, at any rate, reenforced by Scardeone's statement in 1560 that Scrovegni erected the chapel "pro eripienda patris anima a poenis purgationis et ad illius expianda peccata."[7]

This little church, which stood on the site of an earlier one dedicated to S. Maria Annunziata, is situated in what was originally a Roman arena. Scrovegni rebuilt it as his private chapel ca. 1303.[8] He rededicated it to S. Maria della Carità, this word having the contemporary connotation of Divine Love or Compassion, the Latin equivalent being *misericordia* or *commiseratio*.[9] Thus, by the early fourteenth century, a number of names had come to be connected with the little Paduan church; not only was it known as S. Maria Annunziata and S. Maria della Carità, but it was further identified as

[5] The motif of the Roman emperor presenting a temple to a pagan divinity is probably first represented in Asia Minor (G. J. Elderkin, "A note on a Mosaic in Hagia Sofia," *Art in America*, January 1938, pp. 28–31). The earliest representations of a donor offering a church to Christ or to the Virgin date from the sixth century and may be seen in S. Vitale, Ravenna, in Parenzo, and in S. Lorenzo fuori le Mura, Rome. Here the hope of salvation would seem to be implicit. But in the twelfth century, Suger, the outspoken abbot of St.-Denis, explicitly utters the hope that he will receive the benefits that he considers his due. Inscribed on the door was the following prayer: "For the splendor of the church that has fostered and exalted him, Suger has labored for the splendor of the church. Giving Thee a share of what is Thine, O Martyr Denis, he prays that he may obtain a share of Paradise." Elsewhere is inscribed: "Receive, O stern Judge, the prayers of Thy Suger; grant that I be mercifully numbered among Thine own sheep." (E. Panofsky, *Abbot Suger . . .* , Princeton, 1946, pp. 47, 49.)

[6] *Inf.* cxvii, vv. 64 ff.

[7] A. Moschetti, *The Scrovegni Chapel . . .* , Florence, 1907, p. 12.

[8] *ibid.*, pp. 16–19.

[9] *Vocabolario degli Accademici della Crusca*, Florence, 1729, I, p. 568.

S. Maria della Rena from the Roman amphitheater in which it stood.[10] At the beginning of the fourteenth century, however, it seems to have been known chiefly by its new name of S. Maria della Carità, for Scrovegni in his will refers to "ecclesia Sancte Marie de caritate de l'arena de Padua" when requesting that his body be placed in the apse of this chapel.[11] Moreover, a contemporary Paduan chronicler, Giovanni da Nonno, refers to "Henricus de Scruffegnis . . . fecit etiam fieri ecclesiam sancte Marie a Caritate in loco Arena,"[12] while a papal bull of Benedict XI informs us that this pope, on March 1, 1304, granted indulgences "pro visitantibus ecclesiam b. Mariae Virginis de Caritate de Arena, civitatis Paduae."[13]

But although the new chapel had been dedicated to S. Maria della Carità (obviously for personal reasons), the Annunciate Virgin seems to have remained a titular saint of the new church. This may well be due to the fact that the former church of S. Maria Annunziata in the Arena had always played an important part in the lives of the citizens of Padua, having long been connected with the official celebration of the Feast of the Annunciation. This included a procession of ecclesiastics, leading citizens and townspeople to the Arena, where a mystery play representing the event of the Annunciation was performed before the church. Although this festival was suspended between the years 1300 and 1306, the period during which Scrovegni's chapel was being rebuilt, it was then resumed and continued to be a public event of special importance.[14] Thus, in spite of the private nature of his chapel, upon which Scrovegni frequently insists,[15] the little church nevertheless appears to have also maintained its public character. Further evidence that S. Maria Annunziata retained her patronage of the new chapel in spite of its dedication to S. Maria della Carità, is seen in the fact that the foundation and consecration of this new church were celebrated on March 25, the Feast of the

[10] Whether churches at this period were frequently dedicated to S. Maria della Carità, it is impossible to say. Today, they appear to be extremely rare and I am unable to find a reference to any. Although contemporary documents refer to the chapel by its new name, this evidently was not permanently accepted and by the next century, Ghiberti reverts to the earlier form: "la chiesa della Rena di Padova" (*I Commentari*, II, 3, ed. J. von Schlosser, *Lorenzo Ghibertis Denkwürdigkeiten*, Berlin, 1912, I, p. 36); while an eighteenth-century guidebook, *Le cose più notabile di Padova*, Padua, 1791, p. 34, refers to the chapel as "S. S. Annunziata dell'Arena."

[11] Moschetti, *op. cit.*, p. 25.

[12] I. B. Supino, *Giotto*, Florence, 1920, p. 137.

[13] *ibid.*, p. 118.

[14] Moschetti, *op. cit.*, pp. 12–14, 19.

[15] *ibid.*, p. 24.

Annunciation.[16] The same tradition is undoubtedly reflected in the prominence given by Giotto to the scene of the Annunciation on the apsidal arch of the chapel, as well as to the figure of the Annunciate in the donor group of *The Last Judgment.*

In the lower part of the fresco of the Last Judgment and forming an important element of the composition, Giotto has drawn a group of five figures, one of whom represents Enrico Scrovegni, together with a monk whose name still remains undetermined [fig. 77]. Both men kneel before three standing figures with haloes, whose identity has been variously interpreted, from Selvatico's "tre donne" in 1859[17] to Toesca's "Madonna and the pensive saints" some seventy years later.[18] Only Supino has, I believe, identified these three standing figures correctly although, apparently, unconvincingly since subsequent writers ignore or reject his interpretation. "Here we have in the center," writes Supino, "the Queen of Heaven, the crowned Virgin; at her right the archangel Gabriel the Annunciator, at the left the Annunciate Virgin. Thus the three figures illustrate the two titular saints of the church: S. Maria Annunziata and S. Maria della Carità"[19] It will be seen not only that Supino is probably correct in his interpretation of this central figure as S. Maria della Carità but also that it is just this compassionate aspect of the Virgin that plays such a dominant role in Giotto's representation of the Last Judgment.

Of the five figures comprising the group, that of the donor, Enrico Scrovegni, is represented as the most important, reflecting a new and more direct relationship between man and the Deity than had previously obtained.

His large figure emerges from the blue background and is almost isolated from the rest of the group composed of the three celestial figures and the kneeling monk who supports the chapel. It will be noted that Scrovegni performs two separate yet evidently related

[16] C. H. Weigelt, *Giotto*, Berlin, 1925, p. xiv.

[17] P. E. Selvatico, *Scritti d'arte*, Florence, 1859, p. 257.

[18] P. Toesca, *Florentine Painting of the Trecento*, New York, 1929, p. 32. These three figures have also been identified as: three theological Virtues with Charity in the center (Moschetti, *op. cit.*, pp. 62–64); the Queen of Heaven with St. John at her right and possibly a patron saint at her left (A. Venturi, *Storia dell'arte italiana*, Milan, 1907, v, p. 393); three celestial figures (F. Rintelen, *Giotto und die Giotto-Apokryphen*, Munich, 1912, p. 106); the central figure probably the Virgin of the Annunciation, Gabriel at her right and the third figure is not to be identified (Weigelt, *op. cit.*, p. xli); the central figure is Mary, the patroness of the church, Gabriel at her right, the name of the other saint is unknown (H. Thode, *Giotto*, Bielefeld, 1926, p. 122 n. 49).

[19] Supino, *op. cit.*, pp. 137–138 (and 1927 edition, p. 60).

actions: with his right hand, he offers the chapel to the outer standing figure, that of S. Maria Annunziata, the original patron saint, who rests her hand in a proprietary manner upon its roof as she accepts the building and looks down at the donor. Scrovegni also raises his left hand toward the tall central figure of S. Maria della Carità, who graciously extends her right hand in token of acceptance. The peculiar significance of this gesture is emphasized by the proximity of the two hands, dramatically isolated against the blue background, as they emerge from the cubic density of the bodies, while the complete profile of the two heads further accentuates the immediacy of the relationship. The Virgin, with an expression of noble benevolence, inclines her head slightly toward the suppliant who kneels before her and gazes up into her face with parted lips that almost suggest speech. Because of this close physical and psychological relationship between the figures of Scrovegni and of S. Maria della Carità, these gestures of supplication and acceptance seem to be of primary importance, whereas the giving and the receiving of the chapel appears, in comparison, almost a perfunctory act.

On the far side, and as a pendant to the Annunciate Virgin, stands Gabriel, his lowered glance and folded arms proclaiming his limited participation in the event. Indeed, his appearance here would seem to be due only to his connection with the Annunciate; nor would it be easy to identify her in this posture without his presence. For the figures of the Annunciate and of the Archangel Gabriel in this group differ from those of the same two figures in the scene of the Annunciation which Giotto has painted on the apsidal arch of the Arena Chapel [figs. 22, 23]. Although the standing Annunciate of the group wears a blue mantle, her gold-bordered robe of white and the jeweled coronet are similar to those worn by the young Virgin in the scenes of her Presentation in the Temple (here her youth precludes the diadem), her Marriage and her Return from the Temple [figs. 15, 18, 19], whereas the kneeling Virgin in the scene of the Annunciation is clad in a crimson gown embroidered in gold, her hair worn in a coronet of braids. The standing Gabriel of the group, with his lightly-indicated beard and mustache and his square-cut hair, differs greatly from the kneeling archangel of the Annunciation, with his youthful face and wavy locks parted in the center and surmounted by a diadem.

The tall central figure of the group, presumed to be that of S. Maria della Carità, is clad in a white robe beneath a crimson tunic embroidered with a gold rectangular design across the breast. Similarly clad, the Virgin is also shown in a number of scenes of Giotto's fresco cycle—*The Annunciation* (as mentioned above), *The Visitation, The*

Nativity, *The Adoration of the Magi*, and *The Flight into Egypt* [figs. 23, 24, 25, 27, 29]. The first two scenes show the Virgin with her hair worn in a coronet of braids, while in the three later scenes a blue mantle partly or completely covers her head. The Virgin of the donor group, however, for the first time wears a jeweled crown over a transparent veil, proclaiming her Queen of Heaven. It is thus evident that the attire of the sacred figures represented in Giotto's fresco cycle must not be interpreted too narrowly nor used too rigidly as a means of identification.

There can, however, be little doubt that the central crowned figure is represented again higher up on the same wall at the head of the Blessed and that both these tall, regal figures represent the Virgin to whom Scrovegni dedicated his chapel—S. Maria della Carità. Moschetti[20] has recognized this identity, while Foratti[21] observes that the central figure of the donor group wears the same dress as does the Virgin represented above but that their crowns are different. The crown of the upper Virgin has, however, been repainted and traces of a wider jeweled band are still visible.

Although the Virgin's regal figure dominates the entire group of the Blessed as they ascend to Heaven, she is isolated from them by the mandorla in which she stands and by the five angels who surround her. The only figure included in this separate group is a kneeling female personage clad in a mantle, whose arm the Virgin grasps as she gazes downward into her face.

Who is this personage—and a woman at that—who receives such special attention? She has been interpreted as St. Anne, mother of the Virgin,[22] but there seems to be no foundation for this opinion. May she not represent Eve? Indeed, the posture of the Virgin in a mandorla who grasps the arm of this kneeling woman undoubtedly recalls that of Christ at the mouth of Hell who grasps the arm of Adam and draws him forth from Limbo.[23]

Moreover, the antithesis between Eve and Mary, "the new Eve," is frequently discussed by writers from the second century onward. "As Eve," says St. Irenaeus, "by her disobedience was the cause of

[20] Moschetti, *op. cit.*, p. 63.

[21] A. Foratti, "Il Giudizio universale di Giotto in Padova," *Boll. d'arte*, ser. II, vol. I, no. 2, p. 62.

[22] P. Jessen, *Die Darstellung der Weltgerichte bis auf Michelangelo*, Berlin, 1883, p. 43; A. Foratti, *loc. cit.*; H. Thode, *Giotto*, Bielefeld, 1926, p. 122.

[23] As, for instance, in the scene above the *Last Judgment* in Torcello. The relationship between the Descent into Limbo and the Last Judgment is discussed by W. Paeseler, "Die Römische Weltgerichtstafel," *Kunstgeschichtliches Jahrbuch der Bibl. Hertziana*, Leipzig, 1938, II, p. 336.

death for herself and the human race, so Mary, by her obedience, becomes for herself and the human race, the instrument of salvation."[24]
And, as St. Jerome expresses it, "Mors per Evam, vita per Mariam."[25]

This Virgin standing among the Blessed is seen here not as their leader, as she is sometimes described,[26] since her nearly frontal posture, with head and glance directed backward, seems to halt the upward-surging figures. Nor is she the *Mediatrix*, for physically and psychologically she is unrelated to the figure of Christ seated above. But in the role of S. Maria della Carità standing among her servants, she seems to embody the very essence of protectiveness and heavenly love by virtue of her commanding figure and the concentration of her compassionate gaze.

Climbing upward toward the Virgin, their hands raised in prayer, their glances directed toward her, comes a band of haloed figures, undoubtedly patriarchs and saints. Among this group, most of whom are bearded and clad in long mantles, the figure of Moses may be distinguished; but the ruined condition of the fresco on this part of the west wall prevents further identification. The male and female figures in the ranks below have no haloes and many wear contemporary attire. They look upward and extend their hands in prayer, with the exception of St. Stephen Protomartyr, who emerges at the head of the throng and looks downward at the figure of the kneeling Scrovegni.

The angels who marshal these lower ranks of the Blessed have been compared with the similar angels of Cavallini's *Last Judgment* in S. Cecilia in Trastevere,[27] but they are closer to the angels of the Cavallinesque *Last Judgment* in S. Maria in Vescovio, Stimigliano, since they stand at the back of the continuous rows of figures instead of leading each separate group. In spite of this similarity, however, these two Cavallinesque frescoes are very different in composition from the Arena *Last Judgment* and show the Virgin in her usual place at the right of the throne.

The enormous, almost menacing Christ of Giotto's fresco shows a particular interest in the Blessed who mount toward him. His body is turned slightly in their direction as he sits on the rainbow mandorla, his right foot touching it. Head and glance are inclined to the right toward his Mother and the throng behind her climbing upward; and

[24] *Contr. Haereses*, III, cap. XXII, 4; V, cap. XIX, I (Migne, *Patr. gr.*, Paris, 1857, VII, cols. 958 ff.; 1157).

[25] Letter to Eustochium (no. XXII), *Selection and Letters of St. Jerome*, London, 1933, p. 98.

[26] J.-C. Broussole, *Les fresques de l'Arena à Padoue*, Paris, 1905, p. 187; F. Rintelen, *Giotto und die Giotto–Apokryphen*, Munich, 1912, p. 110.

[27] W. Paeseler, *op. cit.*, p. 371.

though his expression is one of anger, the *faccia dura* to which Jacopone da Todi refers,[28] his extended right hand with its welcoming gesture proclaims that his Mother's prayers have prevailed. His left hand turned downward toward the Damned is the only visible sign of his recognition of their presence, unlike his attitude in the latter part of the century when his entire attention is bestowed upon them in anger and in denunciation.[29]

This motif of the Virgin standing among the Blessed in the scene of the Last Judgment is not often represented,[30] and still rarer is the motif, seen in the Arena fresco, of the Virgin among the Blessed who is completely unrelated to the Divine Judge, her whole attention being bestowed upon the Elect among whom she stands. Indeed, the only other representation of this motif known to me occurs on the pulpit of Pisa Cathedral [figs. 93, 94], executed by Giovanni Pisano between the years 1301 and 1310 and thus contemporary with Giotto's fresco dating from ca. 1305.[31] And because it is now apparent that this Pisan *Last Judgment* illustrates episodes from a Byzantine apocalypse describing the Virgin's descent into Purgatory, a brief outline of the legend may throw some light on the motifs represented both here and in Padua.

According to this Greek narrative, which dates from the eighth–ninth century,[32] the Virgin asks the Archangel Michael to show her

[28] See M. Meiss, *Painting in Florence and Siena after the Black Death*, Princeton, 1951, p. 76 n. 13.

[29] *Ibid.*, p. 76.

[30] See note 3 above.

[31] Expressing a similar idea but treated in an entirely different manner is the scene of the Last Judgment on the façade of S. Jouin-de-Marnes. This twelfth-century sculpture shows the figure of the Virgin standing on a plane below Christ seated in majesty. Kneeling figures implore her mercy while others approach in single file. The right hand of Christ designates the Virgin below and she repeats this gesture.

[32] See C. A. Gidel, "Etude sur une apocalypse de la Vierge Marie," *Annuaire de l'Association pour l'encouragement des études grecques en France*, Paris, 1871, p. 108. Gidel publishes the Greek texts of two early (eighth? and late tenth century) incomplete manuscripts in the Bibliothèque Nationale (MSS gr. 390 and 1631) and gives an abstract rather than a literal translation of their contents. The same procedure is followed by E. Pernot, "Descente de la Vierge aux enfers d'après les mss. grecs de Paris," *Revue des études grecques*, 1900, XII, pp. 233–257. He publishes the Greek text of another incomplete manuscript (Suppl. gr. 136) dating from the sixteenth century, supplementing it with a complete and very late manuscript from Chios. Although all these manuscripts contain slight differences, the basic legend of the Virgin's descent into Hell remains unchanged, while the large number that have survived point to the continuing popularity of the legend. For the development of this apocalypse, see M. Vloberg, *La Vierge notre Médiatrice*, Grenoble, 1938, pp. 210–219.

the torments of the Damned, whereupon he conducts her to Purgatory. Here she sees men and women being tortured for various sins, a river of fire filled with souls in torment, and they proceed onward to further scenes of still greater punishment. Finally, feeling that this severity is excessive, the Virgin asks Michael to collect all the angels to implore Christ for clemency. Michael replies that in spite of their prayers, Christ refuses forgiveness. The Virgin then demands to be carried to the Divine Throne where she asks her Son's forgiveness for the sinners. "How shall I pardon them," asks Christ, "when I see these nail holes in my hands?" The Virgin replies: "I ask for Christians, not infidels." "But they have not kept my commandments," says Christ. Seeing herself powerless to move him, the Virgin then calls to her aid Moses, the Prophets, apostles, martyrs, etc. "If your Son will not listen to you," cry the sinners, "show him the stable where you gave him birth, the breasts that nourished him, the arms that held him." Finally, Christ relents, saying: "For the love of my immaculate Mother, I will give rest to the Damned from the day of my Resurrection until All Saints' Day." This legend thus serves to emphasize the efficacy of the Virgin's power to intercede with her Son for the salvation of mankind when all other means have failed.

Some of the episodes described in this legend are illustrated by Giovanni Pisano, whose *Last Judgment,* as has been said above, represents the Virgin wearing a crown and veil, standing among the Blessed toward whom she turns [fig. 93]. Kneeling figures cling to her, imploring her aid while, with her right hand, she grasps the arm of an elderly prelate with a gesture similar to that of Giotto's Virgin in the Arena *Last Judgment.* At her side stands an archangel, presumably the Michael who accompanies her in the legend. To the left of Christ, just below St. John interceding at the throne,[33] stands another figure of the crowned Virgin [fig. 94], her right hand stretched out imploringly to her Son, while with her left she bares "the breast that nourished him," perhaps the first instance of this gesture that is so frequently represented during the latter part of the fourteenth century, although usually in a somewhat different manner.[34] Again an implor-

[33] The Virgin interceding at the throne stands at the right of Christ (fig. 4). She is thus represented three times in this scene of the Last Judgment. The Torcello *Last Judgment* also shows her three times but there her gesture is always one of intercession.

[34] An elaboration of this action showing the Virgin baring her breast to her Son while Christ shows his wounds to God the Father is described by Erwin Panofsky ("Imago Pietatis," *Festschrift für Max Friedländer,* Leipzig, 1927, p. 307), as an act of "double intercession." It is illustrated in Chapter 39 of *Speculum humanae salvationis* (ca. 1324); and perhaps the earliest altarpiece is that by the late fourteenth century Florentine master, Niccolo di

ing figure clings to the Virgin and again she is guarded by an arch-angel.

Other representations of the Virgin standing among the Blessed in the scene of the Last Judgment differ somewhat from those in Pisa and in Padua, since they show her related not only to her devotees but also to the enthroned Christ above.

Perhaps the earliest instance of this variation is met with once again in the sculpture of Giovanni Pisano.[35] His *Last Judgment* carved on the pulpit of S. Andrea, Pistoia, and dating from 1298–1301, shows a crowned Virgin surrounded by kneeling and praying figures [fig. 95]; she looks upward toward the seated Christ to whom she extends her left hand, which nearly touches his lowered right.[36]

All these representations of the Last Judgment showing the Virgin among the Blessed have omitted the figure of John the Baptist in his role of co-intercessor.[37] John, however, is represented in a fresco of the Last Judgment painted in the church of S. Maria Maggiore, Toscanella [fig. 96], and derived from Giotto's composition in Padua. Here the Virgin stands upon the rocky ground and looks upward at Christ in glory, her arm protectively around the shoulders of an

Pietro Gerini. This painting on cloth, now in The Cloisters, New York, is the subject of an article by Millard Meiss in the *Bulletin of the Metropolitan Museum of Art*, XII, no. 10, June, 1954, pp. 302–317. The mystical act represented by this picture has its literary origin in the writings of Arnaldus of Chartres (*Libellus de laudibus B. Mariae Virginis*, Migne, *Patr. lat.*, Paris, 1854, vol. 189, col. 1726), who says: "Securum accessum jam habet homo ad Deum, ubi mediatorem causae suae Filium habet ante Patrem, et ante Filium matrem. Christus, nudato latere, Patri ostendit latus et vulnera; Maria Christo pectus et ubera; nec potest ullo modo esse repulsa, ubi concurrunt et orant omni lingua disertius haec clementiae monumenta et charitatis insignia." This example of the power of prayer is often referred to by mediaeval writers, while Panofsky points out (p. 286 n. 75) that the idea of the mother showing her breast to her son to soften his anger can be traced back through Latin literature to Homer.

[35] The motif of the Virgin standing on a plane below Heaven and look-ing up at Christ, to whom she raises her hand, is seen in an eleventh century panel of the Last Judgment in the Vatican Museum, Rome. Here, however, she is not related to the figures of the Blessed behind her.

[36] A fifteenth century instance of this motif is met with in a *Last Judgment* attributed to Martin Schongauer by E. Laforge, *La Vierge*, Lyon, 1844, p. 310, but not otherwise identifiable. According to this author, the painting shows a vengeful God the Father seated near his Son. The Virgin, standing at the front of the composition, looks up at Christ with an expres-sion of tender supplication, interceding for the sinners who kneel implor-ingly at her feet, their gaze fixed upon her.

[37] Except in the case of the Pisa Pulpit, where a number of traditions are combined, and the Virgin, as has been pointed out (note 33 above), is shown three times in the same scene.

elderly female figure, while behind her stands John the Baptist in a similar posture, recommending an aged man with a long beard. Bearing in mind the tentative identification of the kneeling female figure in the Arena *Last Judgment*, it is tempting to identify these two aged figures as Adam and Eve.[38]

It has been suggested above that all these representations of the Last Judgment which show the Virgin standing among the Blessed in a zone between Heaven and earth reflect the Byzantine legend of her descent into Purgatory and her conversations with its inhabitants. The Western Church, however, sees no reason for admitting a corporeal descent of the Virgin into Purgatory and holds that she can help her servants there without leaving her place in Heaven.[39] Yet if Church writers do not refer in specific terms to this corporeal descent, secular literature, especially in France during the twelfth and thirteenth centuries, abounds in such descriptions showing the miraculous indulgence of the Virgin toward individual sinners and her personal intercession on their behalf.[40] Like the Byzantine legend which they undoubtedly reflect, these *contes-dévots* tell of the Virgin's descent into Purgatory to rescue, in one instance, a repentant nun from the very jaws of Hell [fig. 97] or, again, describe her in Heaven where, kneeling at the throne of Christ and baring her breast, she implores her Son for mercy toward a dishonest knight who would build a monastery in her honor but dies unshriven [fig. 98].[41] This same Byzantine legend is again reflected in another tale, the *Cour de Paradis*, which describes a purgatorial kingdom for whose inhabitants the

[38] It must be admitted that the female figure in Toscanella, unlike the bearded patriarch, has no halo; but these do not seem to have been consistently bestowed here. A similar inconsistency is to be noted in a tenth century Byzantine ivory of Christ's descent into Limbo, which shows Adam without a halo and Eve standing next to him with a halo (A. Goldschmidt, *Die byzantinischen Elfenbeinskulpturen*, Berlin, 1930, II, fig. 41a). The motif of Christ grasping the wrists of both Adam and Eve in this scene is very common in Byzantine painting from the early fourteenth century onward; see, for example, G. Millet, *Monuments d'Athos*, Paris, 1927, I, pl. 85, 3; 129, I.

[39] See the article on the Virgin Mary by E. Dublanchy in *Dictionnaire de théologie catholique*, ed. A. Vacent and E. Magenot, Paris, 1927, IX², col. 2462.

[40] The history of the development of Mariolatry and of the miracles performed by the Virgin is traced by Comte A. de Laborde in chapters 1 and 2 of *Les miracles de Nostre Dame compilés par Jehan Miélot*, Paris, 1929. The author also gives a bibliography of the compilations of these legends from the early twelfth to the late fourteenth century (pp. 4–5, 15–17).

[41] Gautier de Coincy, *Les Miracles de la sainte Vierge*, ed. abbé Poquet, Paris, 1857, cols. 474–480, 493–500.

Virgin obtains a short respite from torture by appealing to her Son with the same maternal gesture.[42]

Hence, although the idea of such a physical and personal relationship between the Virgin and her devotees was not officially recognized by the Church, pictorial representations and secular writings of the Middle Ages suggest that this Byzantine tradition had been incorporated over the years into popular mediaeval thought and had become part of its current beliefs.

It is in this tradition, it would seem, that Giotto's *Last Judgment* has its roots. Moreover, the reason for this choice becomes apparent when it is recalled that the Arena Chapel was privately owned by Enrico Scrovegni, whose personal tastes would, therefore, undoubtedly be reflected in the program for its decoration. Since this church, dedicated to S. Maria della Carità, was built as an act of expiation for the sins of the donor's father (he who had been consigned to Hell by Dante), it is appropriate that the emphasis in this particular representation of the Last Judgment should be placed upon the idea of Salvation rather than upon the terrors of Damnation which were usually stressed, and that so much importance should be given to the figure of the Virgin as an active participant in this work of mercy. Indeed, she so dominates the left half of the composition that this scene of the Last Judgment almost assumes the character of a setting for her glorification.

And as *The Last Judgment* glorifies the figure of S. Maria della Carità, to whom the new chapel was dedicated, so, on the opposite wall, *The Annunciation*, by virtue of its size and prominent position on the apsidal arch, glorifies S. Maria Annunziata, to whom the earlier church had been dedicated and whose continuing connection with the new chapel has already been discussed.

[42] Published in *Fabliaux ou contes . . . du XII et du XIII siècle*, ed. P. J. B. Legrand d'Aussy, Paris, 1929, v, pp. 66–78. In Italy, among the *Laude drammatiche* of Perugia (*Laude drammatiche e rappresentazioni sacre*, ed. V. de Bartholomaeis, Florence, 1943, I, p. 44), is a dialogue between the Virgin and her Son to whom she speaks as follows: "Nove mese te portaie/ en lo mio ventre verginello/ a quiste poppe t'alataie/ mentre foste piccolello;/ io si te priego, se esser puote,/ che la sentenza tu revoche." This is similar to a passage in *L'Advocacie Notre-Dame*, an early fourteenth century poem attributed to Jean de Justice, canon of Bayeux (ed A. Chassant, Paris, 1855, pp. 38–39). Here the Virgin, fighting for mankind against the power of the Devil, appeals to her Son in these terms: ". . . beau douz Fils, je suy ta Mere/ Qui te portey IX mois entiers./ Tu me dois oïr volentiers . . ./ Beau Filz, regarde les mamelles/ De quoy aleitier te souloie,/ Et ces mains donc bien te savoie/ Souef remuer et berchier. . . ." Here the Virgin appeals to her Son not only with "the breast that nourished him" of the Byzantine legend, but also with "the arms that held him."

Moreover, while the action of this latter scene moves implicitly in a downward direction, as God the Father instructs the Archangel Gabriel to descend to earth with his fateful message, so the action of *The Last Judgment* emphasizes the upward-surging movement of the Blessed as they ascend from earth to Heaven, through the intervention of the Virgin. Thus these two events, Annunciation and Last Judgment, symbolizing the beginning and the end, serve to glorify the Virgin, "the New Eve," as the instrument of Incarnation and Redemption.

URSULA SCHLEGEL,
On the Picture Program of the Arena Chapel*

The following is known about the history of the origin of the Arena Chapel: it was erected from 1303 to 1305 by Enrico Scrovegni, then the richest man in Padua, in the immediate vicinity of his palace on the grounds of the Roman Arena, which he had acquired in 1300 from the Dalesmanini family.[1] Scardeone tells us that Enrico Scrovegni built the church out of piety, to wrest the soul of his father, who had acquired his riches through usury, from the torments of purgatory and to atone for his own sins: "His son, Enrico Scrovegni, pious lord, in order to redeem his soul from the punishment of Purgatory and to expiate his sins, built a most beautiful temple in the Arena."[2]

* (A lecture given at the Kunsthistorisches Institut in Florence, December 6, 1955.) *Zeitschrift für Kunstgeschichte*, vol. XX, 1957, pp. 125–146.

[1] a) A. Tolomei, *La chiesa di Giotto nell'Arena di Padova*, Padua, 1880, pp. 29 ff. (Purchase of the land, Document of February 6, 1300) [See pp. 103–105 in this book]. b) O. Ronchi, "Un documento inedito del 9 gennaio 1305 intorno alla Cappella degli Scrovegni," in *Memorie della R. Accad. di Scienze, Lettere ed Arti in Padova*, 1935/36, Padua, 1937, pp. 6, 10 f. According to this, E. Scrovegni had already received permission to build a chapel before March 31, 1302 (death date of Bishop Ottobono dei Razzi). c) Last will of Enrico Scrovegni. Tolomei, *La capp. degli Scrovegni e l'Arena di Padova*, Padua, 1881, p. 38 n. 7.

[2] Bernardinus Scardeonius, *De antiquitate urbis Patavii*, Basel, 1560, p. 332. "Huius filius Henricus Scrovinius pietate ductus, pro eripienda patris anima a poenis purgationis, et ad illius expianda peccata phanum pulcherrimum aedificavit in Arena." [See pp. 110–111 of this book.] That this statement by Scardeone follows an older tradition is proven by the excerpt from the Codex Diplomaticus ad Historiam Militiae B.M.V.G1 from the Chronicle of Giovanni da Nono (died 1346) in F.D.M. Federici, *Istoria de'Cavalieri Gaudenti*, vol. II, Venice, 1787, pp. 138 f.

He had the church consecrated to the Virgin of the Annunciation.[3] Furthermore, we know for certain that Giotto painted the main hall.[4] On its walls, which except for the west wall are divided into three picture rows, we recognize a uniform program [fig. 3]. Stories from the life of the Virgin occupy the upper level of the side walls. On the wall of the triumphal arch, in the segment between the vault and the choir opening, depictions of the life of Christ begin with the dispatch of the Archangel Gabriel. Below it, at the sides of the triumphal arch, the angel announces the message to Mary. In the mural field below the kneeling Virgin we recognize *The Visitation*, and next to it, on the same level and continuing over both side walls, the events from Christ's childhood and the occurrences that end with *The Betrayal of Judas** in the middle zone on the left wall of the triumphal arch.

The depictions of the Passion and the death of Christ, of his Resurrection and Ascension, and of the Pentecost fill the pictorial fields of the lower zones. The full height of the west wall (above the painted marble paneling, which goes around the entire hall) is reserved for *The Last Judgment* [fig. 4]. There we see Christ enthroned in Heaven in a glory of angels, as Lord of the heavens and as Judge over the world, which is divided through the cross into Paradise and Hell. The apostles sit on either side of Christ, and the hosts of angels hover above them. Below the cross held by the Archangels Michael and Raphael is the place of judgment, toward which the resurrected are led by angels, either to be pulled from there into Hell, or to be placed in the procession led into Heaven by the Virgin. The donor, Enrico Scrovegni, kneels at the place of judgment and extends his chapel as a gift of atonement to the mother of God, to whom he had consecrated it on earth.

[3] Giov. da Nono in F. D. M. Federici, *op. cit.*, p. 138 and Scardeonius, *op. cit.*, p. 332.

[4] Francesco da Barberino, *Documenti d'Amore* (cf. Peter Murray, "Notes on Some Early Giotto Sources," in *Journal of the Warburg and Courtauld Institutes*, XVI, 1-2, 1953, p. 62); Riccobaldo Ferrarese, *Compilatio Cronologica*, 1312, in *Rerum Italicarum Scriptores*, IX, 225 A; both before 1320 [see pp. 109 and 110 in this book]. Michaelis Savonarola, Commentariolus de Laudibus Patavii Anno 1440, in *Rerum Italicarum Scriptores*, XXIV, 1738, 1169 f., 1175.

* Here and throughout this article the author refers to the episode in which Judas receives the thirty pieces of silver as the Betrayal of Judas or as the Betrayal of Christ, instead of the Pact of Judas as it is called elsewhere in this volume. We retain Schlegel's nomenclature because of its importance to her iconographic analysis [Ed.]

All these representations by Giotto, which he presumably painted according to a program influenced by some spiritual adviser and in correspondence with the donor of the Chapel, seem quite comprehensible and by no means extraordinary when we consider what we know about the history of the origin of the chapel. With the help of those portions of Giotto's paintings that are unusual—according to our knowledge of the decoration of earlier or later church interiors— and which, apparently, indicate something particular because of their departure from the customary, I believe that we can explain the direct relationship between the entire building (including its decoration) and the donor, as if it were a mirror of himself and his time. First and foremost, this relationship concerns the empty areas on either side of the triumphal arch at the entrance to the choir and, above them, the depictions of The Betrayal of Christ and the Visitation [figs. 38 and 24]. It is certainly extraordinary to have on the wall of the triumphal arch the depiction of the moment when Judas, led on by the Devil, betrays his Master. Just as, above, the angel and the Virgin are brought into relationship across the arch, so is *The Visitation* associated with the other scene; that is, *The Betrayal of Christ* and the first recognition of Him on earth stand opposite each other in a very prominent place.[5] And just as these two events depart from tradition because of their placement, they also stand out from their surroundings through their colors. Although *The Betrayal* and *The Visitation* correspond in their polychromatism to the pictures on the side walls and to *The Last Judgment*, they are located on the wall of the triumphal arch between pictorial fields very subdued in color. The figureless chambers below them have a general olive-brown-yellow tone disrupted only by some blue in the vaults and the windows (which, in a way, leads over to the colors of the narrative representations); in turn, in the Annunciation pictures, a relatively duller tone, this time a reddish purple, prevails.

This coloration could not have been done without intention, and it must have significance. I believe we can find an explanation for it, first, in the history of the Scrovegni family and, secondly, in terms of medieval symbolism. Last, but not least, the interpretations of some

[5] Crowe and Cavalcaselle, *Gesch. der ital. Malerei*, I, 1869, p. 228: the birth and death of Christ in opposition. Weigelt, *Klass. der Kunst*, 1925, XIX: as far as composition is concerned none of the scenes which follow could have been so well likened decoratively to *The Visitation* as *The Pact of Judas*. The entire triumphal arch wall thus received a beautiful balance. G. L. Luzzato, *L'Arte di Giotto*, Bologna, 1927, p. 151: con passione della simmetria . . .

of the pictures will make it possible to clarify specific questions and prove our assertions.

Enrico Scrovegni owed his immense fortune to his father, Reginaldo, who had acquired his riches not through honest work but through base usury,[6] which in medieval times was considered by the Church a mortal sin.[7] After the Lateran Council of 1176, whose declaration was reaffirmed in 1274, usurers were not to be permitted to receive Holy Communion or to have Christian burial if they died without atonement.[8] Scardeone errs in saying that Reginaldo, instead of his son Enrico, received absolution from Benedict XI;[9] however, we can accept as certain that Reginaldo, too, traveled to Rome and received absolution himself.[10] Enrico's absolution must have taken place shortly before the start of the decoration of the Chapel, because Pope Benedict reigned from October 1303 until July 1304. We do not know the conditions of Enrico's absolution. The erection of the church, however, and its particularly resplendent decoration must have been one of them (Cosimo I de'Medici, similarly, donated most of the installation of the monastery of San Marco in Florence at the instigation of Pope Eugene IV in atonement for unjustly acquired money[11]); this likelihood seems even greater since neither the father nor Enrico

[6] Dante, *Inferno*, XVII, 64–65 [see pp. 108–109 in this book]. *Monumenti dell'Università di Padova (1222–1318)*, collected by Prof. Andrea Gloria, Venice, 1884, p. 343.

[7] See W. Heywood, *A Study of Mediaeval Siena*, 1901, pp. 137 ff. An elucidating example of the significance this sin possessed in the imagination of the Middle Ages is the Hell relief of the church at Fornovo Taro. A usurer stands in the middle of the relief field, bent over and facing the viewer. Three heavy money bags hanging from him pull him to the ground while a devil heaves a huge money chest upon his shoulders (illustrated in Venturi, *Storia dell'Arte Ital.*, II, fig. 119).

[8] Heywood, *op. cit.*, p. 139 and A. Dall'Acqua, "Scrovegni," in *Cenni storici sulle famiglie di Padova e sui monumenti dell'Università*, I, Padua, 1842, p. 96.

[9] Scardeone, *op. cit.*, p. 332, mentions the year 1308 in which Reginaldo (!) was supposed to have been in Rome, but Pope Benedict was no longer alive then. Scardeone also records a false date for Enrico's death: 1321 instead of 1336.

[10] Through Honorius IV (1285–87) or Nicholas IV (1288–92). The assertion that Reginaldo was already dead by 1289 is a statement of A. Gloria's based on a document which is not quoted word for word in *Monumenti dell'Università di Padova, op. cit.*, p. 343.

[11] Vespasiano da Bisticci, *Vite di Uomini Illustri del Secolo XV*, ed. Paul Schubring, Jena, 1914, pp. 313f. Giov. da Nono in F. D. M. Federici, *op. cit.*, p. 139. G. Gennari, *Annali della Città di Padova*, Bassano, 1804, III, p. 89: he had it built with his own money in compensation for the many usurious deeds of his father, doing so at the command of Pope Benedict XI.

returned his fortune to the victims[12] but each was able to leave it to his son.[13]

Judas hangs in Giotto's Hell,[14] and behind him we see three other damned men who must atone for their sins in the same way; their torture, however, seems to be increased, since they have been hanged with the strings of their own money purses [fig. 76]. In a particularly prominent place, to the right, below the cross and above the curve of the door arch, a usurious peasant with a fat money bag on his back is led into the abyss of hell by a devil who holds the peasant's promissory notes in his claw. Another of the Damned who likewise cannot separate himself from his money bag, despite the fact that a devil pulls on it vigorously, must go the same way down to the abyss behind the peasant. The depiction of the hanged Judas in the Last

[12] Cf. Heywood, *op. cit.*, pp. 153 ff.

[13] In addition, a Bull granting indulgences issued by Benedict XI on March 1, 1304, is known [see p. 105 in this book]: 'pro visitantibus ecclesiam b. Mariae Virginis de Caritate de Arena, civitatis Paduae.' (Supino, *Giotto*, Florence, 1920, p. 118). These facts have not been taken into consideration in the modern Giotto literature. That the father was not mentioned in the document of January 9, 1305 (see note 1b [and p. 105 in this book]), does not contradict the interpretation of the church as being a chapel of atonement, especially since the Eremitani monks—angered by the magnificent decoration of the church interior, which they apparently feared would draw people away from visiting their own church—leave out of their protestation to the bishop everything that could have been detrimental to themselves. It is as striking as it is elucidating that the bull of indulgences of Benedict XI (see above) is not mentioned at all, and that they actually deny its existence inasmuch as they refer only to the application for a building permit (before March 31, 1302) in which Enrico Scrovegni apparently sought to obtain permission to build only a family chapel, while the indulgence bull of Benedict XI, of 1304, presumes a church accessible to the public. Therefore, the documentary value of the text of this protest is questionable, and it is revealing that the Eremitani monastery did not achieve anything despite its energetic protest. The bishop did not object that Enrico—in the opinion of the Eremitani monks—built the church larger than permitted, that there are three altars instead of only one, that the importance of the chapel whose interior is already being richly decorated with frescoes is even more heightened on the exterior by a bell tower with two bells, and that, above all, although the monks also attempt to prevent this, the Feast of the Annunciation is being celebrated in the Arena with a play (which was repeated every year until 1600, cf. n. 45) in the very same year, 1305.

[14] The presence of Judas in Hell is mentioned in the Giotto literature only by Broussolle, *Les fresques de l'Arena à Padoue*, Paris, 1905, p. 188, and by E. F. Rothschild and E. H. Wilkins, "Hell in the Florentine Baptistery Mosaic and in Giotto's Paduan Fresco," in *Art Studies*, 1928, p. 33. Nor does Oswald Goetz, "Hie hencktt Judas" [Here Hangs Judas], in *Form und Inhalt, Festschrift für Otto Schmitt*, Stuttgart, 1950, pp. 105 ff., mention Padua and Florence as examples.

Judgment is rare. However, it is seen also in *The Last Judgment* in the Florentine Baptistery. But while Judas in the representation in Florence, seems to be an outcast even in Hell, hanging from his tree at the periphery, completely isolated from the rest of the damned,[15] in Padua Judas is in the middle of Hell in a very conspicuous place: he hangs exactly in the center, between the cross and the jaws of Hell [fig. 74]. Vertically, this place is brought into prominence through the right pilaster with its entablature framing the church door. Horizontally, there is a straight line leading, at the right, from the head of Judas to the jaws of Hell and, at the left, through the cross and the model of the Chapel to the head of Enrico. This allows us to place Enrico, even though he kneels with the Blessed, in a very special relationship to Judas, for it is no less obvious that the misers and usurers populating the part of Hell around Judas correspond to the group with Enrico Scrovegni below the Blessed on the other side of the cross, and that the misers and usurers suffer the same punishment as Judas.[16]

[15] Foto Soprint. Florence 47844. He is the only one of the Damned who is clothed, and the specification GIUDA leaves no doubt as to the identity. Judas in Giotto's Hell also wears a garment. Although no inscription distinguishes him, the intestines spilling from his abdomen—mentioned for the first time in the Gospel of Luke—is the distinguishing mark of Judas according to the *Legenda Aurea* (in the account of the Apostle Mathias; Benz, Heidelberg, 1955, p. 216). The motif of the parted garment seems to be based on a French representational type. In Italy, since early Christian times, there has been a tradition according to which Judas is clothed in a tightly fitting garment (ivory casket in the British Museum, Garrucci, *Storia dell'arte christ.*, VI, fig. 446; ivory casket in Brescia, Garrucci, *op. cit.*, VI, fig. 444; bronze door in Beneventum, Goetz, *op. cit.*, fig. 9; ivory diptych in the Treasury of Milan Cathedral, Garrucci, *op. cit.*, VI, fig. 450; ciborium column in San Marco in Venice, Garrucci, *op. cit.*, VI, fig. 497; the Rabula Codex in Florence, Biblioteca Laurenziana, Garrucci, *op. cit.*, III, fig. 138; Florence, Baptistery). Even when the intestines of Judas spill forth, as on the bronze door in Beneventum, his legs remain covered by the garment. In French representations, however, the garment parts—as in Giotto—so that the naked legs make the miserable situation even more conspicuous (illustrations in Goetz, *op. cit.*, figs. 2, 3, 17, and in E. Mâle, *L'Art religieux de la fin du moyen âge en France*, Paris, 1922, fig. 177).

[16] The figure behind the cross is extraordinary and hard to interpret—it is painted as small as all the humans in the group of the Damned [fig. 74]. Crowe-Cavalcaselle, *La storia della pittura in Italia*, first ed., Florence, 1875, p. 495: A sinner, running along the ridge, sees the holy wood hanging down, and he clings there desperately, so that the devils do not come to wrest him from it. The same in the second edition, Florence, 1886, p. 495: perhaps the allusion is to Adam. A. Foratti, "Il giudizio universale di Giotto in Padova," in *Boll. d'Arte*, 1921, p. 62: to exorcise the punishment of the Inferno. Whether this figure belongs to the saved souls because of its touching the cross (an assumption communicated to me by Dr. Metz) cannot

We assume that Enrico wished to atone for his father's sin of usury, the price of which is Hell. For this reason he joined the lay order of the Cavalieri di Santa Maria, whose aspiration it was to lead a model life and whose most significant duty was to combat usury;[17] and for this reason he built the Chapel and gave it to the order as its church.[18] The basis for atonement, however, is the confession of the sin, for every sin is a betrayal of Christ. And here the confession is made through the representation of the greatest betrayal of all, the betrayal of Judas. And since it happened that Enrico's father Reginaldo betrayed Christ for money just as Judas did, *The Betrayal of Judas* is located on the triumphal arch wall in the consciousness of guilt

be gathered simply from the manner of its representation, since its posture could also be interpreted as a flight due to fear; although both arms firmly grasp the cross, the legs still seem to be running and the head is not facing forward, nor is it lifted up but worriedly turned backward. However, it is certain that this figure belongs to the same sphere as Enrico. Its head is on the same level as that connecting Enrico with Judas and the jaws of Hell. Whatever person it may be and whatever significance the flight in this unusual representation may have, it is very unlikely that this depiction is an "ironical joke" and a "stylistic blasphemy" by Giotto (R. Oertel, *Zeitschr. f. Kunstgesch.*, 1943–44, p. 18 f.), for it is not an event of the realm of Hell but of the cross, which in the whole of medieval art only saints were permitted to touch. Therefore, there has to be some extraordinary event connected with this picture, which here demands an extraordinary representation. And the damned one is naked. Therefore, it can be portrayed only behind the cross, not in front of it, since it obviously is not supposed to represent Adam. Moreover, the cross carried by angels floats in the skies according to the words of Ephrem "the cross shall appear . . . first in the skies with all the heavenly hosts" (see note 83 on representations according to Ephrem), and the damned one who attempts to hide behind it, therefore, must have been painted with this striking reference in mind. But Giotto does not seem to dare more here than anywhere else in his works.

17 As can be gathered from the Bulls of Gregory IX and Urban V (Dall'-Acqua, *op. cit.*, p. 99, Urban V: "No one is to be received in the order who is or is held to have charged any others exorbitantly, who either has gained any other good through usurious wickedness, or through other illicit or unjust means for himself or for others who succeed him by will or intestate, if he does not first make restitution of everything he holds illicitly or unjustly, or offer to the prior general or to his bishop, full and satisfactory security to compensate.") Thus the membership of Enrico in this order by itself means such a break with the habits of his father that, according to the customs of the Church, it must have been considered an act of contrition. We may also consider the construction of the church as such an act. Cf. also, Federici, *op. cit.*, I, p. 64 f.

18 G. Gennari, *op. cit.*, pp. 14, 73, 89 and A. Dall'Acqua, *op. cit.*, p. 98 f. Concerning the order of the Cavalieri di Santa Maria—tradition knows them as the Frati Gaudenti—cf. also Federici, *op. cit.*, vols. I, II; Agostino Ceccaroni, *Dizionario Ecclesiastico*, Milan, 1897, p. 617; *Enciclopedia dell'Accademia della Crusca; Enciclopedia Italiana*.

and as its confession.[19] We should, therefore, not look at this representation as the criticism of the father by the son, but only as the confession of guilt of his own—rendered in a language equal in its pitiless candor to Dante's in the *Inferno*. Enrico confesses this guilt because he recognizes Christ and thereby also the Church and its laws, very much as Elizabeth, on the other side of the arch, recognizes Mary and the Son she carries.

But what is the significance of the painted chambers underneath these two scenes?

We see in each picture a pointed arch whose supports—two low columns—rest upon a cornice molding that lies upon a painted marble panel, which in turn fills the entire width of the wall surface [figs. 70, 71]. We may call them marble panels for the simple reason that they are distinguished by very fine profiles. Furthermore, they can be compared to the profiles in the lowest zone which, however, are not as elaborate, just as the marble of the latter is not colored but white. The dark inlaid strip frames a panel that could very well carry an inscription. The room behind or above it, the walls of which are plain and divided into fields only by vertical and horizontal lines, is covered with a ribbed groin vault. A small divided window is in the back wall, which therefore represents the outside wall. From the apex of the vault hangs a black lamp—the only decoration of these strange rooms, which are striking also because of the little depth they display.[20]

[19] In medieval iconography, the figure of Judas is generally connected with the idea of simony. However, the expressions simony, usury and avarice are closely related since all three are expressions of greed. Thus we find in Dante's *Inferno* (Canto XIX) Boniface VIII is the example of simony and avarice, the supreme example of greed. "Judas as the representative of avarice" (Goetz, *op. cit.*, p. 116 n. 26) is a motif in the visual arts not only in Giotto's work, but also in contemporary as well as earlier representations. On the ivory casket in the British Museum (cf. note 12) we see beneath the feet of Judas an open purse from which the pieces of silver roll. In the Last Judgment of the Cathedral at Conques (Aubert, *La sculpture française au moyen-âge*, 1946, p. 118 f.) Judas hangs from the gallows right next to Satan with the purse around his neck. In the tympanum of the main portal of Freiburg Cathedral (Otto Schmidt, *Gotische Skulpturen des Freiburger Münsters*, Frankfurt, 1926, plate 162) the money falls in a long chain from the right hand of the hanging Judas. In the miniature in the Morgan Library (Ms. 360, fol. VIII, cited by Goetz, *op. cit.*, p. 117 n. 28) it is the empty purse which he, although hanging from the gallows, has not let go of.

[20] In addition to the lamps we also see the rope with a small ring attached to its end. Professor Middeldorf has drawn my attention to the fact that the ropes served for letting the lamps up and down for the purpose of refilling them with oil. The lamps in the St. Francis legend at Assisi show the same exactitude in the description.

Could not these rooms be tomb chambers? Since the events depicted above them constitute memorials to the recognition and the betrayal of Christ, and since we believe them to be descriptions of the confession of guilt and the willingness to atone, the two painted chambers seem to be symbols of the eternal rest the donor hopes to gain for himself, for his guilt-burdened father, and also, of course, for his own family.

The form of these tombs is very similar to that of the group of Trecento wall tombs of which the tombs in Santa Maria Novella in Florence may serve as one example among many [fig. 99]. In the quiet, quite smooth marble slabs under the pointed arches I am inclined to recognize the front sides of the deep sarcophagi common at that time.

Their emptiness, their undecorated walls, their lack of altars, and not least of all, their location above the lowest zone—so that they cannot be an illusionistic complement of the actual space of the church, as Weigelt, Isermeyer, Oertel, and Longhi, among others, assume[21]—all these factors indicate that these painted chambers are not chapels. A direct relationship to the surrounding scenes is impossible, since all those have almost "ideal" architectural settings belonging to a different sphere from that of a chapel; also, those settings are always recessed behind the frames that surround the scenes. In

[21] Moschetti, *La Cappella degli Scrovegni e gli affreschi di Giotto in essa dipinti*, Florence, 1904, p. 54: for some strange reason, interiors are represented instead of events.
Weigelt, *op. cit.*, XVII f.: small choirs. "Two fields were to be filled as simply as possible."
Felix Horb, *Das Innenraumbild des späten Mittelalters*, Zürich and Leipzig [n.d.], p. 31: cross-vaulted, small simulated chapels.
A. Isermeyer, *Rahmengliederung und Bildfolge in der Wandmalerei bei Giotto und den Florentiner Malern des 14. Jahrhunderts*, Würzburg, 1937, pp. 9, 10: side choirs.
G. Fiocco, "Giotto e Arnolfo," *Riv. d'Arte*, XIX, 1937, p. 234: coretti.
Hetzer, *Giotto*, Frankfurt/Main, 1941, p. 158: simulated openings.
R. Oertel, "Wende der Giotto–Forschung," *Zeitschr. f. Kunstgeschichte*, 1943–44, p. 5: side choirs.
Toesca, *Il Trecento*, Turin, 1951, p. 476: with a simple perspective play, two open arcades.
R. Salvini, *Tutta la pittura di Giotto*, Milan, 1952, p. 34: coretti.
R. Longhi in *Paragone*, 31, 1952 p. 18 ff.: small chapels.
R. Oertel, *Die Frühzeit der ital. Malerei*, Stuttgart, 1953, p. 81: gallery rooms; p. 167: side choirs.
The disposition of these chambers speaks against an interpretation of them as galleries, for all galleries of any type whatsoever must be open toward the high altar.

contrast, the marble slabs and columns of the paintings under dis-
cussion are directly adjacent to the painted pilasters, so that they
appear to be pushed in between them. The lamps themselves, which
hang black and lonely in each of the chambers, do not compensate
for all these incongruities. On the contrary, they are actually de-
cisive elements in substantiating our interpretation of these rooms as
tomb chambers. First of all, they are the lamps that belong on every
Christian grave according to the repeated prayer of the Requiem
Mass: *Requiem aeternam dona eis, Domine: et lux perpetua luceat
eis*.[22] According to Joseph Sauer, furthermore, in the Middle Ages
the lamps were a reminder of devotion for those whose wish it was
to share in the crowning moment of life and the heavenly light.[23]
At the same time, they were symbols of those who through good
works light the way for others,[24] and in our case we may surely apply
this to Enrico Scrovegni. As Giotto painted them, the lamps are of
iron, that is, of a metal that has been wrought in fire. They are also,
therefore, symbols of the chosen who have been tested in the fire of
affliction and been found qualified to adorn the heavenly Jerusalem.[25]
This interpretation seems to contain an illusion to Reginaldo Scro-
vegni, who had been absolved of his sins in Rome. The triple rings
and triple bars that form the lamps refer to the three stages of
penance.[26] The nine sconces emphasize once more the imperfection
of human works and remind one of eternal punishment.[27] At the same
time, however, they are the symbols of the angels[28] who in the Last
Judgment are, with the priest and the saints, witnesses to the honest
confession of sins and to genuine repentance.[29]

Because of this Last Judgment it would seem that the Chapel was
erected so that the donor might be received into heaven in a state of
grace. Atonement, death, and judgment determine the whole program
of the interior painted by Giotto—a program dominated entirely by
the powerful *Last Judgment* on the entrance wall [fig. 4]. Enrico
Scrovegni had himself portrayed under the cross for this reason. He
kneels before the Madonna [fig. 77], confesses (as we can clearly see
by his parted lips), and offers her his chapel, the symbol, so to speak,

[22] Eisenhofer, *Handbuch der Kath. Liturgik*, Freiburg, 2nd ed., 1941, I,
p. 291.
[23] Sauer, *Symbolik des Kirchengebäudes*, Freiburg i. Br., 1902, p. 183.
[24] Sauer, *op. cit.*, p. 183.
[25] Sauer, *op. cit.*, p. 183.
[26] Sauer, *op. cit.*, p. 71.
[27] Sauer, *op. cit.*, p. 79 f.
[28] Eisenhofer, *op. cit.*, I, p. 287.
[29] Eisenhofer, *op. cit.*, II, p. 339.

of his confession which, presumably, is represented on the triumphal arch. The chapel, and with it his confession, is supported by both the hands of a monk whom we assume to be the priest whose presence was necessary at this judgment—probably it is one of the clerics who ministered to the lay order of the Cavalieri di Santa Maria.[30] With a tense glance he listens to the words of Enrico while the richly robed and crowned saint, to the right of the Madonna, also listens attentively to him as witness of the community of the saints and puts her hand upon the chapel—his confession. We must assume that this saint is St. Ursula, to whom, in 1294, Enrico had consecrated the first church he had built which he had given to the Cistercians,[31] most likely because this order, as he himself, particularly venerated the Virgin.[32]

The Virgin seems to acknowledge his confession and repentance. With the same gesture by which she once had been received by the priest at the temple gate [fig. 15], with the same open hand with which Christ grants entrance into Heaven to the blessed [fig. 74], she holds out her right hand toward Enrico to lead him, too, before the throne of God, Who will adopt him as his son, just as she had adopted John, who stands next to her and watches with his arms crossed. Venturi and Foratti also believe that it is John who stands at the left of the Virgin.[33] Speaking in favor of this are, first, the touch of a beard;[34] second, his posture; and not last, the colors of his drapery, the tunic, which once was blue, while the robe is bright violet. Only

[30] Dall'Acqua, *op. cit.*, p. 101: a *frate gaudente*. According to P. E. Selvatico, *Sulla cappellina degli Scrovegni*, Padua, 1836, p. 73 f., the personification of the order of the Frati Gaudenti.

E. Foerster, *Gesch. d. ital. Kunst*, Leipzig, 1870, II, p. 255, comes closest to our interpretation inasmuch as he says that the figure is the father confessor and that Enrico Scrovegni had the chapel built "for his soul."

Venturi, *Storia dell'Arte Ital.*, V, 1907, p. 395, sees in this figure the priest of the church who reads the daily mass for Enrico.

According to Moschetti, *op. cit.*, p. 23 ff., Sirén, *Giotto*, Cambridge, 1917, I, p. 47, Supino, *op. cit.*, p. 136, and Rintelen, *Giotto*, Basel, 1923 p. 91, it is supposedly the architect of the church. A. Foratti, *op. cit.*, p. 62: neither priest nor architect; "his is a service not an office."

[31] G. Gennari, *op. cit.*, p. 73 and A. Dall'Acqua, *op. cit.*, p. 98, cite the application to Bishop Bernardo for the building permit.

[32] Concerning Mary as protectress and her relation to the order of the Cistercians, cf. Molsdorf, *Christl. Symbolik der mittelalterlichen Kunst*, Leipzig, 1926, p. 149.

Even the choir, painted later, does not show pictures of the life of some saint, but the last events from the life of Mary.

[33] Venturi, *op. cit.*, p. 393. The saint, however, could be St. Catherine. Foratti, *op. cit.*, p. 62: St. John and a saint.

[34] Certainly not overpainted; compare the head of Christ in the *Noli me tangere.*

John wears this combination of colors. He also wears the same-colored garments in the Ascension of Christ.[35]

Formerly, these three figures were thought to be three angels,[36] or three patron saints,[37] or, again, the three theological virtues.[38] Supino[39] assumed that they represented Mary Queen of Heaven, Mary of the Annunciation, and the archangel Gabriel. This seems particularly improbable to me since in all of Giotto's paintings very definite events with equally definite, concretely acting persons are represented, while Supino more or less interprets the figures as personified ideas. Furthermore, such a combination, is also theologically inadmissible; the coexistence of several divine figures in one person is reserved for the Trinity, not for the Virgin. Besides, a Virgin of the Annunciation could hardly wear a crown.[40]

[35] The representations of the different spheres to which the various persons present at the confession of Enrico belong are very neatly differentiated. The earth from which the dead rise is a small path between Heaven and Hell, the direction of which seems to favor Hell rather than Heaven. Enrico and the priest kneel on it. Enrico is still almost connected by one foot with the realm of the dead, while the three saints, although they form a compact group together with the priest and Enrico, do not touch the earth.

[36] Foerster, *op. cit.*, p. 255; the same in Luzzatto, *op. cit.*, p. 154 and Salvini, *op. cit.*, p. 40.

[37] P. E. Selvatico, *op. cit.*, p. 73 f.; Crowe–Cavalcaselle, *Gesch. d. ital. Malerei*, Leipzig, 1869, p. 241: three female figures; also Thode, *Giotto*, Leipzig, 1899, p. 124; also Dall'Acqua, *op. cit.*, p. 101.
Three majestic heavenly figures: Sirén, *op. cit.*, p. 47; Rintelen, *op. cit.*, p. 91.

[38] Moschetti, *op. cit.*, p. 59 f.

[39] Supino, *op. cit.*, p. 137 f. Weigelt, *op. cit.*, p. XLI: Mary, Gabriel, the third figure not identifiable.

[40] The document from the archives of the Convento degli Eremitani of January 9, 1305 (see note 1 b) which has been quoted in the Giotto literature only by R. Oertel, *Die Frühzeit der ital. Malerei*, Stuttgart, 1953, note 143, permits us to accept a *terminus ante* for the Last Judgment fresco. According to this document, a tower with two bells was also constructed: ". . . Enrico Scrovegni . . . had made and newly constructed a new bell tower in the Arena, at the church located there . . ." [See pp. 106–107 in this book.] The church Enrico offers to the Madonna in the Last Judgment painting shows with extraordinary exactness the actual structure, except for some deviations in the east part. Concerning the chapel we see located on the south side, cf. text page 197; but of the tower above the choir square (Ronchi, *op. cit.*, p. 7 ff.) we see nothing at all. Therefore, we must assume that it was not planned and built before the completion of the fresco; otherwise it would not have been left out, since it was a sign of exceptional pretentiousness, according to the protest of the Eremitani monks. Accordingly, the fresco must have been completed before January 9, 1305. Whether the entire decoration of the interior had been finished by the consecration date, March 25, 1305, cannot be ascertained from the known sources. Possibly parts of the cycle of the life of Christ as well as the bottom zone had not been painted by then. Since the representations from

The two painted chambers of the triumphal arch (whose blue vaults may very well represent a symbol of heaven and were, we assume, painted for this significant reason) contain not just an allusion to death and judgment; their lamps signify not just exhortation to believers and the promise of eternal life.[41] The nine sconces are also a particular allusion to the angels as well as to the Virgin of the Annunciation, in whose honor the Chapel is consecrated. Nine candles are lit in the Masses of the Angels, in which the angels praise the Lord,[42] as we see in the picture of the Dispatching of the Archangel Gabriel [fig. 21]. In the Requiem Mass, too, one sings and prays with the angels, archangels, and all the heavenly hosts so that the angels may hasten to meet the soul to lead it into paradise.[43] Nine candles are also lit in the Rorate Masses,[44] those solemn votive masses, in honor of the Virgin Mary, named after the gospel that treats of the dispatching of the Archangel Gabriel to Mary (and this is also the reason they are called Angel Masses). And the Feast of the Annunciation, the 25th of March, was, as we know from numerous reports, a holiday in the city of Padua, which every year, probably even before 1276, celebrated this day with a large procession and a play about the Annunciation.[45]

In the Rorate Mass, one prays for the mercy of God through the intercession of the Virgin: "the angels find their joy in her, the

the life of the Virgin are the earliest (Jantzen in *Jahrb. d. Pr. Kunstslg.*, 1939, p. 187 ff.), and since we have to allow a certain amount of time for the construction of the choir and the chapel, it is quite possible that Giotto painted the west wall before he began work on the frescoes of the east wall and the rest.

[41] The only scholars who, until now, attempted an interpretation of the lamps, Crowe and Cavalcaselle, *op. cit.*, p. 228, wrote that the lamps symbolized the light that leads to virtue and warns against sin. Virtue, furthermore, leads into Paradise.

[42] Schott, *Das Messbuch der heiligen Kirche* [78].

[43] Schott, *op. cit.*, p. 435 and [135].

[44] Braun, *Liturgisches Handlexikon*, Regensburg, 1924, p. 300.

[45] Giambattista Rossetti, *Descrizione delle pitture, sculture ed architetture di Padova*, I, 3rd ed., Padua, 1780, p. 24 f. Bruno Brunelli "La Festa dell' Annunziazione all'Arena e un affresco di Giotto," *Boll. del Museo Civico di Padova*, 1925, p. 100 ff.
G. Gennari, *op. cit.*, p. 89. According to him there was a small chapel of the Annunziata on the same site before the building of Enrico Scrovegni, while Scardeone (*op. cit.*, p. 332 [see p.110 of this book]) tells of a house of prostitution which was supposed to have been there. In the document of purchase of February 6, 1300 (Tolomei, *op. cit.*, 1880, pp. 29 ff. [and p. 103 of this book]) in which the purchased land is exactly described, neither of the above structures is mentioned.

righteous grace, the sinners find forgiveness eternally" (Bernard of Clairvaux)[46]—Mary as intercessor, as mother of mercy—so Enrico Scrovegni envisaged her and, in his last will, he himself named his church Santa Maria della Carità.[47]

It is important in interpreting the Arena Chapel, as well as the numerous representations of the Annunciation on the tombs of the Trecento, particularly in Padua and the rest of the Veneto,[48] that the Virgin of the Annunciation, through the decrees of Providence, is the path and the gate to Paradise.

Her representation, therefore, is brought into prominence above all other paintings in the Chapel: through her location on the triumphal arch, in the view of the person entering the church, and through the architectural structures [fig. 21] surrounding the angel and the Virgin. These structures have in their perspectival arrangement their own spaciousness, not in the depths of the wall surface but protruding from it and expanding away from the triumphal arch into the space of the church. We must assume that these structures, four towerlike balconies, also have symbolic significance, perhaps related to the idea of the inscription on the candlestick in the Cathedral of Bayeux: "the towers house virtues."[49] An allusion to the virtues of the mother of God seems very appropriate in the context of these frescoes, the meaning of which, indeed, is the acquisition of virtue and the conquest of vice. In addition, the number four is the number of the cardinal virtues, and the purple hues that dominate in the Annunciation also point toward the cardinal virtues.[50] The curtains in and on the

[46] Schott, *op. cit.*, [71].

[47] Tolomei, *op. cit.*, 1881, p. 38 nn. 4 and 7. Also named Santa Maria della Carità in the document of donation of January 1, 1317 (Tolomei, *op. cit.*, 1880, p. 33) and in the Bull of Benedict XI [see p. 105 of this book], cf. note 13.

[48] Planiscig, "Geschichte der venezianischen Skulptur im XIV. Jahr.," *Jahrbuch der Kunstslg. des Allerh. Kaiserhauses XXXIII*, 1915, p. 136.

[49] Quoted from H. Sedlmayr, *Die Entstehung der Kathedrale*, Zürich, 1950, p. 128. The towerlike structures are strikingly opened by four large windows in each, "the transparency . . . is symbolic of the virtues of the inhabitants of Heaven which are pure to the innermost" (Sedlmayr, *op. cit.*, p. 132).

[50] O. Doering, *Christliche Symbolik*, Freiburg i. Br., 1933, p. 101. According to Sauer (*Lexikon für Theologie und Kirche*, X, 1938, p. 564), the Annunciation, according to the descriptions of the mystics Mechthild of Magdeburg and Bernard of Clairvaux is an illustration of the scheme of salvation, the will of God, according to which the second person of the council of the three divine persons—or the *four virtues*, veritas, justitia, misericordia and pax—sacrificed himself for the sake of salvation and was dispatched to earth by the other two divine persons.

house are the symbols of the Virgin's purity, according to the apocryphal gospel of James.[51]

We know through Savonarola that, because of a donation by Enrico Scrovegni, a mass was to be read by three priests every day in the Chapel.[52] Three altars were installed in the church after Giotto had finished painting there. The Sacrament altar was not put in until the paintings in the choir of the saints and the last days of the Virgin were begun—that is, during the third, if not the fourth, decade of the fourteenth century.[53] The altar on the other wall of the choir was not installed until the door there had been walled up; we do not know when this was done [fig. 3].

The priests who read mass at the side altars could look over their altars to the side walls of the triumphal arch where, over the tomb chamber on one side were *The Betrayal of Judas* and the Archangel, and over the other were *The Visitation* and the Virgin of the Annunciation. The priest, therefore, faced either *The Betrayal of Christ* or *The Recognition of Christ*. And indeed, betrayal and recognition supplement each other in the symbolism of the church interior. It may be noteworthy, therefore—although it may not have been intended by Giotto—that the priest, at whatever altar he reads the mass, sees the tomb chamber on the opposite wall of the triumphal arch in its actual depth and not foreshortened: the little window is located in the middle of the exterior wall, the painted vault apex is located exactly in the middle of the pointed arch in front, and the lamp hangs, accordingly, exactly in the center of the room. Above all, the side wall forms a right angle to the marble slab, which also means that it appears to be the continuation of the side wall of the Chapel [fig. 103]. And from the vantage point of the priest we also realize that the painted rooms above the painted marble slabs are even less deep than they appeared to be at first glance. Their depth seems to be exactly the same width as the soffit of the triumphal-arch wall, which, from this vantage point, runs parallel to the side wall of the painted room.[54] They have, therefore, exactly the same depth as the wall, just as we are accustomed to see in wall tombs of this type. It may be argued whether it is scientifically permissible to point out this effect of the

[51] The interpretation of the curtain also in R. van Marle, *Recherches sur l'iconographie de Giotto et de Duccio*, Strasbourg, 1920, p. 5.

[52] Savonarola, *op. cit.*, p. 1175. Cf. also the document of donation (Tolomei, *op. cit.*, 1880, p. 33 ff.).

[53] They presuppose Giotto's chapels in Santa Croce.

[54] Which can be seen correctly only in person, not in a photograph, since the photographic lens always magnifies disproportionately the closer objects, in this case the soffit of the triumphal arch.

architecture in these paintings. It is significant, however, that this effect corresponds exactly with the findings based on the view from in front: namely, that the side walls are shorter than the front and back walls; the division into fields points clearly to foreshortened squares whose size can be measured by the vertical line of the field. The sides of the three squares together are shorter than the width of the front. These considerations, on the other hand, appear to be legitimate because of the fact that all medieval art is to be interpreted as it presents itself to the eye of the viewer, so that here we are permitted to speak of the representation of rectangular rooms viewed on their long side. This seems to be a final proof that we are not to look at Giotto's painted chambers as some kind of chapels, but as representations of tombs, so that these sceneless spaces on the wall, through their attributes, lamps and vaults, and symbolism, become exhortative and memorializing pictures, that is, in effect, cenotaphs, the first examples of their kind.[55]

That it was permissible to have tombs or cenotaphs of people who were neither clerics nor princes at such significant locations, that is, on the right and left side of the triumphal arch—at the sides of the main altar, so to speak—is shown to us by an example from the middle of the Trecento in Padua itself. Until Sant'Agostino was torn down in 1816, there were tombs belonging to two members of the Carrara family—the most powerful family in Padua—in the main apse on either side of the main altar.[56] On one of the two tombs, that of Jacopo Carrara, who died in 1351, we find an unmistakable allusion to the Judgment iconography in the representation of the Annunciation, the angels, and the saints.

However, the Arena Chapel was imitated not only in the placement of the tombs or cenotaphs but also in its plan and program.

In the Baroncelli Chapel[57] of Santa Croce in Florence we find the same motif, even the same program, although it is somewhat reduced in scope and does not emphasize the thought of guilt by means of the Judas story and the relevant vices. Here, too, we have a family chapel,

[55] The expression *cenotaph* must still be used in a limited sense. This earliest painted example is not yet exclusively for the memory of one certain person as is customary from the fifteenth century on. Here the person is, first of all, an *exemplum* in the medieval sense; his typical qualities are of greater importance than his individual existence. Despite all emphasis on the private sphere, the general qualities are still placed above it. See also the last paragraph of the text.

[56] Gerolamo Biscaro, "Le Tombe di Umbertino e Jacopo di Carrara," *L'Arte*, II, 1899, p. 88 ff.; Planiscig, *op. cit.*, p. 118.

[57] W. and E. Paatz, *Die Kirchen von Florenz*, I, 1940, p. 556 ff.

consecrated to the Annunciation. It was decorated by a pupil of Giotto, Taddeo Gaddi, and displays events from the life of the Virgin and some from the life of Christ, as well as representations of the Virtues. In this chapel there is a real tomb, the location and nature of which are also quite similar to those in the Arena Chapel: it is located at the entrance to the choir, it is in the wall, and its chamber occupies the full thickness of the wall.

Nor is the interpretation of the cross vault as the symbol of Heaven, of the life to come, unique to the Arena Chapel. Nor is it unique to the Arena Chapel that, in the scenes from the life of the Virgin, the apse vaults in the temple are painted blue, or that we see a sky full of stars in the vault of the nave. Among numerous other examples, we find a painted sky and stars or representations of heavenly groupings on the sarcophagus of Ducio degli Alberti in the Frari Church in Venice[58] as well as in the painted fragments of the tomb of Jacopo da Carrara, which have been in the Eremitani Church in Padua since 1816.[59]

Even the window, whose iconographic significance we are not able to explain in our context, can be found in the frescoes of the Altichiero school in Fondo (Val di Non) on the back wall of the tomb chamber of St. Lucia. There, too, it rises into the pointed arch of a cross vault.[60]

Furthermore, we frequently encounter that particular element of our cenotaphs, the representation of lamps above the tombs, in painting of the Trecento: for instance, on the Daddi predella in the Vatican,[61] in the fresco in Santa Maria del Piano in Loreto (the Abbruzzi),[62] and in the scenes from the legend of St. Bernard in Vincigliata near Florence.[63]

That the number of the sconces in Padua is not accidental is attested to most conclusively, perhaps, by the lamps in the legend of St. Francis at Assisi. There are six sconces in *The Vision of the Thrones.* In the picture of the doubting Girolamo of Assisi, a lamp with seven

[58] Photo Böhm 2554.

[59] The fresco fragments were apparently lost during World War II. Illustrated in Planiscig, *op. cit.*, fig. 81.

[60] Photo: Gab. Fot. Naz., Rome.

[61] The martyrdom of St. Stephen. Offner, *Corpus of Florentine Painting*, Sec. III, Vol. III, 1930, p. 68, plate XVI[8].

[62] Funeral of a monk. Photo: Gab. Fot. Naz., Rome.

[63] Kaftal, *Iconography of the Saints in Tuscan Painting*, Florence, 1952, No. 48. Furthermore, an example from the fifteenth century from the shop of Fra Angelico in a south German private collection: St. Agatha appears before St. Lucia and her mother who pray at her grave. Catalogue: *Frühe ital. Tafelmalerei*, Stuttgart, 1950, No. 4.

sconces hangs above the rood-beam as an allusion to the seven gifts of the Holy Ghost.[64]

It seems reasonable to assume, from *The Last Judgment* that Enrico Scrovegni had intended from the outset to add to his church a small chapel for his real tomb. Indeed, the chapel he is offering to the Madonna has on its right side a square annex with triangular gables that must have enclosed a cross vault [fig. 77]. It is not definite, although it is quite probable, that a similar chapel annex had actually been planned for the south side of the church. We do not know why it is now on the north side, but, in any case, there are clear indications that it was added later.[65] The profiles of the church certainly would have been continued at least around the east side of the chapel annex, the other two sides being invisible because of annexes and the adjoining palace [fig. 100]. Yet it is most obvious from the inside that the chapel was indeed added to the church after the latter had been finished. On its south and west walls—that is, the walls formed by the church and the choir—we can still see the pilasters of the former exterior walls [fig. 101]. The cross vault given to the chapel is a simple groin vault springing from the corners and resting on a console only in the south-west corner.[66] In the center of the east wall there is a narrow vertical window, probably Gothic originally,[67] with the statue of Enrico Scrovegni opposite it in a niche. We do not know whether there was ever an altar below this window, although we must assume it. We learn from Enrico Scrovegni's last will that it was his wish to be buried in the chapel next to the choir. He says in it: "I, Enrico Scrovegni . . . select the tomb for my body just by the Church and in the Church of Saint Mary of Charity of the Arena of Padua, namely in the monument constructed for myself in that Church—which

[64] For an earlier example among many others: Rome, San Clemente, lower church. *Miracle of St. Clement*: above the altar a ring of seven lamps (Wilpert, *Die röm. Mosaiken*, IV, Freiburg, 1917, plate 239). Seven lamps also burn above the tomb of St. Agatha, cf. note 63.

[65] Moschetti, *op. cit.*, p. 22, also assumes that the side annex had not been completed when Giotto painted the chapel, but with the argument that the portal had not received the same form as we see it in the picture of the Last Judgment; however, this is not the case, as we can learn from the parts of the portal still visible today, and since we know that the porch was not constructed until much later.

[66] Inside, the chapel is about half as high as the choir.

[67] The upper part of the exterior wall was completely renovated in the Renaissance. Inside, above the top of the window as it is today, is the curious, small rectangular window put there in the Renaissance with four-teenth-century parts and closed up today with masonry.

Church and which monument I had constructed by the grace of God
for my lasting benefit."[68]

"Just by the Church and in the Church" we have to interpret as
the location of the chapel. The fact that the monument, which he
stated that he himself had set up, cannot stand in any place other
than the one it occupies today, shows not least that Enrico intended
to build the chapel for his tomb chamber. Moschetti assumed that it
stood originally at the back wall of the choir.[69] This appears to be the
more improbable inasmuch as the stone frame for the fully three-
dimensional statue of Enrico would, of course, have to be located
around a wall niche, but also certainly in front of a straight wall
[fig. 102]. It is impossible to think that it could have been put into
the back wall of the choir, which is rounded like a niche up to the
very line where the vault begins.[70] The depth of the frame of the
statue is only 16 centimeters, while the apse niche is 27 centimeters
deep. There is a difference of 11 centimeters the frame lacks in depth;
its size, therefore, is not in proportion to the choir wall from which it
is supposed to protrude. It is not supposed to recede into it and there-
fore it cannot have been made for this location.[71] Moreover, the space
between the frame and the edge of the niche would only be 15 centi-
meters on either side. The frame must have been made at the same
time as the sculpture, because of its style as well as its size. The fact
that a coin minted around 1360 was found under the pedestal of the
figure during the 1881 restoration of the church does not prove that
the figure had been moved;[72] it seems, rather, that the figure was set
up about 1360, at which time it received the inscription: *Propria
Figura Domini Enrici Scrovegni Militis de Larena* (A true image of
Lord Enrico Scrovegni, knight of the Arena). For Enrico Scrovegni
had ordered the monument to be made during his lifetime and the
statue was probably done in Venice where, after an initial exile (1320),
he lived from 1328 until his death in 1336.[73] This fact may account
for a delay in installing the statue, particularly since the monument,
compared to other tomb monuments in the city, may not have been
elaborate enough for his sons. Therefore they finally had a new setting
made for their father's statue around 1360 in the style of the time.

[68] A. Tolomei, *op. cit.*, 1881, p. 38 nn. 4 and 7.

[69] Moschetti, *op. cit.*, p. 37.

[70] Here, all niches had been originally reserved for the choir stalls, which
were removed from the apse when the new tomb was constructed, at
about the same time as the then-empty walls received their frescoes.

[71] The pedestal of the statue has a depth of 30.3 centimeters.

[72] Moschetti, *op. cit.*, p. 35 and Planiscig, *op. cit.*, p. 70 f.

[73] Moschetti, *op. cit.*, p. 30.

The statue, however, which Andreolo de Sanctis himself probably sculpted between 1328 and 1336 [fig. 102],[74] was apparently not set up in the chapel until he erected[75] the new tomb monument in the choir.[76] Perhaps it was then, at the final installation of the tomb monument,[77] or even later, that the original tomb chapel (built at the same time as the bell tower once located over the square of the choir[78]) was transformed into a sacristy. Formerly the priests had entered the church through the door on the north side, coming from an annex the height of which is still discernible on the exterior wall of the church. Through the relationship of its forms with the paintings of Giotto, the sacristy still reveals today, despite all the other changes, a little of the original plan of the donor. Its ground plan and the form of its vault, as well as its location at the choir, are to be found in the model of the chapel in *The Last Judgment*, while the window in the east wall and the simulated ribs in the cross vault can be found in the cenotaphs.

When we recall once more our interpretation of the painting program in the Arena Chapel with its representation of a confession of guilt and the hope for absolution from sins, we also understand that it was the thought of the Last Judgment which led to the construction of the church. Therein also lies the reason Giotto, contrary to custom, began the decoration not in the choir, which is more important liturgically, but in the nave, since the latter was to become the representation of the confession. The different valuation of the sides of the nave is also in direct relationship to the Last Judgment. The wall of the Virtues that leads to the Blessed is, in relation to the altar, on the epistle side; the wall of the triumphal arch on this side displays *The Visitation* with the symbol of those who light the way for others through good works. The Vices, the Damned, *The Betrayal of Judas*, and the cenotaph of the man who had been tested in the fire

[74] Thieme-Becker, 1935, XXIX, p. 430: Andreolo's presence in Venice is documented from 1328. Enrico Scrovegni, too, lived there from 1328 to 1336. The face is very small-featured and linear. The somewhat rectangular hands with the stubby fingers and the veins on the back are typical of Andreolo's style. Cf. the illustration in Moschetti, *L'Arte*, VII, 1904, p. 389. Venturi, *Storia del'Arte Ital.*, IV, 1906, p. 211 f: a follower of Giovanni Pisano. Planiscig, *op. cit.*, p. 70: Tuscan or perhaps Sienese of the first half of the Trecento.

[75] The tombs of the Carraras were also in the choir.

[76] Planiscig, *op. cit.*, p. 130: shop of Andreolo de Sanctis. Thieme–Becker, 1935, XXIX, p. 430 (Moschetti): principal work of Andreolo.

[77] Under the tomb of Enrico the burial vault of the sons. Scardeone, *op. cit.*, p. 333. P. E. Selvatico, *op. cit.*, p. 21.

[78] O. Ronchi, *op. cit.*, p. 7 ff.

of affliction are on the gospel side.[79] This, again, is linked closely to church custom; ever since Ivo of Chartres and Innocent III, the left side is the favored side because it points to the fact that Christ came to call not the righteous but the sinners.[80]

In addition to the dominant theme of the Last Judgment I believe that the over-all program in the Arena Chapel must be interpreted with the personality of the donor in mind. As Giotto's paintings on the side walls of the church relate characteristically in their compositions to the person who stands in the center of the nave,[81] so, we believe, the entire interior must be observed from the same center; the end of the wall decorations is not in the apse but in front of it, below the triumphal arch, which once was closed off through a screen. The exemplary lives of Christ and the Virgin and the virtues and vices of man along the side walls hold the nave together, so to speak; it is bounded by the sin and death of the Scrovegni donors on the front wall, and by the Last Judgment and remission of sins on the back wall—both embraced by the power of the Father and the Son.[82]

We find here in the Arena Chapel the same grand program which pervades the cathedrals, with their representations of Heaven and Hell, angels and devils, virtues and vices, the lives of Christ and the Virgin. What was impersonally related to all of mankind in the cathedrals of the thirteenth century is still aimed at all of mankind here at the beginning of the fourteenth, yet it distinctly refers to a single individual in whose most personal need it originated and to whose pride, belief, distress, and hope it bears witness.[83]

[79] Rintelen, *op. cit.*, p. 101, sees this "only as a matter of orderly arrangement."

[80] Jungmann, *Missarum Sollemnia*, Vienna, 1952, I, p. 145.

[81] Isermeyer, *op. cit.*, pp. 12, 15.

[82] The east and west walls of the hall, unlike the side walls, also have the same architectural system: a large, painted order of pilasters, a fact that cannot be attributed to "external" reasons—whatever they may be—as F. Baumgart assumes in "Die Fresken Giottos in der Arena Kap. zu Padua," in *Zeitschr. f. Kunstgesch.*, 1937, p. 19 f.

[83] In the topmost zone of *The Last Judgment* there stand, at the sides of the window, two angels in armor in front of nail-studded doors, and each one is rolling up a wall behind which the sun and the moon are seen [fig. 74]. Hitherto, the interpretations were as follows: Moschetti, *La cappella degli Scrovegni e gli affreschi di Giotto in essa dipinti*, Florence, 1904, p. 59, calls it a "bizarro motivo." Foratti, *op. cit.*, p. 64: two angels before a door roll up the skies behind which the sun and the moon become visible. Weigelt, *op. cit.*, p. XL: "Above . . . two angels in armor stand guard in front of the gates of Heaven. A broad, empty space underneath them seems to indicate the space of infinity which rises above the scene of the Last Judgment." Toesca, *op. cit.*, p. 488: "two angels who roll up the great awning of Heaven." Despite the formal difference, Giotto's depic-

LEONETTO TINTORI AND MILLARD MEISS

Observations on the Arena Chapel and Santa Croce*

Though much would surely be gained by an attempt to place the *Legend*† in the context of early Trecento mural procedures, a comprehensive study of this sort is beyond the scope of the present book. More time than was available to us would be required for an exploration of the technique and the intonaco pattern of major monuments of the time, and for each we would have needed a movable scaffold of adequate height. We are however unwilling to leave the *Legend* and the preceding murals in the Upper Church isolated except for scattered comments about related aspects of other paintings. We therefore present at this point brief observations, first on the frescoes in the Arena Chapel, which among surviving cycles are chronologically closest to the *Legend*. We shall conclude with a few words on the two later cycles by Giotto in Santa Croce.

In the Arena Chapel we have examined only the frescoes on the chancel arch and those adjacent to it on the nave walls [text illus. 4]. This group offers specimens, however, of the main stages in the paint-

tion can be compared to the depiction of the angels who in the Savior church in Neredizy near Novgorod, 1199 (Wulff, *Altchristl. und byz. Kunst*, II, Neubabelsberg, 1914, fig. 504) roll up the skies like a book; in the *Last Judgment* in Torcello (illustrated in Paeseler, "Die römische Weltgerichtstafel im Vatikan," *Römisches Jahrbuch*, II, 1938, p. 276); in the Sylvester Chapel in SS. Quattro Coronati in Rome (Wilpert, *op. cit.*, plate 268); in Brindisi, Santa Maria del Casale (Toesca, *Storia dell'Arte Ital.*, I, p. 968); in the Evangelary in Paris, Bib. Nat., grec 74 (Bertaux, *L'art dans l'Italie méridionale*, Paris, 1904, p. 261); in the Hamilton Psalter, Berlin (G. Voss, *Das Jüngste Gericht*, Leipzig, 1884, plate 1); in the *Hortus Deliciarum* of Herrad of Landsberg (O. Gillen, *Ikonogr. Studien zum Hortus Delic. der Herrad von Landsberg*, Berlin, 1931, p. 19). There is a miniature in the Morgan Library, Ms. 273, from the end of the century, which originated in the Veneto, "perhaps Padua," according to the catalogue, *Italian Manuscripts*, New York, 1953, No. 15. Its original literary source must be Isaiah 34:4 and the Apoc. 6:13–14, which are also the sources of the *Legenda Aurea* as well as of Ephrem the Syrian. Ephrem, in his hymns and sermons on the Last Judgment, says: "The stars will fall from the skies, the sun will lose its light, the moon will turn to blood, and the skies will be rolled up like a book (cited by Voss, *op. cit.*, p. 67). In another passage (*Bibl. der Kirchenväter*, vol. 37, I a, Kempten, 1919, p. 72): "The skies will roll themselves up from terror; and the stars will fall from them like unripened fruits from the fig tree and like leaves from the trees. The sun will darken from

*From *The Painting of "The Life of St. Francis," in Assisi, with Notes on the Arena Chapel*, New York, 1962, Chapter 5, pp. 159–185

† [The life of St. Francis in the Upper Church at Assisi.]

ing of the chapel because there are two scenes from each tier of fres-
coes, and only the entrance wall is not represented [fig. 103]. Study
of the intonaco has enabled us to give a definitive answer to a question
that has been debated for many years.

Throughout this century historians have commented on the simi-
larities between the uppermost tier of frescoes representing episodes
from the life of the Virgin and the lowest tier representing Vices
and Virtues. In 1911 Axel Romdahl interpreted these similarities as
the result of the execution of the two tiers in immediate chronologi-
cal succession. The life of the Virgin was, he judged, an addition
unforeseen at the outset and painted after the Vices and Virtues.[1]
This thesis was rejected in the great monograph by Rintelen pub-
lished in the following year,[2] and it has not been generally accepted
since then. From time to time, however, it has been revived, by
Vitzthum for instance in 1929[3] and by Baumgart at great length in
1937.[4] This view is incorrect. The overlapping of the patches of
intonaco prove beyond any question that on both nave walls as well

fright, and the moon will fade trembling, the bright stars will darken from
dread of that judgment," and (*ibid.*, p. 73): "He will roll up the whole
of creation." Ephrem, whose writings have been disseminated widely in
numerous translations from the Syrian and in whose writings the Last
Judgment figures eminently ("the most magnificent religious description
before Dante's *Inferno*"—Wulff), probably also influenced Dante. Vincent
of Beauvais quotes Ephrem "with admiration" (cf. the article "Ephraem"
by F. Nau in *Dictionnaire de Théologie Catholique*, vol. 5 a, Paris, 1939).
According to F. Nau, the paradise in Ephrem is divided into three regions,
"and 'the door' is already one of these." This is known to us only in the
description of Ephrem and it is, therefore, most probable that we find in
this description by Ephrem an explanation for the fact that the gates were
included in the program, since Giotto's *Last Judgment* as well as the other
frescoes in the Arena Chapel are based upon "eastern" traditions (the
Annunciation on the triumphal arch!) as well as "western" ones (for the
decisive characteristics, cf. Paeseler, *op. cit.*, pp. 321 and 323 ff.). That the
angels who roll up the skies were painted at the top of the wall, and that
there is such an extraordinary amount of "empty" space between them and
the heavenly hosts, as nowhere else on the entire wall, emphasize the place
from which the stars have fallen and express how extraordinary is the
moment represented. It is something completely new for the expressiveness
of an empty field to be included in the composition and its content.
 Concerning the throne of the judging Christ, cf. Apoc. 4:6–8.
 [1] "Stil und Chronologie der Arenafresken Giottos," *Jahrbuch der preus-
sischen Kunstsammlungen*, XXXII, 1911, pp. 3–18.
 [2] *Giotto und die Giotto-Apokryphen*, Munich, 1912, p. 15, note 29.
 [3] "Zu Giottos *Navicella*," in *Festschrift Paul Schubring*, Leipzig, 1929, pp.
150 ff.
 [4] F. Baumgart, "Die Fresken Giottos in Padua," *Zeitschrift für Kunst-
geschichte*, VI, 1937, pp. 1 ff.

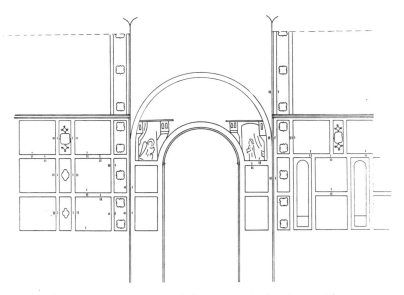

Text illus. 4. Diagram of the Chancel, the Arena Chapel

as on the triumphal arch Giotto worked in the normal and practical
sequence, from above down [text illus. 4].[5]

In contrast with the greater part of the *Legend* in Assisi white
lead is not employed in the frescoes in the Arena Chapel. The lack
of it is one reason for the enduring transparency of the colors and
their relatively good preservation, which matches the breathtaking
brilliance of the painting. Even in *The Expulsion of Joachim from
the Temple* [fig. 104], one of the very first scenes to be under-

[5] Some historians have proposed also a chronological order of work within
each tier. Thus Baumgart (*op. cit.*) concluded that the lowest row on the
left hand side (facing the choir) was painted from the entrance wall to the
triumphal arch, that is, from the *Way to Calvary* to the *Pentecost*, whereas
the opposite wall was painted in the opposite direction, from the *Last Supper*
to the *Mockery*. A test of the intonaco on the left hand wall near the
triumphal arch shows that there at least Giotto and his assistants painted the
vertical ornamental bands between the scenes before the adjacent scenes
themselves, so that it is impossible to discover the sequence of the scenes
themselves (or the bands).

Almost all scholars have recognized that Giotto employed assistants in
the Arena Chapel, especially for the execution of the decorative bands but
also for the scenes. It has not however been pointed out, as far as we know,
that the simulated chapel on the right side of the chancel arch is inferior
to that on the left, and probably a copy of it.

taken and thus closest to the *Legend* in the commonly held sequence of Giotto's work,[6] there is no white lead whatever [fig. 105]. Furthermore, the torso and the feet of each of the two standing figures visible in full length are united in one patch. Such an organic unity appears to be normal though not invariable in the Chapel, whereas it is abnormal, as we have seen, in the frescoes in the *Legend* in Assisi that are considered the best representatives of Giotto's art.

One aspect of the procedure in this early fresco in Padua is entirely unprecedented in the cycle in Assisi. Changes in any of the scenes of the *Legend* after the intonaco was spread are very exceptional. In the first two frescoes in Assisi, to be sure, the garments of two figures (one by the St. Cecilia Master) were given a final form slightly different from that foreseen when the intonaco was spread. To our knowledge no head was changed correspondingly in any of the twenty-eight frescoes. But in *The Expulsion of Joachim* the head of the young man who is blessed by the priest was painted partly on patch 2 and partly on 4 [fig. 106]. Such a division could not have been planned, because of the difficulty of an exact match of the colors, and an intonaco joint in the area of a face is always avoided. At some moment after 2 was laid, Giotto decided to lower the upper edge of the wall of the sanctuary as well as shift its angle, while disclosing more of the man's head. The part of the face that was added was left, however, in greenish-gray, either because of an oversight or a wish to suggest shade.

It is fascinating to observe that this is only the last of three changes Giotto made at this place. On patch 2 there are two red earth lines showing the rim of the sanctuary at levels above the joint. The precise reasons for these changes of mind are not entirely clear. It is conceivable that at one moment the painter decided to show there the upper surface of the wall, which is indeed visible behind the altar and the priest, but there are no clear signs of such an intention along the section of wall below the priest. Whether Giotto was more interested in shifting the angle of the wall or in exposing a larger portion of the head cannot definitely be said, but the addition of the mouth and jaw to this quiet, receptive face heightens the contrast with the rejected Joachim so much that we may safely assume Giotto had this in mind when altering the design.

Other beholders of this sublime painting may have sometimes wondered, as we did, whether the astonishing and highly expressive

[6] This inclusion of the *Legend* in Giotto's early oeuvre is, however, contested by (among a few others) Millard Meiss. See his *Giotto and Assisi*, New York, 1960.

void into which old Joachim is pushed was always entirely lacking in forms. It was.

The fresco opposite *The Expulsion of Joachim, The Virgin Return-ing from the Temple* [*The Virgin's Return Home*], is no less exalted, but it is damaged by water, especially at the right, and disturbed by an unnecessary grill that will, we hope, soon be removed [fig. 107]. Here again the bodies and the feet are together on the intonaco, note-worthy especially where the legs and feet are exposed below the garments. In order to keep the Virgin's mantle and train together patch 8 dips way out to the left.

Most interesting of all are alterations of the design made during the course of painting. Giotto became dissatisfied, as he worked, with the heavy cylindrical mass of the figure in front of the Virgin [figs. 108, 109]. He quickly modified it by two superficial addi-tions. He raised the skirt a little by running over its lower border a strip the color of the ground on which the figures stand. He reduced the monolithic massiveness of the mantle by painting a thin red line over it from the lower left to the right above the level of the knees. By this single genial stroke the garment is transformed from a mantle into a mantle over a tunic. The garb of the figure thus resembles the Virgin's, and the ascending movement of the edge of her mantle is echoed by the pseudo-mantle alongside. The changes beyond any doubt reveal the mind, and probably the touch, of the master himself.

The Nativity too was altered during the course of the painting [fig. 110]. The upper outline of the Virgin originally coincided with the joint between patches 3 and 5. The suture would normally fol-low the contour of the figure, and a red preparatory line along the upper edge of 5 proves that, when the intonaco was laid, the painter still intended the figure to extend to that level. All these scenes, as well as *The Annunciation* [figs. 111, 112] and *The Visitation* [fig. 113], were painted mostly in *buon fresco*. In *The Nativity*, however, some of the beautiful clear blue has come off the mantle of the Vir-gin and all of it from Joseph's tunic. In *The Virgin's Return . . .*, diagonal stripes applied *a secco* have largely peeled off the tunic of the violinist, and the last man in this scene has lost the blue of his dress as well as his trumpet [fig. 107]. For the same reason the walls of the room of *The Last Supper* [fig. 120], now bare, have lost all their ornament.

Losses in *The Expulsion of the Tradesmen from the Temple* have more seriously affected the reading of the design [fig. 114]. The boxes and crates in the foreground, now all in various stages of disintegra-tion, originally were prominent in the composition and the narrative.

The door of the cage held by the agitated young vendor nearest Christ has fallen open, and the birds have escaped through it, vanishing presumably in the direction of the fleeing goats. The crate in front of the man in 12, not yet disturbed, contains five pigeons; they were painted *a secco* and are invisible from the floor of the Chapel today. The framework of the upturned table in front of Christ has disintegrated also, especially those parts painted *a secco* over his mantle. The loss of part of this form has weakened the horizontal movement along the ground, originally powerful as it extended from the animals at the left (actually also facing to the left) through the market boxes to the scampering animals at the right. The figure of Christ, which now interposes a massive uninterrupted vertical at the center of the design, was originally contained in a shallow space between two wooden structures, the farther one higher than the nearer.

This relationship between the two containing form was not finally decided without some deliberation. In fact, at this point we again get an insight into Giotto's procedures, comparable to the one in *The Expulsion of Joachim* discussed above. The blue applied in tempera to Christ's mantle has mostly fallen away, exposing the red fresco preparation. On this surface the painter has sketched some lines for a structure that corresponds with neither of those actually painted [fig. 115]. The lines begin at the level of the feet of the triangular crate behind Christ, but they rise higher than it does. A change of this sort might be interpreted as the consequence of the lack of a full-scale drawing on the *arriccio*, but it involves a secondary, non-figural form, and it would be rash to draw inferences from one or two instances.

It was not only during the course of the work that Giotto changed his mind at several places in this fresco. Even after part of the paint was dry, or the entire scene was completed, he altered forms or introduced new ones. He had adopted for the *Expulsion* the main groups of the Byzantine composition of this scene [fig. 116]: the apostles behind Christ, the fleeing tradesmen, the troubled, plotting Pharisees at the right, and in the background the temple, which may owe its strange round lunettes above and its two prancing horses between two lions to S. Marco in Venice.[7] Giotto departed, how-

[7] For the usual Byzantine composition see O. Demus, *The Mosaics of Norman Sicily*, London, 1949, p. 279. See also the fresco at Curtea de Arges [O. Tafrali, *Monuments byzantins de Curtea de Arges*, Paris, 1913, pl. XLIX (2)]; Paris, Bibl. Nat. gr. 74 fol. 170v. (Paris, Bibl. Nat., *Ms. gr.* 74 . . . *Evangiles avec peintures du* XIe *siècle*, Paris, 1908, pl. 148(1). Especially relevant is the twelfth-century painting in Schwarzrheindorf (E. Aus'm Weerth, *Wandmalereien des Christlichen Mittelalters in den Rheinlanden*, Leipzig, 1880, pl. XXVI, figs. 1–3).

ever, from the normal iconography of the event in one very interesting respect. Looking at his fresco one would conclude that the temple was contaminated only by the purveyors of sacrificial birds and animals. The paraphernalia of another kind of business disrupted by Christ, the coin scales knocked over, the careening table spilling money in all directions, and the large purses carried off by anxious owners,[8] as in the mosaic in Monreale [fig. 116], all are lacking.

The Gospels as well as most large representations emphasized the overthrow of the tables of the money changers. It is not surprising that the scene in the Arena Chapel as elsewhere should often be entitled *The Expulsion of the Money Changers from the Temple*,[9] but the only object that seems to allude to this occupation is the table lying quietly, face-downward, in front of Christ. At best therefore Giotto pays only lip service to tradition. It would be wrong of course to suppose that the calling largely suppressed in the scene was unknown to Giotto and his patron. Enrico Scrovegni's father, Reginaldo, was a notorious money lender who was confined by Dante to the seventh circle of Hell for the crime of usury. Money changing was not ecclesiastically as sensitive an occupation as money lending, but the two were in actual practice commonly combined.

In connection with this diminution of references to money in the *Cleansing* it is interesting to recall other representations of it in the Arena Chapel. The fact that people overly attached to money are bound to sacks of it in *The Last Judgment* might seem to reflect a different attitude. *Caritas*, furthermore, tramples moneybags underfoot. The vice opposed to this virtue however is not the usual Avarice, but Envy [fig. 59]. Envy does, it is true, clutch a bag presumably of coins, but the emphasis is shifted from a lust for money to the more comprehensive covetousness of *Invidia*, and in this shift Giotto went further than one of the great representatives of early capitalism, Giovanni Villani, who still included avarice among the capital sins, although he traced its origin to envy.[10] Giotto's revision of the vice opposed to *Caritas* is related to the fact that no money changers are explicitly expelled from the temple. For subtle reasons about which we can only rather uncertainly speculate, it was de-

[8] For example, the relief on the façade of St. Gilles (R. Hamann, *St. Gilles*, Berlin, 1955, pls. 56, 57).

See also the panel in Ghiberti's North Door (R. Krautheimer, *Lorenzo Ghiberti*, Princeton, 1956, pl. 34).

[9] See for instance Van Marle, *op. cit.*, III, p. 84 and VI (iconographic index), p. 40.

[10] This was pointed out by Meiss, *Painting in Florence and Siena after the Black Death*, p. 50, note 147.

cided to include this very rare scene[11] but at the same time to omit major personages from the cast of characters. It is a rather bold attempt to revise the representational tradition, not to mention the Gospels.

One other aspect of the story is novel. At the left a young apostle is sheltering a child in his mantle, lowering his head so that his face, astonishingly, is in shade. The child, terrified by the anger of the Lord, "molto terribile nella faccia," as Chapter 42 of the *Meditazioni sulla vita di Gesù Cristo* describes him, was the only figure moving away from Christ toward the left when the painting was completed. The bullocks strengthened this movement, but Giotto judged it was not properly mediated; he felt that the passage toward the left from the figure of Christ (lunging toward the right) to the columnar figure of St. Peter and the child near the frame was abrupt and insufficiently rhythmical. He decided, partly at least for this reason, to introduce a mediator, like the famous one between Christ and Lazarus in the *Raising*. In this instance it was to be, largely for lack of space, a child.

Giotto cut out a piece of intonaco from the yellow mantle of St. Peter, laid a fresh patch, and on it painted in fresco the upper part of a child [figs. 114, 117]. Evidently his preference for *buon fresco* was strong, but the fresh patch proved in the end not large enough and the figure was completed in a summary way by red and blue lines painted *a secco* right over Peter's yellow mantle.

Giotto's greatness as an artist and his close relationship to the medieval tradition have not induced us to think of him as a painter with problems and alternatives.[12] The very perfection of the Arena frescoes seems to still thought about the process of creation, and historians incline to conceive of him as Vasari conceived of Fra Angelico, unwilling to retouch any of his works and preferring to leave them as they had first come out, in the belief that this was the will of God.[13] But a close study of just a few frescoes proves that for Giotto, as for later artists, creation was a process of sustained searching, of choice and rejection, and, like many great writers, he was still wont to make changes in galley and even page proof.

[11] We cannot think of another example in Trecento painting. Nor does Van Marle, *loc. cit.*, cite one.

[12] Borsook (*op. cit.*, p. 130) observed that in the *Last Judgment* the blue azurite mantle of Christ was lowered somewhat over the red tunic, and that a cap or two were added in the crowd of the Blessed.

[13] *Vite*, ed. Milanesi, Florence, 1906, II, p. 520. "Aveva per costume non ritoccare nè racconciare mai alcuna sua dipintura, ma lasciarle sempre in quel modo che erano venute la prima volta, per credere (secondo ch'egli diceva) che così fusse la volontà di Dio."

Other trials and changes are visible in the *Expulsion*. A curved red line just to the right of Christ's profile suggests that at one moment the painter thought the head would be placed more to the right and given thus a still more aggressive thrust. The head of the apostle who shields the child was drawn about six inches to the right of its present position; part of the outline may be seen on the chest of St. Peter where the blue has now fallen away. After the halo of the middle apostle of the three at the left was completed its width was doubled.

The little figure added to the composition after the left part, at least, had been completed is not of course simply a new link in a chain of movement but a new actor in a drama. The presence of children is unprecedented in the representation of the cleansing of the temple, but they play a role in other scenes in the Arena Chapel, such as *The Entry into Jerusalem* and *The Raising of Lazarus*. They "invade" other subjects at the time, such as *The Way to Calvary*, freely venting feelings shared but not so overtly expressed by adults.[14] In Italian art beginning in the late thirteenth century *amor proximi* is exemplified by a woman tending not a beggar but a child, and miracles of rescued or revived children are favorite subjects of Trecento art.

Perhaps the form taken by Giotto's afterthought was suggested by the man holding birds who occasionally appears among the evicted tradesmen in medieval representations of the Purging.[15] On the other hand there is warrant in the text of Matthew (21:15) for the introduction of children at the time of the expulsion: "But when the chief priests and the scribes saw the wonderful things that he did, and the children that were crying in the temple and saying, Hosanna to the son of David; they were moved with indignation. . . ." Giotto's children, however, far from hailing Christ, flee from his angry aggression. They act, in other words, at the common human rather than the religious or symbolic level.

Perhaps another extraordinary aspect of the child added on the new patch is to be understood in this sense only. He is clutching a dove, presumably one of those that escaped from the opened cages rather than one bought before the arrival of Christ. But the closeness of the child to St. Peter, from whose mantle he was actually created, and his identification with the group of apostles, inevitably

[14] On the role of children in early fourteenth-century art see Meiss, *op. cit.*, p. 61. For an instance of children in the Way to Calvary see Simone Martini's panel in the Louvre (Van Marle, *op. cit.*, II, fig. 163).

[15] F. X. Kraus, *Codex Egberti*, Freiburg i/B, 1884, pl. XXXII. Also a late Byzantine psalter at Mount Athos, Pantokrater 61, fol. 87.

suggests an association with the Holy Ghost, which inspired the apostles at Pentecost. The sacrificial bird seems to be rescued and transformed by the work of Christ, but it is probably too much to suggest that in this remarkable and wholly unprecedented representation there is latent an idea of Christian progress from the Old Testament to the New.

It is an interesting fact that, though the traditional figure clutching his moneybag is not visible in *The Expulsion*, a very similar man appears in the next scene, at the right on the adjacent triumphal arch [fig. 118]. One almost has the impression that Judas has escaped from the temple to treat, in the next episode, with the priests; and continuity is, in another regard, explicitly indicated by the three priests, who are identical with the three plotting apprehensively in the preceding scene. Of course, Judas has gotten his money not from financial affairs but from a traitorous conspiracy. It is his part in the evil betrayal that is condemned in this remarkably sinister scene.

Because of its peculiar shape and black color the present halo of Judas [fig. 119] has given rise to speculation. There are, however, unmistakable traces of the lower half of the disk on patch 3; the material has simply adhered better on one patch than another, a common phenomenon attributable in this instance perhaps to remaining dampness in the intonaco of 3 when the halo was applied *a secco*. Not only Judas but all the disciples wear similar haloes in the two subsequent scenes in the story, *The Last Supper* [fig. 120] and *The Washing of the Feet* [fig. 40], both painted on the opposite wall.[16]

Analysis in a laboratory of a minute specimen of the substance in these darkened haloes proves it to have been composed of lead, copper, silver, and a little gold; a false gold, in other words, that has oxidized.[17] Cennino Cennini, in Chapter 101, writes of an imitation-gold halo made of gilded tin, but he does not describe the material used in the Arena Chapel.

Though the haloes of Judas and the other apostles in these scenes are composed of the same metal a distinction is preserved between them: the haloes of the apostles have rays, while his alone in all three scenes is perfectly smooth. In *The Last Supper* and *The Wash-*

[16] The haloes of the two angels behind the cross in the *Last Judgment* are similar.

[17] For the analysis of the metal in the haloes we are indebted to the Conservation Center of the Institute of Fine Arts of New York University, particularly to Lawrence Majewski, Research Associate of the Center, and Dr. Edward V. Sayre, Consulting Fellow.

ing of the Feet there are in fact three kinds of haloes: 1) gold and in relief for Christ; 2) without relief, simulated gold, with rays, for the apostles; 3) the same as 2, but without rays, for Judas. Haloes are varied throughout the cycle in accordance with different purposes but with a high degree of consistency, as far as we could judge from the floor. A principle is established in what probably was the first surface painted by Giotto in the chapel, the angels high on the chancel arch. Here all the haloes are in relief except those of the two angels at each side that are both close to the enframing arch and, what is decisive, deepest in space. A halo without relief is used similarly for the angel deepest in space and closest to the frame in the *Baptism* and for the one in a corresponding position on the empty tomb. The same spatial considerations seem to have governed the flat haloes of the apostles in *The Raising of Lazarus* [fig. 34] and in *The Pentecost* [fig. 121], where the apostles in the front row have haloes in relief, while those deeper in space have not. Iconographic factors seem more important in the choice of flat haloes for the centurion in *The Crucifixion*, [fig. 47] for the figures immediately to the left and right of Lazarus, and the apostle at table in *The Marriage at Cana* [fig. 33].

The only mural paintings after those in the Arena Chapel that were carried out under the supervision, at least, of Giotto are much later in date and therefore less relevant to our central subject, the *Legend* in Assisi. The intonaco pattern in the one scene in the Bardi Chapel that we were able to map shows, despite the regrettable damage, the characteristic mosaic of fresco [fig. 122]. Several distinctive painters carried out the commission in this chapel, but they all tended to relegate more of the work to a tempera technique than Giotto had done at Padua. Thus the head and hands of St. Francis in *The Appearance at Arles* were painted entirely in fresco, but his habit was only prepared in this technique and completed on a dry, or nearly dry, wall [fig. 123]. The extent of the completion *a secco* may account for the large size of patch x in the scene of *The Death* [fig. 122]. Some changes on the intonaco are visible, but fewer than in the Arena Chapel. In the scene of the saint denying his father, the molding over the heads of the figures was given a steeper decline on both sides of the building [fig. 124]. And the position finally assumed by the head and hand of the friar in *The Death* who looks up at the ascending saint differs slightly from the outlines still clearly visible alongside. Nowhere are there any traces of sinopia drawings on the *arriccio*.

In the Peruzzi Chapel Giotto and his assistants returned, as we have said, to secco painting [fig. 125]. Secco painting, but not pure

secco, because just as fresco painting is normally combined with a certain amount of secco, so secco often includes some fresco—as in the "fresco secco" technique. Colors such as the pink on the tower behind the violinist in *Herod's Feast* that were spread while part of the plaster in the huge patches was still damp have been fixed in the process of carbonation.[18] The intonaco in the Peruzzi Chapel was laid in the large rectangles of the *pontata*, two patches to a scene, with the joint between them falling near the neck and shoulders of the majority of the figures. Since each scene, from inner border to inner border, measures about 8½ feet high the *pontate* were about 4¼ feet high. The supporting beams of the scaffold were fixed in the wall, and the places into which they fitted were plastered separately. Either the removal of the beams or the plastering of these squares was deferred until the *pontate* had been spread and had dried. The levels of the scaffold were so close that a man could not stand up, much less work comfortably, on one platform if the boards above were left in place.

In technique the Peruzzi Chapel is further removed than the Bardi Chapel from the cycle at Padua. This greater difference might suggest that the Peruzzi Chapel was painted later than the Bardi. However, the need for great speed or other considerations at which we can only guess might have been responsible for the readoption of a technique that heretofore historians, guided by Cennino, believed had been decisively outmoded by Giotto. As Anatole France reminds us: ". . . L'embarras de l'historien s'accroît avec l'abondance des documents." (*L'île des pingouins.*)

[18] Over the window of the chapel there is a roundel containing a Lamb on an altar, all executed in *buon fresco*, but perhaps painted somewhat later than the large frescoes. Possibly it replaces a roundel painted in this area originally.

BIBLIOGRAPHY

The standard bibliography on the Giotto literature is that compiled by Salvini and published in 1938. For more recent literature the reader should consult the article on Giotto by Gnudi in Volume VI of the *Encyclopedia of World Art*. The selective list given here contains a number of the more important general studies on Giotto and those which deal principally with the Arena Chapel frescoes.

Ancona, P. de, *Giotto*, Milan, 1953.

Arcangeli, F., *Le storie di Giotto: La Vita della Vergine*, Milan, 1953.

Battisti, E., *Giotto, Biographical and Critical Study*, Lausanne, 1960.

Baumgart, E., "Die Fresken Giottos in der Arenakapelle zu Padua," *Zeitschrift für Kunstgeschichte*, VI, 1937, 1–31.

Bellinati, P., *La Cappella di Giotto all' Arena (1300–1306), studio storico-cronologico su nuovi documenti*, Padua, 1967.

Berenson, B., *Italian Painters of the Renaissance*, New York, 1952.

Borsook, E., *The Mural Painters of Tuscany, from Cimabue to Andrea del Sarto*, London, 1960.

Broussolle, J. C., *Les fresques de l'Arena à Padoue; étude d'iconographie religieuse . . .* , Paris, 1905.

Brunelli, Bruno, "La festa dell'Annunziazione all'Arena e un affresco di Giotto," *Bollettino del Museo Civico di Padova*, XVIII (new ser. 1), 1925, 100–109.

Bucci, M., *Giotto*, Florence, 1966.

Callcott, Maria G., *Description of the Chapel of the Annunziata dell'Arena; or, Giotto's Chapel, in Padua*, London, 1835.

Carrà, C., *Giotto*, London, 1925.

Cecchi, E., *Giotto*, New York, 1960.

Crowe, J. and Cavalcaselle, G., *A New History of Painting in Italy*, I, London, 1864.

Eimerl, S., *The World of Giotto* (Time-Life Library of Art), New York, 1967

Fisher, M. R., "Assisi, Padua and the Boy in the Tree," *Art Bulletin*, XXXVIII, 1956, 47–52.

Florence. Commissione della Mostra giottesca. *Pittura italiana del Duecento e Trecento; catalogo della Mostra giottesca di Firenze del 1937*, ed. G. Sinibaldi and G. Brunetti, Florence, 1943.

Foratti, A., "Il Giudizio universale di Giotto in Padova," *Bollettino d'arte*, ser. 2, I, 1921, 49–66.

Gilbert, Creighton, "The Sequence of Execution in the Arena Chapel," *Essays in Honor of Walter Friedlaender*, in *Marsyas, Studies in the History of Art*, Supplement II, New York, 1965, 80–86.

Gioseffi, D., *Giotto architetto*, Milan, 1963.

Gnudi, C., "Giotto," in *Encyclopedia of World Art*, VI, New York, 1962, cols. 339–356.

Gnudi, C., *Giotto*, Milan, 1959.

Gnudi, C., "Il passo di Riccobaldo Ferrarese relativo a Giotto e il problema della sua autenticità," *Studies in the History of Art Dedicated to W. Suida*, London, 1959, 26–30.

Gosebruch, M., *Giotto und die Entwicklung des neuzeitlichen Kunstbewusstseins*, Cologne, 1962.

Gyarfes-Wilde, J., "Giotto-Studien," *Wiener Jahrbuch für Kunstsammlungen*, VII, 1930, 45–94.

Hetzer, T., *Giotto di Bondone: Die Geschichte von Joachim und Anna*, Berlin, 1946; Stuttgart, 1959.

Hetzer, T., *Giotto, sein Stellung in der europäishen Kunst*, Frankfurt a. M., 1941.

Isermeyer, C., *Rahmengliederung und Bildfolge in der Wandmalerei bei Giotto und den florentiner Malerei des 14. Jahrhunderts*, Würzburg, 1937.

Jantzen, H., "Die zeitliche Abfolge der Paduaner Fresken Giottos," *Jahrbuch der preussischen Kunstsammlungen*, LX, 1939, 187–196.

Jantzen, H., *Uber den gotischen Kirchenraum und andere Aufsätze*, Berlin, 1951.

Longhi, R., "Giotto spazioso," *Paragone*, III, 31, 1952, 18–24.

Mariani, V., *Giotto*, Rome, 1937.

Marle, R. van, *The Development of the Italian Schools of Painting*, The Hague, III, 1924.

Marle, R. van, "Giotto narrateur," *Revue de l'art ancien et moderne*, L, 1926, 154–166; 229–240.

Marle, R. van, *Recherches sur l'iconographie de Giotto et de Duccio*, Strasbourg, 1920.

Mather, Frank J. Jr., "Giotto's First Biblical Subject in the Arena Chapel," *American Journal of Archaeology*, XVII, 1913, 201–205.

Meiss, M., *Giotto and Assisi*, New York, 1960.

Meiss, M., *Painting in Florence and Siena after the Black Death*, Princeton, 1951.

Moschetti, A., *La Cappella degli Scrovegni e gli affreschi di Giotto in essa dipinti*, Florence, 1904; English translation: W. Cook, *The*

Scrovegni Chapel and the Frescoes painted by Giotto Therein, Florence, 1907.

Moschetti, A., "Donde abbia inizio il racconto giottesca nella Cappella Scrovegni," *Atti del R. Istituto Veneto di scienze, lettere ed arti,* LXXXIV, 1924–25, 485–92.

Moschetti, A., "Il Giudizio universale di Giotto nella cappella degli Scrovegni," *Atti e Memorie della R. Accademia di scienze, lettere ed arti in Padova,* XX, 1904, 45–61.

Moschetti, A., "Questioni cronologiche giottesche," *Atti e Memorie della R. Accademia di scienze, lettere ed arti in Padova,* XXXVII, 1920–21, 181–200.

Murray, P., "Notes on Some Early Giotto Sources," *Journal of the Warburg and Courtauld Institutes,* XVI, 1953, 58–80.

Nagy, M. von, *Die Wandbilder der Scrovegni-Kapelle zu Padua: Giottos Verhältnis zu seinen Quellen,* Bern, 1962.

Oertel, R., "Wende der Giotto-Forschung," *Zeitschrift für Kunstgeschichte,* XI, 1943–44, 1–27.

Perkins, F. M., *Giotto,* London, 1902.

Previtali, G., *Gli affreschi di Giotto a Padova,* Milan, 1965.

Prosdocimo, A., *Il Comune di Padova e la Cappella degli Scrovegni nell' ottocento, acquisto e restauri agli affreschi,* Padua, 1961 (*Bollettino del Museo Civico di Padova,* XLIX, no. 1, 1960).

Rivista d'arte, Numero speciale del centenario Giotesco, Florence, 1938. (XIX, nos. 3–4.)

Romanini, A., "Giotto e l'architettura gotica in alta Italia," *Bollettino d' arte,* L, 1965, 160–180.

Romdahl, A. L., "Stil und Chronologie der Arenafresken Giottos," *Jahrbuch der preussischen Kunstsammlungen,* XXXII, 1911, 3–18.

Rothschild, E. and Wilkins, E., "Hell in the Florentine Baptistery Mosaic and in Giotto's Paduan Fresco," *Art Studies,* VI, 1928, 31–35.

Ruskin, John, *Giotto and his Works in Padua; being an explanatory notice of the series of wood-cuts executed for the Arundel Society after the frescoes in the Arena Chapel,* London, 1854.

Salvini, R., *Giotto, bibliografia,* Rome, 1938.

Salvini, R., *Giotto, La Cappella degli Scrovegni,* Florence, 1956.

Selvatico, P. E., *Scritti d'arte,* Florence, 1859.

Selvatico, P. E., *Sulla Cappellina degli Scrovegni nell'Arena di Padova e sui freschi di Giotto in essa dipinti,* Padua, 1836.

Semenzato, C., *Giotto: la Cappella degli Scrovegni,* Florence, 1966.

Sirén, O., *Giotto and Some of his Followers,* London, 1917, 2 vols.

Smart, A., "Reflections on the Art of Giotto," *Apollo*, LXXXI, 1965, 257–263.

Supino, I. B., *Giotto*, Florence, 1920, 2 vols.

Supino, I. B., "Giotto a Padova," R. Accademia della Scienze dell'Istituto di Bologna. Classe di Scienze Morali, *Rendiconto*, Ser. II, vol. VI, 1921–22, 10–22.

Telpaz, A., "Some Antique Motifs in Trecento Art," *Art Bulletin*, XLVI, 1964, 372–376.

Thode, H., *Giotto* (Kunstler Monographien, 43), Bielefeld and Leipzig, 1899; third edition, W. F. Volbach, ed., 1926.

Tintori, L. and Meiss, M., "Additional Observations on Italian Mural Technique," *Art Bulletin*, XLVI, 1964, 377–380.

Toesca, P., *Florentine Painting of the Trecento*, New York, [1929].

Toesca, P., *Giotto*, Turin, 1941.

Tolomei, A., *La chiesa di Giotto nell'Arena di Padova. Relazione al Consiglio Comunale dell'assessore A. Tolomei*, Padua, 1880.

Tolomei, A., *La chiesa di S. Maria della carita dipinta da Giotto nell'Arena* . . . , Padua, 1880.

Tolomei, A., *La cappella degli Scrovegni e l'Arena di Padova* . . . , Padua, 1881.

Vasari, G., *Le vite de' più eccellenti pittori, scultori ed architettori* . . . , ed. G. Milanesi, I, Florence, 1878.

Venturi, A., *Storia dell'arte italiana*, V., Milan, 1907.

Vigorelli, G., *L'Opera completa di Giotto*, Milan, 1966.

Weigelt, C., *Giotto: des Meisters Gemälde* (Klassiker der Kunst), Stuttgart, 1925.

Weigelt, C., "Giottos Fresken in der Arena-Kapelle zu Padua als Epos und Weltbild betrachtet," *Die Christliche Kunst*, XXV, 1929, 193–213.

White, J., *Art and Architecture in Italy, 1250–1400* (The Pelican History of Art), Baltimore, 1966.

White, J., *The Birth and Rebirth of Pictorial Space*, London, 1957.

JAMES H. STUBBLEBINE, a leading authority on Italian painting of the Gothic period, is Professor and Chairman of Art at Rutgers University. His publications include *Guido da Siena* and various articles in art historical journals. He holds the A.B. degree from Harvard University and the Ph.D. from the Institute of Fine Arts of New York University.